How the Essay Film Thinks

How the Essay Film Thinks

Laura Rascaroli

OXFORD
UNIVERSITY PRESS

OXFORD
UNIVERSITY PRESS

Oxford University Press is a department of the University of Oxford. It furthers
the University's objective of excellence in research, scholarship, and education
by publishing worldwide. Oxford is a registered trade mark of Oxford University
Press in the UK and certain other countries.

Published in the United States of America by Oxford University Press
198 Madison Avenue, New York, NY 10016, United States of America.

© Oxford University Press 2017

Library of Congress Cataloging-in-Publication Data
Names: Rascaroli, Laura author.
Title: How the essay film thinks / Laura Rascaroli.
Description: New York : Oxford University Press, 2017.
Identifiers: LCCN 2016044879 (print) | LCCN 2017006161 (ebook) |
ISBN 9780190238247 (hardback) | ISBN 9780190238254 (paperback) |
ISBN 9780190238261 (updf) | ISBN 9780190656393 (epub)
Subjects: LCSH: Experimental films—History and criticism. |
Documentary films—History and criticism. | Motion pictures—Aesthetics. |
BISAC: PERFORMING ARTS / Film & Video / History & Criticism. |
PERFORMING ARTS / Film & Video / Screenwriting. | ART / Film & Video.
Classification: LCC PN1995.9.E96 R37 2017 (print) | LCC PN1995.9.E96 (ebook) |
DDC 791.43/611—dc23
LC record available at https://lccn.loc.gov/2016044879

CONTENTS

ACKNOWLEDGMENTS

My journey toward this book began after the publication of *The Personal Camera: Subjective Cinema and the Essay Film* in 2009. Although for some time I believed that my new work on the topic consisted in an extension of the theses I had put forward in that book, in particular on the communicative structures of first-person cinema, I eventually came to realize that my focus had shifted to questions of usage and functioning, thus prompting a new understanding of the essay film's method and practices, which is at the basis of the present monograph.

This process was aided and, indeed, catalyzed by the work that I have been invited to present and publish since *The Personal Camera*, and so, at the end of this journey, I gratefully acknowledge those who have given me precious opportunities to discuss my ideas with diverse audiences, to be challenged by them, and to receive their responses. My conversations with Kieron Corless and Chris Darke at an essay film season held at the British Film Institute, London, in August 2013 were particularly illuminating; I thank them and David Edgar for inviting me, as well as the wonderfully cinephile BFI audience for the exciting discussion that followed my presentation. I enjoyed equally stimulating debates at Visible Evidence XX, Stockholm, where Malin Wahlberg, Anu Koivunen, and Patrik Sjöberg generously asked me to deliver a keynote address; at the "The Self-Portrait in the Moving Image" event organized by Laura Busetta, Marlène Monteiro, and Muriel Tinel-Temple at the Birkbeck Institute for the Moving Image in March 2014, London; at the 2014 Avant Festival in Cork, on the invitation of Sarah Hayden; at an event on Pier Paolo Pasolini organized by Giuliana Pieri and James Williams at the Istituto Italiano di Cultura, London, in October 2014; at the 2015 PLASTIK Festival of Artists' Moving Image in Galway curated by Megs Morley; at the 2015 Essay Film Festival organized by the Birkbeck Institute for the Moving Image, an invitation for which I am indebted to Laura Mulvey and Michael Temple; at the 5th Association of Moving Image Researchers Annual Meeting, Lisbon, where I was asked to deliver a keynote by Tiago Baptista and Susana Viegas; at the Architecture

| Essay | Film Symposium, organized at the Bartlett School of Architecture by Anna Andersen, Penelope Haralambidou, and Nguyen Phuong-Trâm in April 2016. A very special thank you goes to Susana Barriga and to the students of the Maestría Cine Ensayo at the Escuela Internacional de Cine y TV for the two unforgettable weeks of intensive teaching and learning on the essay film that we shared in San Antonio de Los Baños, Cuba, in spring 2016. I am equally indebted to the colleagues and friends who invited me to present my developing work on the essay film at their universities over the past few years: Efrén Cuevas (Universidad de Navarra), Cecilia Sayad (University of Kent), Liz Greene (Dublin City University), Alisa Lebow (University of Sussex), John David Rhodes (University of Cambridge), and Alison Smith, Lisa Shaw, and Tom Whittaker (University of Liverpool).

A heartfelt thank you goes to Matt Carter and Adam Jones for generously granting me access to LUX's film archives; to Ilona Jurkonyte for our conversations on the essay film under totalitarian regimes; to Juan Antonio Suárez for letting me have an offprint of his inspirational work on noise in experimental film; to Gianluca Pulsoni for sharing his thoughts on a number of essayists; to Mary Thompson for generously engaging in dialogue on Peter Thompson's films; and to Lawrence Abu Hamdan, Rebecca Baron, Irina Botea, Mohammadreza Farzad, and Nguyễn Trinh Thi for granting me access to their wonderful work and for discussing their films so productively and so generously with me.

An early version of Chapter Two was first published in *Holocaust Intersections: Genocide and Visual Culture at the New Millennium*, edited by Axel Bangert, Robert Gordon, and Libby Saxton and published by Legenda in 2013. I thank the editors for inviting me to contribute to their volume and Graham Nelson at Legenda for generously granting permission to republish my work here.

Working with Oxford University Press has been a privilege. I thank Brendan O'Neill for commissioning the book, Suzanne Ryan, Editor in Chief, Humanities, for so sensitively engaging with the manuscript during the refereeing process, and Norman Hirschy for being such a responsive and supportive editor.

Of all the friends and dear friends who have sustained me in precious ways while writing this book, I thank in particular Alba Bariffi, Cristiana Longo, and Maria Mantovani for always being unfailingly and lovingly there; Pierluigi Laffi for our inspiring conversations on film technique and for being such a wonderful human being; Ewa Mazierska for her continued openness to our precious, ongoing dialogue; Jill Murphy for being such a constant collaborator and point of reference; and Gwenda Young for enduring the toughest part of the past few years with me. Stefano Baschiera knows why he's being thanked here.

Finally, it is with infinite tenderness that I express my gratitude to my family for their love—in particular, Mum and Dad, Luca, Paola, my magnificent Alice, and my funny, clever nieces and nephew, both Irish and Italian—Gemma, Aileen, Tullio, and Claudia.

My last thoughts are for my darling aunt Carla, for her capacity for love, her generosity, her life of work, her hidden cigs, the bottle of mint syrup, our chats on the swing; and for my dearest Eugenio, who knew what matters most in life, and with whom it was always possible to talk both as an uncle and as a friend. Ciao zii.

Introduction—Openings

Thinking Cinema

The "essayist" approach is not to impose a definitive meaning to the images, but to create an opening. (Tode 1997–1998, 41)

Less than a decade ago, the expression "essay film" was encountered only sporadically; today, the term has been widely integrated into film criticism and is increasingly adopted by filmmakers and artists worldwide to characterize their work—while continuing to offer a precious margin of resistance to closed definitions. Examples of filmmaking that have been called essayistic (even if the term itself has not always universally been used) have existed since at least the 1930s, although it was groundbreaking, reflexive work by filmmakers and intellectuals, in France especially, in the 1950s that made of the essay film, whether so called or not, an appreciable strand of nonfiction since then—examples include Jean-Isidore Isou with *Traité de bave et d'éternité* (*Venom and Eternity*, 1951), George Franju with *Hôtel des Invalides* (1952), Alain Resnais with *Les Statues meurent aussi* (*Statues also Die*, 1953), *Nuit et brouillard* (*Night and Fog*, 1955), and *Toute la mémoire du monde* (1956), Chris Marker with *Dimanche à Pekin* (1956) and *Lettre de Sibérie* (*Letter from Siberia*, 1957), Agnès Varda with *L'Opéra-mouffe* (*Diary of a Pregnant Woman*, 1958), Jean Cocteau with *Le Testament d'Orphée* (*Testament of Orpheus*, 1959), and Guy Debord with *Sur le passage de quelques personnes à travers une assez courte unité de temps* (*On the Passage of a Few Persons through a Rather Brief Unity of Time*, 1959). Key early conceptualizations of the form were indeed prompted by films released during the same decade. First published in 1955 in *Cahiers du cinéma*, Jacques

Rivette's (1977) "Lettre sur Roberto Rossellini," a text prompted by the release of Rossellini's *Viaggio in Italia* (*Voyage to Italy*, 1954), is probably the first article comparing a film to an essay and, more specifically, to a metaphysical essay, a confession, a logbook, and an intimate journal—in other words, as Rivette remarks, an essay in the style of those of Michel de Montaigne (1700). For Rivette, Rossellini's was the first film that created for the cinema the possibility of the essay, a form that, he claimed, so far had only been achieved in literary writing. The importance of this novelty for the cinema is highlighted by Rivette's assertion that, because of its freedom, inquisitiveness, and spontaneity, the essay is the true language of modern art. André Bazin's (2003) review of Chris Marker's *Letter from Siberia*, in turn, first published in 1958 in *France-Observateur*, also remarks on the utter novelty of this "essay documented by film," claiming that it resembles "nothing that we have ever seen before in films with a documentary basis" (44). Bazin's description of Marker's style in his review deeply shapes how we continue to think of the essay film today—especially the emphasis on a cinema of the word, one that cannot do without an "intelligent" text, to use Bazin's expression, read by a voiceover, as well as on the hybridity of the essay and the freedom of the essayist filmmaker.

The history of the essay film, however, is even longer, and so is that of its theorization. Although this history has been reconstructed before now (Rascaroli 2009; Corrigan 2011; Montero 2012), it is useful to recall it again here, albeit concisely, to emphasize some of the questions that will form the basis of my argument in this book. In particular, I wish to attract attention to the "moment" of the essay film, that is, to its historical import and relevance. This issue acquires renewed significance today, at a time that can be described as that of the essay film's greatest fortune and expansion. Bringing this question to the fore means beginning to focus on how the essay film thinks and also on what it thinks about—the two matters that will be at the core of my investigation in this book.

THE ESSAY FILM AS FUTURE PHILOSOPHY

A Descartes of today would already have shut himself up in his bedroom with his 16 mm camera and some film, and would be writing his philosophy on film. (Astruc 1999, 159)

As mentioned in 1948 by Alexandre Astruc (1999), the first filmic reference to the term "essay" appears to have occurred in 1927, in a note written by Sergei Eisenstein on his project of making a film based on Karl Marx's *Das Kapital*. Critics converge in thinking that the first explicit discussion of the essay film was Hans Richter's article "Der Filmessay, eine neue form

des Dokumentarfilm," first published in *Nationalzeitung* in 1940, in which he announced a new type of cinema, capable of creating images for mental notions and of portraying concepts. For Richter (1992), as later for Rivette and for Bazin, this cinema was a novel, freer form of documentary, capable of accessing a much broader reservoir of expressive means than the old documentary film. Richter here identified some of the features that will continue to be ascribed to the form: transgression and crossover of generic boundaries, inventiveness and freedom from conventions and expressive constraints, complexity and reflexivity. Also regularly associated with the birth of the essay film is Alexandre Astruc's article "Naissance d'une nouvelle avant-garde: la caméra-stylo," first published in *L'Ecran français* in 1948. The same suggestion of freedom of expression appears here also, captured by the fortunate metaphor of the camera-pen. Although he does not focus directly on the essay film, Astruc (1999) compares cinema to literature and announces a new type of film of the future, which will be capable of expressing thought in a flexible and immediate manner.

Meanwhile, critics and curators have traced scattered examples of essay films made throughout the 1920s, 1930s, and 1940s, including experimental, reflective, satirical, or lyrical nonfictions such as Dziga Vertov's *Chelovek s kino-apparatom* (*Man with a Movie Camera*, 1929) and *Tri pesni o Lenine* (*Three Songs about Lenin*, 1934), Jean Vigo's *A propos de Nice* (1930), Luis Buñuel's *Las Hurdes* (*Land without Bread*, 1933), Henri Storck and Joris Ivens's *Misère au Borinage* (1934), Humphrey Jennings's *A Diary for Timothy* (1945), Roger Leenhardt's *Lettre de Paris* (1945), Leo Hurwitz's *Strange Victory* (1948), George Franju's *Le Sang des bêtes* (*Blood of the Beasts*, 1949), Nicole Védrès's *La Vie commence demain* (*Life Begins Tomorrow*, 1949), and Leonardo Sinisgalli and Virgilio Sabel's *Una lezione di geometria* (*Geometry Lesson*, 1949). Whether all these films should be considered essays wholly depends on how one defines the genre, something that continues to be a point of sustained critical contention. What is uncontentious is that the essay film became fully established, both as a filmic practice and as a critical category, in the 1960s, when it rapidly spread worldwide. Although compiling an exhaustive list would be challenging, a few examples demonstrating its global appeal in the decade would include works made in Germany (*Brutalitat in Stein* [*Brutality in Stone*, 1961] by Alexander Kluge and Peter Schamoni), Iran (*Khaneh siah ast* [*The House Is Black*, 1963] by Forugh Farrokhzad), Chile with French collaboration (. . . *à Valparaiso* [1963] by Joris Ivens, with Chris Marker's commentary), Italy (*La rabbia* [*Rage*, 1963] by Pier Paolo Pasolini), France (*Méditerranée* [1963] by Jean-Daniel Pollet and Volker Schlöndorff), Mexico (*La Fórmula secreta* [*The Secret Formula*, 1965] by Rubén Gámez), the Soviet Union (*Obyknovennyy fashizm* [*Ordinary*

Fascism, 1965] by Mikhail Romm), Japan (*Yunbogi no nikki'* [*Yunbogi's Diary*, 1966] by Nagisa Ōshima), Argentina (*La hora de los hornos* [*The Hour of the Furnaces*, 1968] by Fernando Solanas and Octavio Getino), and Armenia (*Menq* [*We*, 1969] by Artavazd Peleshian).

The global spread of an essayistic practice in the 1960s is reflected in writings of those years; for instance, in their influential manifesto of Third Cinema, Fernando Solanas and Octavio Getino (1976) cite the essay film as one of the privileged forms for the realization of a revolutionary, antico-lonialist, anticapitalist filmmaking practice. Their text was first published in 1969, the year by which the term "essay film" truly became established. The same year saw the first edition of Noël Burch's (1981) *Theory of Film Practice*, a chapter of which, on the topic of "nonfictional subjects," is devoted to the essay film as a new type of documentary, one that Burch found to be particularly current and "most relevant to contemporary needs" (158).

The emphasis on the modernity of the form and its contemporary rel-evance is a recurrent feature of all the conceptualizations of the essay film on which I have touched here and has a vital bearing on how we frame it as an object. In each decade since the 1940s, critics have saluted the essay film as an utterly novel and revolutionary form, mostly on the basis of its ability to bring the cinema closer to a medium at once per-sonal and intellectual, such as writing. The utopian nature of this idea can be seen in a crucial aspect of all of these theories: on each occasion, the possibility of the essay film's coming-into-being is linked to the pre-condition of almost futuristic technological development. This is obvi-ously because such development is needed to actualize the dream of a camera that becomes increasingly flexible, portable, always ready to be used, and responsive to human thought—just like a pen. This key tech-nological point is at the root of the repeated presentation of the essay film as cinema of the future and, I argue, also explains why it has become today one of the liveliest expressions of international documentary film-making, one in constant growth and expansion. This is in no small part the result of the introduction of digital technology, which, with its wide availability, portability, ease of manipulation, and suitability for the new channels of distribution and consumption of alternative audiovisual products, provides the tools to make and share personal, unorthodox, idiosyncratic forms of audiovisual expression more readily than ever before. Thanks to new technologies, the possibility of using the camera as a pen, and of producing a fully personal *cinécriture*, has become much less utopian today than when Astruc coined the term "*caméra-stylo*." At this time of proliferation of individual audiovisual narratives, especially

on the Internet, the old dream of the camera-pen seems to have been finally realized—only that, of course, technology never ceases to promise to become more portable and more flexible, and so the essay film forever remains the "film of tomorrow," to use an expression from a famous article by François Truffaut (1957, 4).

Although technological development facilitates a cinewriting that is increasingly personal and idiosyncratic, this outcome cannot be isolated from its political significance. The possibility of making a cinema less conditioned by mainstream forms of signification and industrial systems of financing and production has obvious political implications. To say "I" or "we" is, first, a gesture of responsibility and accountability, in filmmaking too. The moment of the essay film is, therefore, politically inflected. Precisely for this reason, we can venture, the essay film first boomed worldwide in the 1960s, a decade marked by a widespread desire for increased participation, democracy, and self-expression; and it also explains why previous embodiments tended to coincide with examples of dissident analysis of actualities. Since then, the essay has continued to be at the core of critical nonfiction produced by oppositional, postcolonial, accented, exiled, feminist, and lesbian, gay, bisexual, transgender, and queer subjects, among others, precisely because it is the most direct embodiment of the dream of a cinema of personal and critical expression, unencumbered by the constraints of systemic production, and better suited to escape the control of all forms of censorship.

The moment of the essay film, then, is politically inflected not only because the essay gives voice to the need for independent critical expression, if utopianly so, but also because it is constitutively against its time. This point is best argued by drawing on one of the most influential theorists of the literary/philosophical essay, Theodor W. Adorno (1984), whose article "The Essay as Form" will be central to my argument in this book. Noting that at the time of writing (between 1954 and 1958), "[i]n Germany the essay provokes resistance because it is reminiscent of the intellectual freedom that, from the time of an unsuccessful and lukewarm Enlightenment, since Leibniz's day, all the way to the present has never really emerged, not even under the conditions of formal freedom" (152), Adorno places much emphasis on the essay's heretical, contrarian stance, which is transgressive of the orthodoxy of form. Such transgression means that "[t]he relevance of the essay is that of anachronism" (166). The anachronism of the essay, its untimeliness, accounts for its political value. Anachronism, for Adorno, is relevant to the essay inasmuch as this embodies an eclecticism that counteracts the separation of art and science that is typical of a "culture organized according to departmental specialization"

and, ultimately, of a "repressive order" (156). Adorno observes of the untimeliness of the essay:

> The hour is more unfavorable to it than ever. It is being crushed between an organized science, on one side, in which everyone presumes to control everyone and everything else, and which excludes, with the sanctimonious praise of "intuitive" or "stimulating," anything that does not conform to the status quo; and, on the other side, by a philosophy that makes do with the empty and abstract residues left aside by the scientific apparatus, residues which then become, for philosophy, the objects of second-degree operations. (170)

It is for this reason that the role of the essay is, for Adorno, that of "transgressing the orthodoxy of thought" (171). As Michelle Boulous Walker (2011) has commented in "Becoming Slow: Philosophy, Reading and the Essay," such transgression continues to be fully relevant in the new millennium, at a time when alternative modes of philosophy, such as slow thought, are emerging:

> In an age of increasing technocracy our need for the essay and its anti-systematic resistance is ever more crucial. The essay resists thought's reduction to what Adorno elsewhere refers to as an instrumental rationality [. . .] The law of the innermost form of the essay is heresy and this heresy lies (paradoxically) in the attitude of respect that the essay demonstrates towards thought. By refusing too hurriedly to seize the world, to understand it by containing, to speak definitively, to summarise, or assimilate it, the essay offers us a future philosophy—one that holds out the hope for a slow engagement with the complexity and ambiguity of the world. (274)

Returning to the cinema, then, the anachronistic matrix of the form is at the basis of the argument that the essay film is the future film, the film of tomorrow. It is so not only because it will always be the technology-to-come that will make it possible for filmmakers to use their cameras like pens, to mobilize the personal camera, to an increasing extent, but also because the essay is against its time and, thus, it is not of the "now"; it is future philosophy. It is, indeed, "precisely its unfashionable or untimely nature that speaks to its urgency" (Walker 2011, 274). Unearthing the essay film's distinctive political concerns will be one of the leading objectives of this book.

THE METHOD OF "BETWEEN"

But how does the essay film's anachronistic, antisystematic resistance come into being? What is the method of its future philosophy? And where does

its thinking take place? These questions are at the core of my investigation in this book, in which I will engage with the essay film as a critical, contrarian form of audiovisual expression.

Adorno's discussion of the essay form is, again, an illuminating starting point in this regard. Adorno (1984) places disjunction and differentiation at the core of the essay's functioning. Thus, he writes,

> In the essay the persuasive aspect of communication, analogously to the functional transformation of many traits in autonomous music, is alienated from its original goal and converted into the pure articulation of presentation in itself; it becomes a compelling construction that does not want to copy the object, but to reconstruct it out of its conceptual *membra disjecta*. (169)

Rather than copying its object and offering a closed argument about it, then, the essay operates on its object's scattered parts. In this way, the essay shuns suture and works in a regime of radical disjunction. "Discontinuity" (Adorno 1984, 164) and "juxtaposition" (170) are terms also used by Adorno, which emphasize break and the contrasting positioning of elements that characterizes the essay's argument. For Adorno, the essay is, indeed, "more dialectical than the dialectic as it articulates itself" (166).

It is precisely this dialectics that I wish to bring into focus, because it is through a disjunctive practice, I argue, that the essay film articulates its thinking and, in particular, its nonverbal thinking. Although thus far the essay film has been studied by and large as a cinema of the word, which heavily relies on verbal commentary, its argumentation is not limited to spoken or written text. Its specificity, when compared to the literary essay, is indeed the multiplication of the levels of signification. What I wish to investigate in this book is how disjunction is to be found at the core of the essay film's diverse signifying practices, among which the verbal is only one of several levels of intelligence.

Issues of differentiation and disjunction have been emphasized before by theorists of the essay film. Noël Burch (1981), in his above-cited discussion of the form, claims that films such as George Franju's *Blood of the Beasts* and *Hôtel des Invalides* are works of "tremendous originality" that differ from the "old-style documentary" in that they propose not an objective portrayal of reality, but conflicts of ideas. Franju's films for Burch are meditations, reflections on nonfictional subjects that "set forth thesis and antithesis through the very texture of the film" (Burch 1981, 159). These dialectical films achieve a complex disjunction of form and amount, for Burch, to explorations in discontinuity. Burch remarked indeed on the "beginnings of a disjunct form" in Franju's *Blood of the Beasts* and wrote

that in his subsequent documentaries Franju "carried these explorations in discontinuity even further" (160). For Burch, such discontinuity is related to Franju's use of thesis and antithesis.

Similarly, thirty years later Thomas Tode (1997–1998) traced an irreconcilable dialectics at the core of the essay film, which for Tode reflects the complexities of our encounter with reality:

> The essay film regards the accidental and the elementary, the individual and the general, as the manifestation of a dialectic which must also preserve the contradictions of the artistic and aesthetic product, so reflecting the irreconcilability of its elements. The uncertainty of the essay film is salutary, for it refines the whole set of approaches through which we encounter reality, a reality in which social phenomena deploy themselves just like a living organism. (45)

Drawing on these analyses, which are germane to my understanding of the essay film, my hypothesis is that the dialectical disjunction that is at the basis of the essay form creates in film in-between spaces that must be accounted for, inasmuch as they are central to the essay film's functioning. It is this in-betweenness that calls for investigation. Thus far, work on the essay film has focused more on dialogism than on dialectics. In his monographic study focusing on the combination of different discourses in the essay form, for instance, David Montero (2012) borrowed Mikhail Bakhtin's concepts of heteroglossia and dialogism to emphasize the presence of differentiated speech and encounter of socioideological positions in the essay film, as well as the "double-voicedness" that accounts for the dialogism of texts. My perspective here, by contrast, will be to focus not so much on the relational aspects of the essay film as verbal structure, which have already been thoroughly accounted for by Montero; by Timothy Corrigan (2011), who describes essayistic thinking as "modeled on the question–answer format initiated as a kind of Socratic dialogue" (35) and the essay as an encounter between the self and the public domain that "measures the limits and possibilities of each as a conceptual activity" (6); and by myself (Rascaroli 2009), where I discussed the communicational structures of the essay film as a dialogue between enunciator/narrator and spectator (32–43). Although I continue to acknowledge the centrality of dialogue to the essay form, and to the spectatorial experience of the essay film, my interest in this book lies in addressing the dialectical tension between juxtaposed or interacting filmic elements and, more precisely, the gaps that its method of juxtaposition opens in the text. Studying these in-between spaces is key if we wish to move beyond logocentrism and to understand how the essay film thinks—because its thinking capitalizes on discontinuity.

A first attempt to think of filmic in-betweenness was the concept of "interval" proposed by Dziga Vertov. The notion was central to his theory of montage; Vertov's "theory of the interval began as a theory of the intervals between frames and was then expanded into a theory of editing by way of a generalization from intervals between frames to intervals between shots" (Cook 2007, 90). The interval thus becomes in Vertov the gap between shots, a dynamic space on which the film is built; it is a complex quantity that implies correlations including the correlation of planes (close-up, long shot etc.), of foreshortenings, of movements within the frame, of light and shadow, and of recording speeds (Vertov 1984, 90). Montage, then, is the organization of intervals into phrases; the rhythmic, quasi-musical value of intervals can be seen, for instance, in the idea that "[i]n each phrase there is a rise, a high point, and a falling off (expressed in varying degrees) of movement" (9). The function of the interval in Vertov is, thus, mostly rhythmic and aesthetic.

When looking at existing conceptualizations of in-between spaces in film, which can support a discussion of the essay film such as the one I aim for in this book, Gilles Deleuze's film-philosophy stands out for its distinctive theorization of the signifying power of interstitiality. In his work on cinema as image of thought, Deleuze (1989), by contrast with Vertov, emphasized disjunction as the element that generates new filmic thinking. Significantly, he did so with reference to an essay film: Jean-Luc Godard and Anne-Marie Miéville's 1976 *Ici et ailleurs* (*Here and Elsewhere*). Based on footage shot by the selfsame Godard and by Jean-Pierre Gorin (as Dziga Vertov Group) for a never-completed pro-Palestinian project (*Jusqu'à la victoire*, 1970), and a critique of that film and of the methods of the Dziga Vertov Group, *Here and Elsewhere* is placed already by its title in an in-betweenness, one that is defined not only spatially, but also temporally and ideologically. In writing on this film, Deleuze introduced the concept of interstice, which, drawing on the complexity of film language, he described as spacing "between two actions, between affections, between perceptions, between two visual images, between two sound images, between the sound and the visual" (180).

Deleuze placed the interstice at the center of his conception of cinema as image of thought. The elliptical narratives and nomadic characters of Italian Neorealism and the French New Wave, which bring about the possibility of the time-image, point to a disconnectedness that subsequently becomes ever more radical and constitutive of the modern image. With the breaking of the sensory-motor linkages typical of the movement-image, the interval is set free; what emerges is the irrational cut, which stands on its own. Images are no longer linked to each other; the chains of images are broken and the fissures between them become larger. What matters, argues

Deleuze, is no longer the association of images but the interstice between two images, as a result of which these become radically external to each other. The irrational cut does not belong to either image or sequence that it separates and divides, but becomes discernible and "sets out to be valid for itself" (Deleuze 1989, 200).

Created by an irrational cut, the interstice for Deleuze (1989) is distinct from the interval, which appeared in the movement-image as interval of movement and was identified with the affection-image (29). The interstice is specific to the time-image. As mentioned, Deleuze theorized it starting from Jean-Luc Godard's dissociative method, which he describes as the "method of BETWEEN" (180; emphasis in the original). The interstice is, then, an incommensurability; it is a differential of potential that determines the incommensurable relations between images and that produces the possibility of the new:

> Given one image, another image has to be chosen which will induce an interstice *between* the two. This is not an operation of association, but of differentiation, as mathematicians say, or of disappearance, as physicists say: given one potential, another one has to be chosen, not any whatever, but in such a way that a difference of potential is established between the two, which will be productive of a third or of something new. (179–80; emphasis in the original)

Images are now radically external to each other; and yet the confrontation between their inside and their outside produces something new, that is, a new image of thought. Ils Huygens (2007) generalizes Deleuze's treatment by linking it to the unthought:

> There is "an image of thought" that underlies all of our thinking, and acts as a kind of presupposition to it. This image of thought is also constantly moving and varying in time. The image of thought is constantly challenged precisely by what lies outside of it, by what is yet to be thought, the unthought. Thought for Deleuze is thus always correlated with something outside thought, the "unthought in thought," pure difference that cannot be assimilated into something we know. It is the confrontation with this unthought which forces us to think and re-think our own thinking, bringing about a new image of thought.

The interstice as potentiality brings about the possibility of "thought from the outside," of a thought that does not have its origin in the subject, but is provoked by forces from the outside, by being "haunted by a question to which I cannot reply" (Deleuze 1989, 175). This outside is not the actual, the physical world as in the movement-image, but the

virtual as "becoming"; it is a virtuality that is difference in itself. One recalls that, for Deleuze, "[t]hinking [...] is not to interpret or to reflect, but to experiment and to create" (Rodowick 1997, 198). Thinking is linked to the new and to the emergent and crucially is "not external to thought but lies at its very heart" (Deleuze 2006, 80). The space in which the new occurs is, in Deleuzian terms, an event that coincides with an act of speculation for the spectator. As Tom Conley (2000) has remarked, "[t]he space-event is located in intervals opened by the differences of the sound and image tracks or the visible and lexical registers of the film. The viewer moves from an act of perception to an act of intensive speculation that becomes an event" (316). It goes without saying that a neat separation of perception and speculation is problematic; however, what is fecund is the association of the interstice as space of possibility with a thinking spectator.

Deleuze gives us a way to think about in-betweenness in film as a space for new thought. Although he sets off from Godard and the irrational cut, I believe Deleuze's idea of the interstice accounts for more than just a Godardian cinema of radical disjunction. Deleuze (1989) himself clarifies the point: "Interstices thus proliferate everywhere, in the visual image, in the sound image, between the sound image and the visual image. That is not to say that the discontinuous prevails over the continuous" (181). His discussion of other filmmakers offers indeed many variants of interstitiality, such as Philippe Garrel's use of the black screen as a "medium for variations" (200) or Alain Resnais's sheets of past and relinkages of images. For Deleuze, "this limit, this irrational cut, may present itself in quite diverse visual forms" (248), which include images, black or white screens and their derivatives, or an "act of silence," or a speech-act, or an "act of music" (249). Or it can be a form of heterogeneity, for instance, between image and voiceover, as in Jean Eustache's "*Les Photos d'Alix* [which] reduces the visual to photos, the voice to a commentary, but between the commentary and the photo a gap is progressively excavated, without, however, the observer being surprised at this growing heterogeneity" (249–50). As such, the interstice is a concept that lends itself to producing an understanding of a broad set of practices. A vital qualification, however, must be made. As Raymond Bellour (2011) has observed, Deleuze "is completely indifferent to the essay as a category; he just does not need it" (49). What Deleuze talks about is, indeed, and much more comprehensively, cinema as thought. Accordingly, I am not claiming that the method of interstitiality is unique to the essay film. Rather, I say that the essay film, as thinking cinema, thinks interstitially—and that, to understand how the essay film works, we must look at how it forges gaps, how it creates disjunction.

The cut alone, however, cannot account for the disjunctive method of the essay film. Although the interstice is not associative, it does determine relinkages (or reassemblages, to use another Deleuzian term); when writing of Resnais, for instance, Deleuze observes,

> There is [. . .] no longer association through metaphor or metonymy, but relinkage on the literal image; there is no longer linkage of associated images, but only relinkages of independent images. Instead of one image after the other, there is one image plus another, and each shot is deframed in relation to the framing of the following shot. (214)

The same concept of relinkage, intended as overcoming of disjunction, is also in Adorno. Adorno (1984) clarifies that the essay as a form based on discontinuity is committed to self-relativization and also that the gaps in its structure do not determine insurmountable disjunction:

> Even in its manner of delivery the essay refuses to behave as though it had deduced its object and had exhausted the topic. Self-relativization is immanent in its form; it must be constructed in such a way that it could always, and at any point, break off. It thinks in fragments just as reality is fragmented and gains its unity only by moving through the fissures, rather than by smoothing them over. The unanimity of the logical order deceives us about the antagonistic nature of that on which it was jauntily imposed. Discontinuity is essential to the essay; its concern is always a conflict brought to a standstill. (164)

In his discussion of Roland Barthes's key influence on the renewal of the literary essay, Réda Bensmaïa (1987) in turn has argued that the essay functions according to a "fundamental structure of gap" that questions "the closure of the text as Totality and the mastery of meaning as Truth" (19). These latter passages from both Adorno and Bensmaïa suggest that the essayistic method of creating fissures inscribes in the text the potentiality of a breaking down, a disassemblage. This potentiality can be equally described as a distinctive fragility linked to an ethos of unreserved openness, which, however, the essay dynamically overcomes by "moving through the fissures." Such a movement resonates with the activity of the "intermittent reader" postulated by the poet André du Bouchet, a figure he associated with a moving through the text shaped by the poetic interstice—where this is defined as a gap that "can approach the real by allowing access beyond the immediate visible surface of things" (Wagstaff 2006, 32). Aby Warburg perhaps meant something similar when he "commented on the signification of the black spaces that he placed between images in his analysis of the network of intervals in *Mnemosyne*, by quoting Johann Wolfgang Goethe's dictum 'the truth inhabits the middle space'" (Latsis 2013, 785).

Such movement through the gaps creates a unity that is a reassemblage; similarly, Burch's (1981) understanding of the discontinuity in Franju's use of thesis and antithesis is that it creates "conflicts that give rise to structures" (159). These structures, however, do not amount to a "smoothing over" of the gaps. To quote Adorno (1982), the essay "co-ordinates elements, rather than subordinating them" (170); it is "a constructed juxtaposition of elements" (170), whose "transitions disavow rigid deduction in the interest of establishing internal cross-connections, something for which discursive logic has no use" (169). Something similar was expressed by André Bazin (2003) when he described the "horizontal" form of montage in Chris Marker's *Letter from Siberia*, in which "a given image doesn't refer to the one that preceded it or the one that will follow, but rather it refers laterally, in some way, to what is said" (44). It can therefore be seen that the essay's dialectics, as shaped through these theorists, is not equal to that of historical materialism or to Hegelian dialectics; there is no logical deduction, but a moving through fissures. In this, for Adorno, "the essay verges on the logic of music, the stringent and yet aconceptual art of transition" (169).

As will be seen from these premises, this book, although it places at the center of its concerns both the interstice and the essay's constant tension between disassemblage and reassemblage, is not intended as a work of strict Deleuzian film theory; rather, it takes Deleuze's ideas on interstitiality as an opening and makes the most of his suggestion of the diversity of forms in which the cut can occur. Although it is timely to interrogate the increasing cultural importance of the essay film from the vantage point of Deleuzian theory, the corpus to be considered here calls out to be viewed in other contexts too. The histories, the conflicts, the traumas with which this corpus contends have been and continue to be intensively debated in the determinate interpretative frameworks to which these works themselves have given rise. By engaging with such frameworks, this book will go before, beside, and beyond Deleuze, so to speak; and it will think of interstitiality in its own ways, which are adapted to its object and which modify the Deleuzian interstice by extending the capacity of its "method of between." In so doing, it will also draw from cognate concepts, without however uncritically equating them to the Deleuzian irrational cut.

Other terms that will be used in the book include the "lacuna-image," Georges Didi-Huberman's (2008) conception in his work on Auschwitz of an image between trace and disappearance, which is "neither full presence, nor absolute absence" (167) and which, placed in a sequence/montage, encourages readability and an effect of knowledge. The lacuna-image is in-betweenness to the extent that it is understood by Didi-Huberman in relation to Giorgio Agamben's claim that "the 'remnant of Auschwitz' is to

be thought of as a *limit*; 'neither the dead, nor the survivors, neither the drowned, nor the saved, but what remains between them'" (167; emphasis in the original). This concept will become particularly fruitful in Chapter 2, which engages with spacing between images and the ability of montage to take thought beyond positions of deadlock. Chapter 2 will also draw on Walter Benjamin's dialectical image, an idea that is particularly fruitful in a filmic context and that can offer a further angle to think about the dialectics of the essay film.

Another "neither/nor" type of in-betweenness, although in a different context, is implied by Roland Barthes's (2005) notion of the "Neutral"— which is not a position of neutrality, of undecided grayness, but rather is that which challenges and "baffles the paradigm" (6). The Barthesian Neutral is, for Réda Bensmaïa (1987), what positively characterizes the fragmental nature of the essay as "a text that is capable of integrating the contradiction" (48) and is responsible for the collapse of the economies of textuality as a classical rhetorical system. The essay's elusion of the binary constructions that structure Western thought and discourse shows indeed the unconventionality and in-betweenness of its dialectics.

The Neutral will inform my understanding of the position of ideological in-betweenness of a film by Pier Paolo Pasolini in Chapter 5. My adoption of the Neutral to work through ideas of ideological thought in the essay film brings me to emphasize the political side of the interstice, which emerges also from other uses that have been made of the term, like Homi K. Bhabha's (1994) description of the emergence of interstices, seen as "the overlap and displacement of domains of difference" (2), an emergence that allows for the negotiation of different experiences of nationness and cultural value: "The social articulation of difference, from the minority perspective, is a complex, on-going negotiation that seeks to authorize cultural hybridities that emerge in moments of historical transformation" (2). The political value of the interstice was also already present in Deleuze; as D. N. Rodowick (1997) has written, "*The Time-Image* suggests a political philosophy as well as a logic and an aesthetic. [. . .] Thought from the outside, this unthought-in-thought, is always a thought of resistance" (40). Equally, for Adorno (1984), the essay is "the critical form par excellence; specifically, it constructs the immanent criticism of cultural artifacts, and it confronts that which such artifacts are with their concept; it is the critique of ideology" (168). The anachronistic resistance of the essay, its heretical nature, and its baffling of the paradigm will be central to this book, which is interested in the essay as philosophy of the future and which will focus on the politics of its interstitial practice.

Implied in Adorno, derived from Deleuze, and adapted through other theoretical as well as filmic encounters, then, the interstice will prove to

be a supple concept, capable of unlocking the strategies of the essay film, thus significantly advancing our understanding of the workings of such an important expression of our audiovisual culture. This gesture is at the heart of the current project. By shifting the attention away from the ongoing and somewhat underproductive debate on the essential features that "make" an essay film and that, supposedly, make it different from everything else, this book sidesteps the theorist's desire to capture what an essay is and focuses instead on what it does and where it does it. This is a decisive step, which bypasses the need to define the form on the basis of a series of features (subjectivity, reflexivity, hybridism, dialogism, voiceover commentary, mix of fiction and nonfiction, and autobiographical elements, just to cite some of its most debated features), which are, of course, important, but which never coalesce in an exhaustive and clear definition. Eschewing essentialist notions of genre and form, this book aims to offer a novel understanding of the epistemological strategies that are mobilized by the essay film and of *where* such strategies operate. It also moves beyond the auteurist approach, which, although wholly justified by the personal and, often, first-person approach of the essay film, opens itself to the temptation of an univocal identification of the essay's communicative position with a real, embodied subject. Most important, then, by going beyond the essentialist debate, this methodological move brings issues of practice and of praxis to the fore, thus responding to the contention that, "like every 'modern' work, the Essay does not raise problems of meaning, but rather a *problem of usage* (Deleuze) or, in other words, a problem of *effect and of functioning*" (Bensmaïa 1987, 53; emphasis in the original).

Although my focus in this book will be on usage, effect, and functioning, it still seems necessary to clarify what I regard as an essay. Drawing on communication theory and using poststructuralist tools, in my previous work on the essay film I argued for the importance of examining its textual commitments and the modality of reading that it produces (Rascaroli 2009). I therefore tackled it as the expression of a subjective critical reflection, which is offered not as anonymous or collective, but as originating from a single authorial position (even when this is a plural authoriality, as is the case of Dziga Vertov Group or the Black Audio Film Collective). The essay's enunciator, who overtly says "I" and often acknowledges that he or she is the director, usually embodies in the text a narrator who sometimes shares a voice and a body with the empirical author. This structure is often complicated by the presence of multiple or split narrators. Because the essay's enunciator is never a generalized authority (unlike in more traditional nonfiction), however, but a subject who speaks in the first person, takes responsibility for his or her discourse, and overtly embraces his or her contingent viewpoint, it follows that he or she does not speak to an

anonymous audience. The argument of the essay film addresses a real, embodied spectator, who is invited to enter into a dialogue with the enunciator, to follow his or her reasoning, and to respond by actively participating in the construction of meaning. Hence, the essay film is a fragile field because it must accept and welcome the ultimate instability of meaning and embrace openness as its unreserved ethos. The problematization of authorship is demanded by the essayist's aim of extending authorship to the audience. Rather than "pretend to discover things," as in Montaigne's (1700) famous saying, "I do not pretend to discover things, but to lay open my self" (254), thus camouflaging a perfected and closed reflection as an open-ended process of uncovering, the essayist asks many questions and only offers few or partial answers. These are allowed to emerge somewhere else: in the position of the embodied spectator. It is around this textual structure, which translates in a constant address of the I/essayist to the You/spectator, that the experience of the essay film materializes and our impression of being summoned to participate in the construction of essayistic meaning is achieved.

Although stemming from the above-described understanding of the form's communicative structures, this book shifts its attention to the spaces of intelligence that account for the opening of essayistic meaning. Accordingly, the case studies in this book are identified as essays by their dialectic use of interstitiality to carve out spaces for thought. The selection will purposefully mix established instances and recent works, films that employ voiceover and silent films, installations and documentaries, archival and original footage films, works by acclaimed international directors and by lesser-known artists, material shot in celluloid and video, feature-length and short. In so doing, the book will show how the essay becomes manifest in ways that are forever new. This does not mean, however, that historicity is not a concern here; on the contrary, temporality will not only be the focus of a dedicated treatment, but also emerge as a key theme in each chapter and will thus inform this study in multiple ways. The book will ultimately characterize the essay film as a metahistorical form, which critically and self-reflexively comments on its own activity as it reorders, reframes, and reinterprets history. The book as a whole, then, may be read as an essay on concerns that are at once situated historically and inherently political—including the Enlightenment, colonialism, imperialism, racism, ethnic effacement, the Second World War, the Holocaust, Palestine and Israel, Vietnam, the Cold War, and the Iranian Revolution. Films from Russia, Germany, France, Spain, the United Kingdom, Italy, Cuba, Sweden, Romania, Vietnam, the United States, and Iran, made from 1933 to date, will be called on as case studies of the essay's method of between.

The idea of essay film as a cinema centered on disjunction is open, then, to being theorized. But it is not generalizable, because each text must create the conditions of its own form—and, consequently, also of its form's point of potential crisis and disassemblage. It follows that only an engagement with specific films can bring to light the ways of each text's articulation of this potentiality, which is at the core of the essay film's anachronistic, counterhegemonic philosophy. This book argues indeed that essay films create interstices at multiple levels and through a variety of strategies, which are potentially infinite. Accordingly, each chapter will explore different essayistic interstices—working at the level of medium, genre, montage, temporality, sound, narration, and framing—through an engagement with a series of specific case studies. The analysis will aim to shed light not only on these texts, but also on some of the tactics developed by essayists to forge in-between spaces, which are idiosyncratic but may be extended to the study of other works. By virtue of their scope, the chapters will explore a number of essay forms, including the travelogue, the lyric essay, the epistolary essay, the ethnographic essay, the diptych and the hypertextual essay; they will study both sound and silent films and hypothesize a genre of musical essay films; they will tackle key themes that are at the heart of the ongoing scholarly engagement with the essay film, such as issues of medium, the uses of the archive, technology and the obsolescence of film, the profilmic, reenactment, performativity, and hypertextuality; they will consider techniques such as irony, distancing, formalism, and lyricism and will engage with how affect too produces intelligence.

To be more specific, Chapter 1, "Medium: Liquid Europe, Fluid Cinema," will focus on the tendency of the essay film, already remarked on by André Bazin in his 1958 review of Chris Marker's *Letter from Siberia*, to use hybrid materials and to be transmedial, as well as nonhierarchical and nonsequential, in a bid to reproduce the nonlinearity of thought and to reflect the crisis of rationality in post-Enlightenment modernity. Shot with special anamorphic lenses that distort and "liquefy" the image, Aleksandr Sokurov's video *Elegiya dorogi* (*Elegy of a Voyage*, 2001) is a hybrid, unstable, fluid text between commissioned art piece, installation, documentary, auteur film, and experimental cinema. Its instability and fluidity are so constitutive as to be thematized and become the core of Sokurov's reflection on authorship, spectatorship, medium, film, and image, on the one hand; and on ideas of Europe and European identity on the other hand. The film's obsession with the element of water in all its forms (snow, rain, waves, clouds, vapor) is coupled with a persistent emphasis on movement—of peoples, thoughts, and images. Going against the tradition of a solid, coherent essayist, who

confidently speaks in the first person and controls the development of a rational argument, Sokurov debunks his own authority by presenting his subjectivity as fluctuating and uncertain. Through the fragmented image of his body, coupled with an asynchronous voiceover, he creates interstices among narrator, film, and spectator. These interstices assist the extension of authorship to the audience and the development of a reflection all at once on the liquid state of Europe, of subjectivity, and of the filmic medium in the twenty-first century.

Setting off from Deleuze's concept of the "unthought," seen in relation to the interstice and to montage, Chapter 2, "Montage: Essayistic Thinking at the Juncture of Images," will engage with the interstice as incommensurable gap that advances thought beyond its positions of deadlock and with notions of transit and transition, linking them to ideas of filmic montage, on the one hand, and of transience and mortality on the other. Focusing on two essay films on the Holocaust, Harun Farocki's *Aufschub* (*Respite*, 2007) and Arnaud des Pallières's *Drancy Avenir* (1997), the chapter engages with Georges Didi-Huberman's concept of "image-lacunae," with which he refers to the incomplete, fragmentary nature of the visual archive of the Holocaust and which he combines with Walter Benjamin's notion of the dialectical image and with Siegfried Kracauer's concept of cinematic montage to theorize ways in which the image-lacunae may be made readable. Although they adopt radically different strategies (sporadic captions versus sustained voiceover; archival images versus contemporary footage), both Farocki and des Pallières articulate essayistic thinking through a montage that highlights gaps and discontinuities. In their films, pauses and interstices (between images, between sequences, between soundtrack and image-track) assist the transit of Benjaminian "true images" from the past to the present.

The argument of the essay film, I claim, is always also an argument on genre. The taxonomic difficulties generated by the essay film are rooted in its in-between positioning vis-à-vis genres, which facilitates the subversion of their conventions and the uncovering of their ideological underpinnings. Chapter 3 will work through these ideas by engaging with a particular type of essayistic ethnofiction, here represented by Luis Buñuel's 1933 *Las Hurdes*, Werner Herzog's *Fata Morgana* (1971), and Ben Rivers's *Slow Action* (2011). Located somewhere between documentary and fiction, surrealism and ethnography, science fiction and anthropology, these texts create generic interstices from within which the project of ethnography is satirized and deconstructed—and discourses of otherness, nature, culture, power, imperialism, ecology, and sustainability are both foregrounded and called into question. I will claim that landscape is strategic to these films'

statements on cinematic ethnography. Because of its profilmic material presence, nature is offered as an element of authenticity, which at once conceals and discloses the constructedness of the ethnographic film's gaze. Framing the environment simultaneously as raw reality and as nonsensical impossibility, these films introduce an irony gap, from which they unveil the ethnolandscape as the Foucauldian product of a set of practices that are as much scientific, cultural, and political as they are photographic and cinematic.

Opening with a discussion of the diptych form in film, seen as a dialogic structure activated in a spatiotemporal in-betweenness, Chapter 4, "Temporality: The Palimpsestic Road and Diachronic Thinking," will focus on essay films constructed around an interstice between incommensurable temporalities. In particular, it will look at filmic practices that spatialize time, especially films that articulate the road as a palimpsest through which to develop a diachronic way of thinking. The first case study is a diptych by Cynthia Beatt, *Cycling the Frame* (1988) and *The Invisible Frame* (2009), two films that follow the actor Tilda Swinton while she cycles the route along the Berlin Wall, before and after its fall, respectively. *The Invisible Frame*'s relationship to the earlier film, as well as to the absent Wall, reveals a temporal gap that is at once material, historical, and ideological. The second example is an essayistic road documentary that develops in the gap between East and West of Europe, as well as present and past. Davide Ferrario's *La strada di Levi* (*Primo Levi's Journey*, 2007) retraces the route traveled by the writer Primo Levi on his return to Italy after his release from Auschwitz. Some passages of *The Truce*, Levi's book on his liberation and journey home, are read in voiceover. Although most of the visual track is firmly in the present, Levi's description of the immediate postwar period carves a temporal in-betweenness within which compelling questions on the inheritance of both Fascism and Communism, on the return of the past, and on old and new Europe are allowed to surface and to fade once more.

In embracing an understanding of essay film's soundscape that does not stop at voiceover, but extends to all elements of a complex environment made up of speech, music, sounds, noise, and silence, Chapter 5, "Sound: The Politics of the Sonic Interstice and the Dissonance of the Neutral," moves beyond the traditional, and still predominant, logocentric and vococentric approaches to the essay film to explore the disjunctive interstice of an expanded Deleuzian sound image. The complexly imbricated auditory space of *Language Gulf in the Shouting Valley* (2013) by Lawrence Abu Hamdan will be considered in light of the role of disjunction and of affect in an essayistic use of voice and sound as political agents.

Hypothesizing a genre of musical essay films, then, the chapter will move on to examine sound in Pier Paolo Pasolini's *La rabbia* (*Rage*, 1963), seen in comparison with Santiago Álvarez's *Now!* (1964) and Erik Gandini's *Surplus: Terrorized into Being Consumers* (2003). The Barthesian Neutral and ideas of dissonance will form the basis of a discussion of musical queering as a form of protestation.

Continuing the previous chapter's critique of the traditional logocentric and vococentric focus of much scholarship on the essay film, Chapter 6, "Narration: Epistolarity and Lyricism as Argumentation," will explore narration beyond the verbal, accounting for aspects such as the use of specific narrative forms, plot structures, narrators and point of view, temporal organization, rhythm, and music. Reappraising the connections between narration and argumentation, it will contest the claim that narrative is merely a fictional layer superimposed on the nonfictional content (and, by extension, the true essence) of the essay film. The work examined in this chapter explores some of the ways in which narration can give expression to argumentation. The essay form is inherently fragile, with a particular potential for disassemblage. The chapter will focus on epistolarity as a disjunctive narrative form marked by distance and by absence and on the counternarrative aspects of lyricism, based on its tendency to fragmentation, its allusiveness, metaphoricity, formalism, and affectivity. Two long-standing traditions will be addressed, the epistolary essay via an engagement with *Lettres de Panduranga* (*Letters from Panduranga*, 2015), by Nguyễn Trinh Thi, and the lyric essay via a study of *The Idea of North* (1995), by Rebecca Baron.

Essay films are performative texts that explicitly display the process of thinking; their reflexive and self-reflexive stance implies that issues of textual and contextual framing are at the center of their critical practice. To frame is, ultimately, to detach an object from its background and, thus, to create a gap between object and world. Chapter 7, "Framing: Looking for an Object, or The Essay Film as Theoretical Practice," will set off from a discussion of Irina Botea's *Picturesque* (2012), shot on the Gaina and Apuseni mountains in Transylvania, seen here as a film whose critical argument on the picturesque and the tourist image is predicated on a dual recourse to the frame—intended both as the literal operation of mise en cadre and as narrative, ideological, and cultural framing. The chapter will argue that the specificity of the essay must be sought not in its production of objects but in their arrangement and that this arrangement reflects a fundamental structure of gap. The act of framing in essay films often becomes a visible search for an object, either in the living image of the world or within film or photo archives. The chapter will further conceptualize the function of framing as the coming-into-being of the essay and of its object through

a discussion of two archival essay films, Mohammadreza Farzad's *Gom o gour* (*Into Thin Air*, 2010) and Peter Thompson's *Universal Diptych* (1982). These two films adopt comparable reframing strategies to put forward their reflection on images as historical documents, on the object of history, and on historical discourse. Ultimately, this chapter will establish that the essay film is a critical and theoretical practice that rests on the frame.

Overall, by resisting the urge to define the essay film through a list of normative features, this book seeks to illustrate the kind of flexibility that will allow us to broaden our concept of this practice and, in turn, to trace the essayistic not within a fixed generic form but within a method of filmic thinking that exists and thrives in gaps.

Medium

Liquid Image, Fluid Cinema

It would be imprudent to deny, or even to play down, the profound change which the advent of "fluid modernity" has brought to the human condition. The remoteness and unreachability of systemic structure, coupled with the unstructured, fluid state of the immediate setting of life-politics, change that condition in a radical way and call for a rethinking of old concepts that used to frame its narratives. Like zombies, such concepts are today simultaneously dead and alive. (Bauman 2000, 8)

[W]hile the media are increasingly ubiquitous, the mediated global world is also profoundly discontinuous and fragmented. For this reason, there is a great urgency at this time to situate the "fluid" media in the context of media histories, political economy, cultural practices and policy, new articulations of identity and time, and media specificity. As unstable and transitory as these media may be, it is vital to understand them through a historical lens not in terms of simple chronologies but as part of a larger "media archaeology" of contiguous and sometimes singular practices and circumstances. (Marchessault and Lord 2008, 6)

Drawing from Theodor W. Adorno's compelling analysis of the essay form as critique of ideology and via an engagement with Gilles Deleuze's ideas on cinema as image of thought, read in dialogue with conceptualizations of the essay film by theorists such as Noël Burch and Thomas Tode, in the Introduction I argued that the essay film is a dialectical form that thinks not exclusively through verbal commentary, but also via an audiovisual and narrative disjunctive practice that creates textual gaps in which new meanings are allowed to emerge. This book will concern itself with the exploration of some of these in-between spaces and interstitial gaps, which are the product of diverse and multiple (indeed, potentially infinite) processes of disconnection and separation, as well as of relinkage and reassemblage. By focusing on the essay's disjunctive work and on the

interstitiality of its textuality, this and the following chapters will aim to elucidate how and where the thinking of the essay film takes place. Although this book is not a manual of the essay film, it is shaped by ideas of practice and processes of signification; its own thinking is inspired by a close scrutiny of some of the levels at which meaning is formed and conveyed in film, namely medium, montage, genre, temporality, sound, narration, and framing. As such, and against the background of the conceptualization presented in the Introduction, the overall aim is to study nonverbal signification in the essay film (although the analysis will also engage with verbal meaning).

In his 1958 review of Chris Marker's *Lettre de Sibérie* (*Letter from Siberia*, 1957), André Bazin (2003) calls it "an essay documented by film" (44). The expression suggests the predominance of the written text over the image, which is seen by Bazin almost as mere support of "verbal intelligence" (44). Despite placing much importance on the written text, however, Bazin does offer an analysis that emphasizes the cinematic qualities of Marker's film and, in fact, identifies an important element in what he sees as a particular, novel articulation of montage:

> Marker brings to his films an absolutely new notion of montage that I will call "horizontal," as opposed to traditional montage that plays with the sense of duration through the relationship of shot to shot. Here, a given image doesn't refer to the one that preceded it or the one that will follow, but rather it refers laterally, in some way, to what is said. (44)

Bazin's remark resonates with Gilles Deleuze's (1989) ideas on the new type of disjunctive montage that distinguishes the movement-image from the time-image and facilitates the oncoming of a new image of thought, as explored in the introduction. The idea that horizontal linkages are broken and images now refer to one another in a lateral way tallies with Deleuze's observation that gaps and irrational cuts appear between images. Bazin's conception can also be likened to Theodor W. Adorno's (1984) claim that "[i]n the essay, concepts do not build a continuum of operation, thought does not advance in a single direction, rather the aspects of the argument interweave as in a carpet. The fruitfulness of the thoughts depends on the density of this texture" (160). Adorno's striking idea of the essayistic carpet is not just a metaphor of the meanderings of thought, with its twists and turns and its constitutive multidirectionality; it is also a structural observation on the essay's lack of continuous operational sequences. The nonlinear, disjunctive structure of the essay film's tapestry, then, is augmented by its use of heterogeneous materials. In the same review of *Letter from Siberia*, Bazin emphasizes the freedom of the essayist filmmaker, who may make use of "all filmic material that might help the case—including still images

(engravings and photos), of course, but also animated cartoons" (45). Bazin's is one of the early acknowledgments of the essay film's tendency to incorporate multiple sources and media, resulting in inhomogeneity as well as nonlinearity; his is a more distinctive statement than the customary allusion to the mix of fiction and nonfiction that many have detected in the essay film.

The tendency highlighted by Bazin to hybrid materiality and multimediality is further intensified today in the age of digital technologies and their facilitation of a multichannel approach to montage and to postproduction, which assist activities of recuperation, multilayering, and accumulation of both images and sounds. As Ursula Biemann (2003) has explained,

> the essay has always distinguished itself by a non-linear and non-logical movement of thought that draws on many different sources of knowledge. In the digital age, the genre experiences an even higher concentration. New image and editing techniques have made it easy to stack an almost unlimited number of audio and video tracks one on top of another, with multiple images, titles, running texts and a complex sound mix competing for the attention of the audience. (9)

Digital video amplifies today a tendency that is of all essay films: a striving for nonlinearity and the stratification of meaning and materials that also has rhetorical, critical, and political dimensions; as Jacob Hesler (2009) has argued, indeed, "the essay configures its material in a non-hierarchical textual process," thus reflecting the "crisis of rationality in post-enlightenment modernity" (193). Predigital essay films, despite the constitutive linearity of the filmic medium, prefigured the nonhierarchical capabilities of the digital medium by available techniques. This is by no means unusual if, as Maureen Turim (1999) has suggested, "the principles of image construction are only in part determined by a technology, since all the techniques associated with that new technology existed before, in a form of prefiguration" (52). She goes on to say,

> with digital video, the artisanal approximation that performed similar processes include the ways art, photography, film, and video prefigure the work of digital imagery through compositional devices, mise-en-scene, constructivism, and collage/superimposition techniques. (52)

The use of mise en scène, montage, and postproduction techniques to create superimposition and proliferation of images, written text, and sound are only some of the ways in which essay films have, since their inception, prefigured the digital and overcome the linearity of the medium to approximate the nonlinearity of thought (and to refer to, and incorporate, other

media at the purpose of experimenting with, and commenting on, plural sources and objects). Textual interstitiality, I argue, also creates discontinuities that subvert the sequentiality of film language. This chapter will focus precisely on ideas of medium and explore how the interstice may be deployed by the essay film to create nonlinear forms of discourse, thus opening gaps within which new meaning is allowed to form. It will do so via the discussion of a case study: Aleksandr Sokurov's *Elegiya dorogi* (*Elegy of a Voyage*, 2001). Although other recent films demonstrate more immediately how the essay may exploit the capabilities of new technologies, *Elegy of a Voyage* was selected because it at once exemplifies the essay's nonlinear (and predigital) method and foregrounds a "thought from the outside" that mimics the interstitial actualization of the unthought as conceptualized by Deleuze. As such, Sokurov's film is an ideal starting point for my discussion of the gaps in which the essay film thinks nonverbally. *Elegy of a Voyage* may indeed be said to thematize the crisis of rationality in post-Enlightenment modernity, while also foregrounding a reflection on the fluidity of the image in our age, one that parallels the film's analysis of the liquidity of contemporary Western societies. Such intricately interwoven reflections are built on ideas of cultural, geographical, historical, and ideological in-betweenness and are conveyed through a set of disjunctive production and postproduction operations that carve multiple gaps between narrator and image, lens and world, the film and its object. The interstices thus created attract attention to the image as image and interrogate its nature and that of the filmic medium at a time when the mobility of images has exponentially increased.

Impossible to place neatly in any one category, *Elegy of a Voyage* is a hybrid, intentionally puzzling, deeply unorthodox work. The account of a strange journey, it is a travelogue of sorts, in which the protagonist and narrator, played by Sokurov himself, gives account of his feelings, impressions, and reflections while journeying not of his will, but as if pulled by an invisible force. Having set off from a snowy expanse in an unnamed Siberia, the narrator finds himself journeying on foot, by car, and by boat, finally arriving in an equally unnamed building (the Boijmans Van Beuningen Museum, Rotterdam), which he then proceeds to explore. An essayistic drive to muse about large-scale issues—religion and faith, weakness and fortitude, solitude and the longing for human contact, ideology and the meaning of life—emerges throughout the film and as if in waves.

Elegy of a Voyage's own interstitial mediatic positioning is reflected in its history. Born as an installation commissioned by the Boijmans Van Beuningen Museum, Rotterdam (where it was exhibited from January 5 until February 24, 2002), and thus as an art piece, shot in Betacam SP, the forty-eight-minute video was nominated for Best Documentary at the 2001 European Film Awards. Thus reframed as nonfiction, it was screened

at a number of festivals, starting with the 31st International Film Festival Rotterdam; it was then digitally distributed by Facets, the North American company specializing in art film, in its DVD series devoted to Sokurov's oeuvre, and thus within an auteurist framework, supported by the endorsements of intellectuals such as Susan Sontag. *Elegy of a Voyage* has lived several lives: as installation piece, documentary, art, and auteur film and as both video and digitized text. This generic and mediatic instability encapsulates the destiny of contemporary images, which, unhinged from their original support, travel through, and are consumed via, a number of different, often convergent, media. *Elegy of a Voyage*'s fluidity is so constitutive, however, as to become the core of the film's reflection on authorship, spectatorship, medium, film, and image, on the one hand; and on ideas of Europe and European identity on the other. It is from the latter aspect that I will start my investigation. The chapter will be organized in three sections. In the first, I aim to show how *Elegy of a Voyage* thinks about Europe as a continent in flux, in which old values have liquefied but old institutions are still alive, thus inscribing the film's reflection on fluidity within a social theory backdrop. In the second section, I will show how the film presents thought as coming from the outside, thus undoing the traditional conception of a strong authorial control of the essayistic argument, and how this is a precondition for the carving of gaps between enunciator and narrator, narrator and experience, lens and world. In the third part, I will show how *Elegy of a Voyage*'s metaphor of liquidity and interstitial method converge in a discourse on medium and on the image that makes space for the flashing up of the unthought.

THINKING EUROPE

We are born in the museum, it's our homeland after all. (Jean-Luc Godard, in Godard and Ishaghpour 2005, 70)

The commission of *Elegy of a Voyage* by the Boijmans Van Beuningen Museum was linked to the 2001 exhibition *Unpacking Europe*, curated by Salah Hassan and Iftikhar Dadi as part of the events of Rotterdam 2001 European Capital of Culture. Participating artists were invited to present work commenting on the meaning of Europe in the past and today.[1]

1. Participating artists included Maria Magdalena Campos-Pons, Heri Dono, Coco Fusco, Ni Haifeng, Fiona Hall, Isaac Julien, Rachid Koraichi, Ken Lum, Nalini Malani, Johannes Phokela, Keith Piper, Anri Sala, Yinka Shonibare, Vivan Sundaram, Nasrin Tabatabai, Fred Wilson, and Shi Yong.

The narrator's journey from a dreamy Siberia to a mysterious museum in Rotterdam is, for Sokurov, an opportunity to sketch a broad reading of the continent, based not only on ideas of classical culture, art, Christianity, and humanism, but also on issues of borders, ideological enslavement, segregation, and war. Although the narrator does not overtly discuss Europe, the focus of the film is on ample, overarching issues that are of continental import. Furthermore, along with many Dutch paintings, the Rotterdam museum collects international art; as such, it is at once a national symbol and a deeply cosmopolitan space that transcends national identification and replaces it with broader, cosmopolitan bonds and meanings.

As much as it is difficult to place *Elegy of a Voyage* with respect to medium and genre, it is also challenging to locate it in space and time because of the reticence of the narrator and film to provide us with cues to do so. The points of departure and arrival elude firm local and national identification and, indeed, inherently problematize them. A vast region of ambiguous definition, Siberia can be seen alternatively as Asia and as Europe, as a country and as a border. The white expanse where the narrator finds himself at the start of the film is nondescript and formless; the snow blanket erases landmarks. The location of the museum that the narrator reaches at the end of his trip is also profoundly destabilized; from seeing a cherry blossom in the courtyard at night, he thinks he may find himself in Japan. The geographical accuracy of the journey is equally undermined; the narrator first walks and drives through Siberia, then crosses the Baltic Sea by boat, and, finally, is driven through Germany and into the Netherlands. He therefore crosses several countries, east to west, and encounters different cultures and language areas; however, by not naming places and by favoring fluid, indistinct shots of snow, rain, sea, and fog, the film undermines geographical specificity and points to broad ideas of space and place, journeying and dwelling, and, therefore, to an ample European framework. The temporal dimension is equally extensive; when walking through a Siberian village, for instance, the narrator muses about the past of the local community as if he had been part of it and hints at processes of migration, depopulation, and secularization. In a key episode, the narrator enters a church, where he witnesses the baptism of a child; later, soldiers at a frontier checkpoint scrutinize his identity documents. The two incidents are opportunities to query the belief systems and ideologies represented by these places: religion and militarism, control and the containment of people's mobility, and right to self-determination. Overall, a sense of the continent's past, of its institutions, values, and interconnected historical trajectory, is conjured. The journey ends in a museum, a key site for the construction and preservation of ideas of history, identity, and culture—a culture that is here understood as a broadly European one. As Tim Harte (2005) has argued,

writing of Sokurov's *Russkij Kovcheg* (*Russian Ark*, 2002)—a tour-de-force, single-shot exploration of three hundred years of Russian history set in Saint Petersburg's State Hermitage Museum—the museum and the works of art it contains "constitute an important conduit between the past, when these cultural objects were produced, and the present (and future), when they are encountered" (45).

But what kind of Europe is Sokurov's? Through an obsession with the element of water and its mutability, coupled with an emphasis on people's movement, the film puts forward an idea of Europe as a place in flux, shaped by cultural encounters and exchanges. This framework emphasizes the common past and the continent's shared concerns, prominent among which are values, beliefs, and matters of ideology and religion and the management of frontiers and identities. The narrator muses on some of the key themes that are at the basis of the common European home and that are linked to Christianity, family and community, individual freedom, humanism, and the Enlightenment. A broad idea of Europe's common home, resting on historical progress, a shared past, and a conception of community that extends beyond specific linguistic and cultural enclaves, becomes tangible in the sequences set in the museum. Hosting a collection that extends from the Middle Ages to the twenty-first century, this museum covers and represents the entire history of modern Europe. The shared tradition of myths, stories, and ideas collectively conveyed by the paintings crystallizes into a common history of encounters and exchanges between interconnected cultures and value systems. In particular, the exchange with people from the past, with a broad human community, here takes place through art; before a large painting of a ship's return home, for instance, the narrator comments, "This life is not unfamiliar. Their joy is like ours."

The diachronic cultural encounter as the basis of a shared continental identity is thus a key topic, one that is closely linked to the themes of motion, travel, and flux that are at the heart of the film. Aside from the mediated, art-historical encounters that take place in the museum, Sokurov's narrator meets three main subjects in the course of his journey: a monk in a village in Siberia; soldiers at a border checkpoint; and a young man at a roadside café in the Netherlands.

The episode of the monk offers the opportunity for a reflection on Christianity. The narrator acknowledges the centrality of Christianity to Eurasian identities by showing the baptism of a child as the founding ceremony of his life, one that makes him a full member of his community. At the same time, he challenges organized religion, as well as some of the values that are central to Christian faith, in particular sacrifice. He asks, "Why did Christ want to avoid crucifixion? And if he so loathed being crucified, then how can I accept his sacrifice?" He knows, however, that his question

will remain unanswered by the monk: "I doubt seriously that he knows the answer to my question." The disconnection between people and dogma and the interrogation of the Christian ethics of sacrifice becomes direct during the ceremony, when, over a close-up of the child, the narrator ponders, "What can this child know about sacrifice? Isn't it too early?" (Figure 1.1). In the same sequence, he problematizes the harshness and lack of warmth he perceives among the churchgoers, as well as the rule of solitude to which the monks are subjected. We emerge from the church sensing that the narrator is deeply unpersuaded that organized religion has the ability to respond to the needs of the modern person—spiritual needs included.

A similar and even greater vexation is experienced in the encounter with the border guards, an episode that immediately follows the one of the church and is indeed joined to it via an irrational cut that erases the time and space separating the two places—thus strengthening the sense of an almost magic journeying, as well as suggesting the ideological sameness of church and military. Several soldiers slowly and repeatedly scrutinize the narrator's documents and his face before allowing him to continue his journey beyond the frontier (Figure 1.2). Aggravated by the investigation, the narrator openly questions the legitimacy of border controls and asks several times what right the officers have to scrutinize him. An image of one of these guards also occurs in a dream sequence that opens the film, next

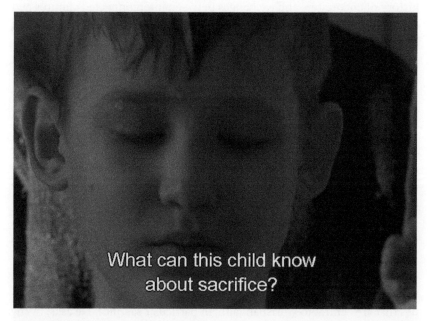

Figure 1.1: The baptism of a child in Aleksandr Sokurov's *Elegy of a Voyage* (*Elegiya dorogi*, 2001). Facets Video/Ideale Audience 2007. Screenshot.

Figure 1.2: The narrator is scrutinized at a frontier post. *Elegy of a Voyage.* Facets Video/Ideale Audience, 2007. Screenshot.

to one of a soldier covering his ears at the explosion of a device. The close connection of religion and army in the film suggests Sokurov's dual critique of institutions that have been key to the history of the continent and that emerge from these sequences as oppressive, outdated, and controlling of human beings and their aspirations.

The ubiquitous, preponderant visual emphasis that the film places on the element of water in all its forms (rain, clouds, fog, waves, vapor, snow, drinking water) is suggestive of the metaphor of liquid modernity adopted by Zygmunt Bauman (2000) to define the late-modern condition of Western societies, which have progressed from heavy to light capitalism, from solid to fluid modernity. Fluidity, the quality of liquids and gases, is for Bauman "the leading metaphor for the present stage of the modern era" (2), a phase that, at the opposite of modernity, does not strive for solidity but for its opposite: a phase of "deregulation, liberalization, 'flexibilization'" (5) of the capital, in which "patterns, codes and rules to which one could conform, which one could select as stable orientation points and by which one could subsequently let oneself be guided" (7) are in short supply. The melting powers of modernity have affected all institutions, so that these are now "zombie institutions" that are at once "dead and still alive" (6). The paradox is certainly felt in the institutions that Sokurov looks at in the film. Organized religion's rituals still mark the time and lives of

individuals, families, and communities; at the same time, they appear emptied out of meaning, make disproportionate demands of people, or seem inadequate to answer basic contemporary human needs and questions. In the face of the steep depopulation of the area, for instance, the villagers' upholding of religious ceremonies looks like a desperate attempt to cling to by-now brittle cultural and identity roots. The militarization of border controls, then, is a reality that seems anachronistic in a world that, Bauman notes, "must be free of fences, barriers, fortified borders and checkpoints" (14); as he writes,

> Any dense and tight network of social bonds, and particularly a territorially rooted tight network, is an obstacle to be cleared out of the way. Global powers are bent on dismantling such networks for the sake of their continuous and growing fluidity, that principal source of their strength and the warrant of their invincibility. And it is the falling apart, the friability, the brittleness, the transience, the until-further-noticeness of human bonds and networks which allow these powers to do their job in the first place. (14)

Allan Sekula (2003) has similarly described the demise of communal and social ties drawing strikingly from the metaphor of liquidity:

> [I]n an age that denies the very existence of society, to insist on the scandal of the world's increasingly grotesque "connectedness," the hidden merciless grinding away beneath the slick superficial liquidity of markets, is akin to putting oneself in the position of the ocean swimmer, timing one's strokes to the swell, turning one's submerged ear with every breath to the deep rumble of stones rolling on the bottom far below. To insist on the social is simply to practice purposeful immersion. (14)

For Bauman (2000), the desperate protection of the identity of the community from others in our contemporary society is a logical "response to the existential uncertainty rooted in the new fragility or fluidity of social bonds" (108). Uncertainty is a true marker of Sokurov's film: uncertainty of geography and time, as we have seen, but also of subjectivity, identity, and values. It is the final chance encounter of the narrator with a young man sitting on his own at a café by the highway that brings the fluidity of contemporary Europe fully into focus (Figure 1.3). This episode is central to *Elegy of a Voyage*, and not just in terms of screen time. It is here that the only the words of someone other than the narrator are heard in the film (with the exception of a brief farewell uttered by the monk at the end of his episode); and it is at this point that the narrator suddenly realizes that his journey had a purpose, as he remarks.

The young man joins the narrator at his table and spontaneously starts to share his philosophy of life. Having once been wrongly incarcerated in

Figure 1.3: The young man alone in the roadside café. *Elegy of a Voyage.* Facets Video/Ideale Audience 2007. Screenshot.

the United States and having spent one night in prison there, treated like an inferior being, he returned to the Netherlands full of rage and sunk into depression, till he made the decision to reach out to people again. In his speech on the meaning of life, which rests on the principle of the equality of all people and on the choice to embrace the creative force that he calls love over the equally powerful, destructive force of hatred, the man touches on a set of values that are central to humanism and the idea of the common European home and that point to a tradition that has its roots as much in Christianity as in the Enlightenment. The young man's philosophy, based on his belief in God as love, in self-determination and in freedom of choice, in the human community and the equality of individuals, rests somewhere between Christian traditions, the Enlightenment's ideals, the founding principles of Western democracies, and the inheritance of 1968 (as he recognizes when he ironically remarks that he is sounding "flower-power").

During this encounter, the narrator, who likes his interlocutor and calls him "a kind man," nevertheless problematizes his convictions and asks, "If this man is as happy as he says he is, why does he so crave baring his soul with a perfect stranger?" The narrator concludes that the young man's philosophy of life is "too human," without explaining why and how (Figure 1.4). In the context of the film's reflection, the young man's philosophy is too human, I would argue, because it is an attempt to make sense of a confusing,

Figure 1.4: A philosophy of life that is "too human." *Elegy of a Voyage*. Facets Video/Ideale Audience 2007. Screenshot.

melting universe by borrowing from a hybrid set of "zombie" values and ideas, which are at once dead and still alive. His individualized, ad hoc, mix-and-match approach is a direct consequence, as Bauman (2000) would say, of the liquidity of our modernity, the outcome of the melting down of once-solid institutions: "Ours is, as a result, an individualized, privatized version of modernity, with the burden of pattern-weaving and the responsibility for failure falling primarily on the individual's shoulders" (7).

As if to confirm the liquidity of the young man's condition, at the end of the sequence we observe him from the café's window, while he steps into a camper van—a mobile home—and drives away. This gentle, lonely European seeking human encounters along the highway and sharing his personalized philosophy of life with a stranger is a rootless, mobile subject, whose liquid identity rests on an individual, too-human blend of principles and values, once firmly held by various institutions that have now liquefied.

THINKING THOUGHT

Subjectivity, reflexivity, and self-reflexivity are among the main features commonly attributed to the essay form, both in literature and in the cinema.

Traditionally, the literary essay is associated with a single, autobiographical enunciator, who speaks in the first person through a narrator-essayist (irrespective of how rhetorical the narrator's performance may be) and who is seen to control the development of a rational argument (irrespective of how tortuous or hesitant his or her rhetoric may appear). This type of individualized, intellectual, first-person enunciation, which tends to generate a rather direct identification of the speaking voice with a real author, continues to influence how we think of the essay film today—although, as Alisa Lebow (2012) has clarified, "articulating an address in the first person emphatically does not imply an autonomous and autogenous 'speaking self,' as if the Cartesian subject had never undergone review" (3). In the essay film, the enunciator most frequently finds expression through a narrating voiceover and sometimes also physically appears in the text; often, although by no means always, the essayist delivers the voiceover and, when this is visible, plays the onscreen body as well. The physical visibility of the enunciator through markers of the filmmaker's self increases the impression of a first-person enunciation and its identification with a real, extra-textual subject: the director. Nevertheless, frequently such straightforward identification is purposefully problematized by the essay film, in view of a debunking of authority that makes space for a more open and dialogical rhetorical structure. The essay, in fact, heavily relies on the spectator's response to, and collaboration in, the author's reasoning, which is thus often set up as a dialogue between equal subjects (Rascaroli 2009, 12–15 and 32–37).

Although essayistic texts regularly problematize authorship and the enunciator's authority, and even if "performing authorship combines disparate impulses towards exposure and masking" (Sayad 2013, 37), it is rare to encounter a textual figure of essayist whose subjectivity and identity are as radically incoherent, discontinuous, and fragmented as in *Elegy of a Voyage*. The strategy of the film is here deeply disjunctive. The narrator, who is sunk in a disconcerting reverie throughout the film, is disconnected from himself, from thought, and from the world around him. The origin and motivation of his trip are beyond his grasp; he describes himself as possessed by an external, unfathomable motion and as passively carried by vehicles; he misrecognizes places or is only vaguely familiar with them, sometimes experiencing déjà vu. Sokurov is both voiceover narrator and onscreen body; however, no synchronization is ever achieved between the two. What is more, his face, the prime identifier of human identity, is never shown. Three types of shots of Sokurov's body recur: he is sometimes framed from a distance, thus appearing as a small figure in the landscape; or else in close-up, but fragmented (as in the shots of his feet walking in the snow or on the

museum's floorboards and shots of his hand stroking a tree's blossoms or lightly skimming the paintings); or, again, from behind, so that all we see is his back (Figure 1.5).

With regard to the latter type of framing, Silke Panse (2006) has likened the back shots of Sokurov to the image of the *Rückenfigur* of German Romantic painting: an observer inside the picture (Figure 1.6). For Panse, the presence of Sokurov as a figure viewing a scene spread out before him achieves the effect of representing "the documentary film-maker as powerless, not only in confronting reality but also with regard to his own existence. He does not appear to have authorship on his own life or film, but rather looks at it as a distanced, but nevertheless emotional, observer" (9). Panse sees Sokurov (as a figure in his video) as a Romantic, "inasmuch as he is serious about his lack of agency in relation to the fragments of reality which he himself paints as being exposed to rather than being in control of" (21). Having removed himself from all agency, "Sokurov exaggerates the passivity of the observational approach of documentary film-making towards the world," rather than acting as "a Cartesian subject explaining an autobiographical and identity-based documentary and asserting meaningful causal chains" (21).

Although Panse's learned reading of Sokurov's *Rückenfigur* as a powerless observer is eloquent and persuasive, my interest here is to consider how

Figure 1.5: Fragmented body: Sokurov's hand stroking a tree's blossoms. *Elegy of a Voyage.* Facets Video/Ideale Audience 2007. Screenshot.

Figure 1.6: Sokurov as *Rückenfigur. Elegy of a Voyage.* Facets Video/Ideale Audience 2007. Screenshot.

these rhetorical choices affect the film as an essay rather than as a documentary, whether observational or autobiographical (*Elegy of a Voyage* is, in fact, neither). What Sokurov debunks in his film, in this sense, is the thinker, thus casting doubts on the essayist's authority over, and control of, the logical argument and on thought more broadly. Rather than reflecting the Cartesian belief that thinking cannot be separated from the subject, *Elegy of a Voyage* represents thought as separated from the thinker and happening from the outside—as thought that is not at one with the subject, but that is caused by forces from the outside. The "I" here thinks because it is "haunted by a question to which I cannot reply" (Deleuze 1989, 175). I will show in the course of my analysis that this question is nothing less than the question of meaning—the meaning of life, of experience, subjectivity, perception, consciousness; and, at once, it is film theory's foundational question: what is cinema?

Although it is at the heart of the essay's strategy, however, disjunction is not insurmountable, as already clarified by Adorno (1984) and explored in the book's introduction: the essay "gains its unity only by moving through the fissures, rather than by smoothing them over" (164). Sokurov's film moves through the fissures by adopting metaphors of liquidity and motion to actualize the idea of thought as flow. Thought is represented through a visual emphasis on the mobile, uncontainable element of water, as well as through the theme of the (passive) journey. Fluidity, thought, and

movement are grafted onto each other from the first sequence. The film opens under the sign of a displaced, dream-like subjectivity and in a phase of stasis: the first image is that of an autumn tree, shot through a veil of dancing snowflakes. It is when the initial displacement and the disconnected observation of images and feelings give way to movement that the film itself begins, literally, to move: the camera takes off and drives forward along the road, the voice registers the emergence of a village and then speculates about the absence of people in the streets. Suddenly, the film slows down; the narrator finds himself in a clearing, admires the landscape covered in snow, and muses on the mystery of the invisibility of the world's beauty. The camera then begins to move again, now framing a row of houses, while the voiceover returns to the previous train of thought and wonders whether it is possible to recall at least one face of those who once lived in the village. In this way, by following the irregular rhythms of the journey—which starts, accelerates, slows down, stops, and starts again—the film "flows" and creates relinkages that give it unity. The rhythm is not imposed by a self-aware traveler in control of his route and of his argument; Sokurov's essay does not develop a logical, Cartesian reflection through causal chains. The route itself is rendered in nonnaturalistic, illogical ways; significant gaps in the journey, compounded by jump cuts, remain unjustified, and the traveler abruptly finds himself in places without realizing how he has reached them. Because thinking and passive traveling are tightly conjoined in the film, thought is presented as an external force, rather than originating from within the subject—although it is also *of* the subject. This inside/outside dynamic is what is actualized in the interstice.

One of the ways in which the film produces interstices is in its articulation of the relationship between narrator/traveler/thinker and image. This gap is carved through technical means, thus working on medium specificity (an anamorphic lens and a series of profilmic and postproduced "veils" that come between the lens and the world, as I will further analyze below), and through the narration itself, which introduces an experiential distance, a disconnection and displacement that are at once temporal and cognitive. One of the most striking instances of this interstitial method is the already discussed emblematic sequence of the encounter with the young man in the roadside café. Despite the importance of the man's monologue, the film inexplicably chooses not to let the spectator listen to his words directly, but leaves them in the auditory background and superimposes the narrator's voice, which translates his speech into Russian at once commenting on it. The linguistic layering is intensified in the DVD version of the film by the addition of subtitles translating the narrator's words, with a further layer added by the melancholy extradiegetic music (the soundtrack includes work by Chopin, Glinka, Mahler, and Tchaikovsky) and by voices coming

from a radio and other ambient sounds, which are occasionally given audi-tory prominence, carving further sonic gaps. The disjunction between voiceover and onscreen narrator, then, could hardly be stronger: Sokurov is only seen once, from behind, sitting opposite the young man, radically mar-ginalized by the framing and barely visible; although he is a silent witness onscreen, his voice is present throughout the sequence, so the mismatch is striking. The anamorphic quivering of the image's surface is an addi-tional separating mechanism, as if the images emerged from some deeper time sheet.

Such a disjunctive approach works against the linearity of the filmic medium because it stratifies meanings temporally and opens cracks in the film's sequentiality. In particular, the voiceover's translation of, and com-mentary on, the man's speech creates a crevice between narrator and scene, breaking the illusion of the presentness of the story and increasing the temporal displacement, because it highlights the gap between the time of filming and the time of postproduction, the time of action and the time of reflection. Furthermore, although the narrator's voiceover is more rational here than elsewhere in the film, and although the young man's discussion of the meaning of life, if too human, comes across as logical and intelligent, cracks appear through irrational cuts that insert unrelated images—a child swimming, a glass of water, a soldier at a frontier post, cars speeding on the highway—further breaking the spatiotemporal continuity. Between images, the pull of the irrational is felt; in Deleuze's (1989) words, when the power of the outside passes into the interstice, "then it is the direct presentation of time, or the continuity which is reconciled with the sequence of irratio-nal points, according to non-chronological time relationships" (181). Part memories, part anomalous flashes, these thought-images emerge as if from under dark waves, reaching for the surface of the image, sometimes short-circuiting with it—as when the young man seems to "see" the boy swim-ming in waves because of a sudden eyeline match. The rational discourse of the young European and its critical querying by the narrator are thus threatened by irrational flashes of thought from the outside, which generate new images.

THINKING MEDIUM

Shot with special anamorphic lenses that flatten the image, often steeped in dim light, the film looks as if it were framed through a veil of trickling water or as if the surface of the image were liquid; *Elegy of a Voyage*'s images are slightly indistinct and fluctuate, like waves or vapor. Such aesthetics con-tributes to the metaphor of liquidity that characterizes *Elegy of a Voyage*,

while the nonnaturalistic photography attracts attention to the bidimensionality of the image, which is both foregrounded and transcended and plays a key role in the interstitial reflection that *Elegy of a Voyage* delivers on medium. As Diane Arnaud (2005)[2] has written,

> The undulating effect of the image imparts to what becomes visible something of the material medium through which it comes into being. This effect connects the movement of the film to an origin that is to be identified more with an emergence than an unwinding. What defines the bidimensionality of film is the illusory attempt to imprint an originary mobile substrate on a surface shaded by the breath of time and to elicit from it the sense of depths which are other than visible ones. (135)

Since the end of the twentieth century, in an age in which images travel independent of their original support and the technology through and for which they were produced, the fluidity of the concept itself of film has been in evidence. Digital technology's departure from the bedrock of indexicality, in particular, has generated repeated announcements of the death of the cinema and its transformation into something radically new. Against the backdrop of these discourses, of the current instability of film as both a concept and an object, *Elegy of a Voyage* engages in subtle ways with the question: "What is cinema?"[3] Interestingly, for *Elegy of a Voyage* Sokurov chose the Betacam SP analog video format, the "Superior Performance" improvement on the 1980s-introduced Betacam, which was in turn superseded by Digital Betacam in the early 1990s. Now perceived as an in-between technology, Betacam is no longer celluloid but it is not yet digital and has become a somewhat obsolete format; as such, it is indicative of the constant shifts of the image through ever-changing technologies that has characterized the entire history of film, as well as the history of the image *tout court*—and, more specifically, of the demise of celluloid-based technologies. This broader framework is invoked by Sokurov himself in a film that reaches back before the cinema, all the way to the question of the art-historical image, and that reflects also on sight and on our being at once viewing subject and viewed object.

Elegy of a Voyage's reflection on medium, in fact, develops in interstices that inscribe in the video the undecidability of the image in its intramedial status and, at once, the incommensurability of the interface among subjectivity, sight, and knowledge. Suggesting that "intermediality in film

2. This and all translations in the book from languages other than English are by the Author.

3. Meaningfully, a number of the artists whose work was featured in the *Unpacking Europe* exhibition also participated in a series of discussions organized as part of the 31st International Film Festival Rotterdam precisely on the topic "What is cinema?"

is grounded in the (inter)sensuality of cinema itself" (Pethő 2011, 69), Ágnes Pethő has described two modes that generate an emphatic sense of intermediality in film:

1. A "sensual" mode that invites the viewer to literally get in touch with a world portrayed not at a distance but at the proximity of entangled synesthetic sensations, and resulting in a cinema that can be perceived in the terms of music, painting, architectural forms or haptic textures; and

2. A "structural" mode that makes the media components of cinema visible, and exposes the layers of multimediality that constitute the "fabric" of the cinematic medium, revealing at the same time the mesh of their complex interactions. (99)

Elegy of a Voyage capitalizes on both modes: it sensually creates a deeply synesthetic "painted" image; and it structurally attracts attention to itself as filmed image in various ways—starting with the anamorphic veil that constantly quivers on the image's surface and that queries the nature of what we see. The gap between viewer and viewed, and therefore the presence of the camera and the status of the image as image, is indeed frequently emphasized by "veils" that are interposed between camera and profilmic, such as swirling fog or snowflakes dancing before the lens. At one point, the narrator mentions a mysterious black sheet, which unfathomably appears, partially obliterating the screen. All these veils attract attention to the surface of the image and to the intangible and (normally) invisible interstice embedded in the image itself, which separates the camera from the profilmic and the eye from the object and positions the spectator as spectator. A similar effect is achieved by the mise en abyme of spectatorship provided by Sokurov's onscreen presence as *Rückenfigur*, which is at once a positioning of the filmmaker as viewer rather than as thinker.

The idea of the image's flatness is constantly and simultaneously foregrounded and challenged. The film's first shot is of an autumn tree. The shot is fixed and looks at once depthless and like the realist painting of a rural landscape (similar to those that the narrator will encounter in the museum, later in the film); yet it is also alive, it moves, because of the falling snow and its anamorphic shivering. The undecidability of the status of this image, which is painting, indexical trace, aesthetic object, and moving film all at once, is reinforced by the narrator's description of its seasonal paradox: it is an autumn tree, but snow is already falling; then clouds appear in the sky, as if it were summer. Following an image of clouds moving against the still background of a blue sky, we are then shown a water surface, framed from high up—a green–gray canvas seen by an observer whose distance from the image is made visible by birds flying in the gap between the lens and

the sea. Concepts of flatness and depth, proximity and distance, are also repeatedly mentioned by the narrator, who more than once refers to the idea of the world as picture and to the observer's desire and fear to touch it, to fall into and to become part of it. Through all these strategies, *Elegy of a Voyage* continuously places its image between flatness and depth, stillness and mobility; in so doing, the image keeps shifting incommensurably before our eyes—between indexical trace and painting, art-historical image and moving film, photograph and video. The narrator, then, is always liable to change from viewing subject to viewed object, being foregrounded at once as narrator/observer and as spectator/*Rückenfigur*—in other words, he is at once outside and inside the picture. He is attracted to the picture, wants to become part of it, while being irremediably on its outside. During the opening, dream-like sequence, for instance, the narrator confesses he is afraid of falling; once the movement of the film starts, then, over images of a road covered in swirls of fog, the voiceover likens it to something smooth and transparent (the video strip?), commenting that he can nearly touch it. Later, standing on the deck of a ship, he feels attracted to the waves and is almost compelled to let himself fall into them. The narrator not only mentions his desire to become part of the picture; he also directly evokes the mystery of the gaze, both as a look that is directed at him and as one that is implied by the world as picture. Examples of the first gaze occur when, on the Siberian clearing at the start of the film, just after commenting on the "perfect solitude" of the place, he suddenly feels observed by someone whom he thinks is behind a tree—but whom we do not see; or when he is openly scrutinized by the guards at the checkpoint; or, again, when he is examined by the young man at the café, who then comes to sit at his table. On each of these occasions, the narrator goes from being the (mostly unseen) bearer of the look to the object of somebody's sight; each time, he expresses discomfort about it. As for the second type of gaze, the narrator overtly discusses the mystery of the world as picture more than once, for instance, when, observing the beauty of the snow-covered Siberian clearing, he wonders, "For whom is all that beauty? No one to see it; still, it is just as beautiful" (Figure 1.7); or again when he says that an empty landscape, which he observes from above, looks as if it were built "for those living above." The emphasis thus keeps shifting from the gaze as instrument of knowledge and apprehension to the gaze as tool of objectification, evoking the Lacanian consideration that the act of looking alone makes one feel like an object and turns one into a picture—and, at once, his striking description of the unfathomable outside/inside dynamic of the act of looking that compares all images of sight to painting: "That which is light looks at me, and by means of that light in the depths of my eye, something is painted" (Lacan 1998, 96).

For whom
is all that beauty?

Figure 1.7: The world as picture. *Elegy of a Voyage*. Facets Video/Ideale Audience 2007. Screenshot.

The gaze, its inside/outside dualism, and the reflection on medium and image become even more explicit in the final section of the film, set in the museum. Here, the emphasis is on paintings' frames, both empty and full, on pictures of the world/the world as picture, and on the desire of the observer to enter the picture. In a video interview included as special feature in the Facets 2001 DVD edition of the film, Sokurov states that their flatness, their lack of three-dimensionality, is what cinema and painting have in common; as such, they both hold something back from the viewer, they limit the vision, thus producing a mystery. It is this mystery that the film evokes, interstitially producing an image of thought. Framing and frames as limens become especially important in this process. As Tim Harte (2005) has argued in relation to *Russian Ark* and its emphasis on frames of all sorts (doors, windows, pictures), "[i]n making these marked borders so conspicuous, Sokurov begins to underscore the critical link between his celluloid [*sic*] images and the medium of painting, which both depend on the frame for visual and presentational purposes" (46). Quoting José Ortega y Gasset, Harte mentions the value of paintings and frames as "openings of illusion into which we can peer" and suggests that "the frames and their respective paintings constitute vivid, ideal worlds— eternal spheres—into which the viewer enters" (46). In the museum section of *Elegy of a Voyage*, the camera regularly performs movements that progressively bring it closer to the paintings, until the frame of the video

fully coincides with the painting's frame. The filmic image, then, ineffably transforms into painted image and vice versa; the painting gifts the video with textural richness and tactility, and video gifts the painting with temporal duration. The narrator talks about the pictures as if they were real and present; sounds and voices are heard on the soundtrack, as if the scenes were alive and taking place before his eyes, although the tension between their animation and stillness is not dispelled. Inspecting a painting of *St Mary's Square and St Mary's Church in Utrecht* (1765) by Pieter Saenredam, the narrator so feels at one with the painter's eye that looked at the square as to identify with it completely. By the addition of naturalistic sounds and the narrator's descriptions, the soundtrack works to synesthetically overcome the image's stillness and bidimensionality. The audiovisual painted image thus expands in the dimensions of both space and time and replaces "historical linearity in favour of an idealised, continual simultaneity" (Condee 2011, 193), thus allowing the narrator to feel he has finally entered the picture and become part of the world as picture.

It is notable that the film ends on the fullness of the narrator's sense of belonging to this scene, a European square, a privileged site of sociality and human encounter and exchange. As such, the theme of the liquidity of contemporary Europe that I explored at the onset of my analysis would seem to dissolve and be replaced by a reassertion of the continuity and ultimate solidity of the European home.[4] Similarly, the disjunction that is at the basis of *Elegy of a Voyage*'s discourse on the image would appear to be overcome by the complete assimilation of art-historical picture and post-celluloid film. However, the last image of the film is of an interstice created by Sokurov's body. By standing between the camera lens and Saenredam's painting, by placing his hand close to the canvas and brushing it without touching it, Sokurov chooses once again to mark the gap between observer and observed, lens and profilmic, eye and picture (Figure 1.8). It is this gap within which the imponderable question of knowledge can appear.

The question of knowledge is, indeed, deeply connected to that of perception. A note from *On Certainty* by Ludwig Wittgenstein (1969), which builds on the Lacanian concept of sight as projection of images inside the eye described earlier, helps to apprehend the simultaneous conjunction and disjunction of perception and knowledge:

> "I know" has a primitive meaning similar to and related to "I see" ("wissen", "videre").
> [. . .] "I know" is supposed to express a relation, not between me and the sense of a proposition (like "I believe") but between me and a fact. So that the fact is taken into

4. However, the narrator also describes the square as frozen in time, as if time had stopped flowing when the painter painted the image.

Figure 1.8: The interstice. *Elegy of a Voyage.* Facets Video/Ideale Audience 2007. Screenshot.

my consciousness. [...] This would give us a picture of knowing as the perception of an outer event through visual rays which project it as it is into the eye and the consciousness. Only then the question at once arises whether one can be certain of this projection. And this picture does indeed show how our imagination presents knowledge, but not what lies at the bottom of this presentation. (Note 90)

By marking the gap in the image, *Elegy of a Voyage* allows the imponderable question of what lies at the bottom of the representation to be asked and an image of thought to flash up.

SUMMARY

My analysis in this chapter has aimed to show how Aleksandr Sokurov's *Elegy of a Voyage* effects disjunction at various levels (including narrative, framing, editing, mise en scene, and soundtrack) to evoke multimediality, heterogeneity, and nonlinearity and to carry out a nonverbal reflection on the filmic medium and on the nature and history of the image. The multiple interstices carved in the text by Sokurov's choices attract attention to the image as image, as well as to the gap between observer and observed, subject and world, perception and knowledge. The dialectical attitude that is at the core of the essay form creates tension between various types of

image—image as sight and image as knowledge; still and moving image; painted image, film, and video. Irrational cuts between images, and between images and sounds, then, allow for the surfacing of new images of thought. Disjunction is at the heart of this film, which constantly threatens to break down, in the absence of a coherent narrator and story; this disjunction is, however, counterpoised by fluidity, the unifying visual and conceptual force of the film's probing of issues of history, society, identity, subjectivity, culture, art, and the cinema.

Starting from notions of medium, then, *Elegy of a Voyage*'s case study has allowed me to begin to reflect on the disjunctive practices of the essay film and to highlight its use of textual interstices, while also paying attention to the relinkages that, in Sokurov's film, are provided by notions of fluidity. In the next chapter, I will concentrate on montage and the irrational cut as a form not only of dissociation but also of transition that moves thought beyond its positions of most radical standstill.

CHAPTER 2

Montage

Essayistic Thinking at the Juncture of Images

Discontinuity is essential to the essay; its concern is always a conflict brought to a standstill. (Adorno 1984, 164)

To thinking belongs the movement as well as the arrest of thoughts. Where thinking comes to a standstill in a constellation saturated with tensions—there the dialectical image appears. (Benjamin 1999, 475)

Aleksandr Sokurov's *Elegy of a Voyage*, the case study discussed in Chapter 1, represents thought as almost independent of the subject. In this film, thought comes to the narrator in a quasi-automatic way; the narrator is, indeed, characterized by lack of agency and an uncertain subjectivity. The recognition of the autonomous character of thought is also at the basis of Gilles Deleuze's conception. For Deleuze, "[s]omething in the world forces us to think" (1994, 139); thought, in other words, happens to us from an outside "more distant than any external world" (Deleuze 1989, 226). Our thinking implies an image of thought, which constantly changes and is challenged and produced by what lies outside of it: the unthought.

In *Cinema 2*, Deleuze discusses the unthought in relation to the interstice and to montage. As explored in the introduction, Deleuze theorizes the interstice as a method of in-betweenness that produces something new. In writing on *Ici et ailleurs* by Jean-Luc Godard and Anne-Marie Miéville, he describes the interstice as spacing "between two actions, between affections, between perceptions, between two visual images, between two sound images, between the sound and the visual" (Deleuze 1989, 180). The interstice, or, to use an expression of Maurice Blanchot mentioned by Deleuze, the "vertigo of spacing" (180), in which the unknown announces itself, is

for Deleuze a void that is a radical calling into question of the image, a difference of potential between two incommensurable elements, which produces something new. Whereas classical montage, with its suturing skills, created a unified whole, the interstice carves a gap between two images; this gap may confront us as incommensurable unthought, which brings about the possibility of a new image of thought:

> [The] time-image puts thought into contact with an unthought, the unsummonable, the inexplicable, the undecidable, the incommensurable. The outside or obverse of the images has replaced the whole, at the same time as the interstice or the cut has replaced association. (1989, 206)

Although the interstice is not associative, it does not result in unsurmountable disjunction; indeed, it can create relinkages and, thus, its own form of montage, as I have already had the opportunity to remark both in the introduction and in Chapter 1. The carving of interstices that occurs in Deleuzian time-image cinema and in its specific form of montage is the topic of the current chapter. Rather than focusing my attention on the interstices themselves, as I have mostly done in Chapter 1, here I am interested in studying their use as part of the montage's function of transition between images and of its method for moving thought forward. Therefore, this chapter will contribute to an understanding of the associative function of the interstice in the essay film.

In his cinema books, Deleuze places much emphasis on the role of the Second World War and its inheritance of wreckage and horror in the radical transformation of both filmic image and thought in the postwar era. This view of the Second World War as an incommensurable watershed for art and philosophy is in line at once with Theodor W. Adorno's famous statement that "[t]o write poetry after Auschwitz is barbaric" (1982, 34) and with the argument of the "unthinkability" of the Holocaust. Focusing on the interstice in montage as space for the emergence of the unthought, but also on dialectics—and, in particular, on Walter Benjamin's notion of the dialectical image—in this chapter I will take two essay films on the Holocaust as my case studies in a bid to elucidate the centrality of the interstice to the essay film's ability to move thought beyond unthinkability.

TRANSITIONS

The debate on how to best remember the Holocaust, and thus not to betray it, and on whether narrative is an adequate means to preserve and communicate its memory has become particularly crucial in the face of the

progressive disappearance of direct witnesses and survivors. As Stephen Feinstein has observed, "[t]here is more and more of a burden and an increasing urgency to tell the story. The generation of witnesses is passing" (2000, 19). Passing is here, of course, a euphemism for dying; but the first meaning of the verb in its intransitive form has to do with moving in a specific direction and with going through. The Latin verb for "to traverse" and "to go past," *transeo*, is also used figuratively for "to die." Thus, transit is both a passing and a passing away—the double semantic value of the verb gestures toward our understanding of human life as a journey and as a transitory state. The effects of transitoriness (of time, life, and matter) are very much at the core of the question of Holocaust remembrance; they are, indeed, at the root of the issue of the difficulty of testifying to a horror that is not only commonly perceived as unspeakable, but also obliterated by both the enforced and the natural disappearance of many of its material traces— the camps, the bodies, the documents. In the harrowing opening sequence of Claude Lanzmann's documentary *Shoah* (1985), Simon Srebnik, one of the only two survivors of Chełmno, returns to the site of the extermination camp, now an empty field, where he was shot in the head and left for dead forty years before and comments in disbelief, "It's hard to recognize, but it was here. They burned people here [. . .]. Yes, this is the place [. . .]. I can't believe I'm here. No, I just can't believe it. It was always this peaceful here." Although Richard Kearney (2002, 59), in his compelling reading of the sequence, focuses on the paradox of the impossible testimony, what strikes me most in Srebnik's verbal response to the view of the site is the image of a place that is simultaneously unrecognizable and familiar—a place that still is and, at the same time, is no more; as well as his disbelief at, and concomitant recognition of, its peacefulness.[1] Such peacefulness, settled in place over long postwar decades of neglect, now seems almost to enclose within parentheses the horror years of Chełmno, during which at least 152,000 people were annihilated—as if those years were but a transitory interlude.

It is indeed on transits that I will reflect in this chapter, in ways that interrogate memory, testimony, narrative, and representation, as well as specific elements of the essay film's deployment of montage as transition between images. My case studies are Harun Farocki's *Aufschub* (*Respite*, 2007) and Arnaud des Pallières's *Drancy Avenir* (1997). *Respite*, a contribution to the 2007 Jeonju International Film Festival Digital Project, is a silent film based on a montage of the 16mm footage of the Westerbork camp, the Netherlands, shot in 1944 by the inmate Rudolf Breslauer under orders from the SS camp

1. Alain Resnais's *Nuit et brouillard* (*Night and Fog*, 1955) starts with a similar reflection, and its method throughout focuses on showing how the apparent normality filmed by the camera in the now of the narration conceals a horrifying past.

commander, Albert Gemmeker. Devoid of archival footage or interviews, *Drancy Avenir* gives voice to several narrators: a survivor expresses his horror at returning to an indifferent France; a history teacher muses over the inheritance of the Holocaust; a young historian studies survivors' accounts of the Parisian Drancy camp and the relationship between the old camp site and the housing project it now hosts; a captain taking his boat upriver worries about hostile strangers hiding in the forest. Adopting diverse and almost opposite strategies—one contains only archival footage, the other only present-day, original images; one is silent, the other places much emphasis on the word; one is documentary, the other fiction (or, as Jacques Rancière [1997] defines it, quasi-fiction)—they share an interstitial essayistic approach and a focus on transit camps: both Westerbork and Drancy served in fact as interim way stations on the journey toward extermination.

Situated in the northeastern Netherlands, Westerbork was established by the Dutch authorities in October 1939 to intern Jewish refugees who had entered the Netherlands illegally from Germany. In July 1942, the German authorities took control of Westerbork, which served until September 3, 1944, as a transit camp for Dutch Jews who were to be deported to German-occupied Poland. In this period, 97,776 Jews were deported from Westerbork, most of whom were killed on arrival at Sobibor and Auschwitz. Westerbork was, for the vast majority of its inmates, "the penultimate stage of their earthly existence. [. . .] However, the Westerbork sojourn itself was still bearable to its transients" (Mason 1984, 335). This stage on the inmates' journey that would end further east was, in fact, an endurable way station, an impression certainly fabricated for the purpose of camouflaging the horrors awaiting them and thus of obtaining collaboration along the way. " 'Natural' death did not occur at Westerbork: apparently no one was beaten, nobody starved, and medical care was surprisingly good" (335). Still, life at the camp was dominated by "the inexorable rhythm of the trains" (336): about one thousand Jews left the camp every Tuesday, and panic among the inmates increased every weekend, when lists of those to be deported were drawn up by the Jewish camp administration.

In France, La Cité de la Muette (the housing development of La Muette) was also a way station, situated in the district of Drancy, twelve kilometers northeast of Paris. Of the 75,000 Jews deported from France to the death camps in Poland, 67,000 were interned at Drancy. Built in the 1930s, La Cité de la Muette was originally a *cité-jardin* development, a modernist experiment in public housing; it was turned into a hub for the deportation of Jews after the notorious roundup of August 1941, the *rafle du Vél' d'Hiv'*, when more than 12,800 people were held at the Parisian Vélodrome d'Hiver for days without food and then transferred to Drancy, Beaune-la-Rolande, or Pithiviers. Drancy remained under the control of the French

police until SS captain Aloïs Brunner took charge of it in June 1943. As Renée Poznanski explains, "from the German perspective, Drancy was supposed to be just one stop along the route that was to lead all of these Jews to Auschwitz" (Poznanski 2001, 310). However, life in Drancy was by far less bearable than that in Westerbork: "French (and later German) prison guards at Drancy were among the most brutal of any camp outside Auschwitz and Dachau. [. . .] Most conservative rates place the number of deaths in Drancy itself at around 3000" (Sachs 2009, 12).

Both Harun Farocki and Arnaud des Pallières chose to engage with transit camps of Westerbork and Drancy through the essay film form; in doing so, they connected their films to a long tradition. In a list of movies on the Shoah, Jean-Michel Frodon (2007, 337–46) includes under the "essay film" heading no less than thirty-two titles produced in various countries between 1947 and 2007, encompassing both little-known and prominent films—among the latter, Marcel Hanoun's *L'Authentique procès de Carl Emmanuel Jung (The Authentic Trial of Carl Emmanuel Jung* 1966), Marcel Ophüls's *The Memory of Justice* (1973–1976), and Hans-Jürgen Syberberg's *Hitler: Ein Film aus Deutschland (Hitler, A Film from Germany,* 1977). According to Toby Haggith and Joanna Newman (2005), two main traditions may be recognized in the manner in which the cinema, both fictional and documentary, has dealt with the Holocaust: a realist tradition and a nonrealist tradition. Whereas the first is an intuitive category of (apparently) simple definition (the authors point to what they call the "classical narrative cinema of Hollywood" in fiction and to didactic and chronological documentaries in nonfiction), their some- what convoluted description of the nonrealist tradition is revealing of clas- sificatory strain: a "non-linear or non-chronological, poetic and occasionally reflexive approach, in which there is particular concern, and often experi- mentation with, the cinematic form" (9). This "nonmainstream approach" can be traced for the authors as far back as Alfréd Radok's *Daleká cesta (The Long Journey,* 1949) in fiction film and Alain Resnais's *Night and Fog* in doc- umentary. Haggith and Newman resort to a psychological argument from existing critical literature to account for this tradition:

> Joshua Hirsch explains the non-realist approach as a kind of cultural manifestation of post-traumatic stress disorder: artists have responded to the trauma of the Holocaust and exposure to the atrocity footage that documented it [. . .] by developing a form of film- making that conceded the impossibility of representing this event through realism. (9)

Although the explanation is suggestive, I would rather argue that film- makers who have chosen the essay form have done so for its capacity to summon the unthought—seen as an incommensurability that brings about a new image of thought. The interstitial thinking mobilized by the essay film

is a "radical calling into question of the image" (Deleuze 1989, 174), which is necessitated by the crisis of rationality and of representation instigated by the Holocaust; it is also a way of moving thought beyond the impasse of the Holocaust's unthinkability. The making of essay films on concentration camps suggests, in fact, a position of dissent from the argument of the radical unthinkability of the Holocaust, proposed as a limit of thought by Jean-François Lyotard (1995, 1988), among others. As such, these films are political films. It is significant that key essays on the Holocaust, such as *Night and Fog* and *Le Chagrin et la pitié* (*The Sorrow and the Pity*, dir. Marcel Ophüls, 1969), have been controversial to the point of being censored or banned from television broadcasting (Haggith and Newman 2005, 11). But what kind of thinking do *Respite* and *Drancy Avenir* produce, and where does their thinking take place?

In the case of Farocki's film, thought is generated by the encounter with archival images (those of the Breslauer footage), in a manner that evokes Arlette Farge's observation in her *Le Goût de l'archive*, that "in its singularity, an archival object can rupture the fabric of received thought and pose a challenge that the historian can meet only through a highly self-reflexive and unfinalizable conceptual labor" (quoted in Rose 2008, 126). The labor of film's thinking, thus, aims to produce a tear in the fabric of the "received thought" of overfamiliar images, and it does so by confronting the unthought in the crevices produced by the ruptures of a dialectic montage. This conceptual labor in Farocki's film, as we will see in more detail below, parallels the analysis of the archival object itself as the product of labor at many levels.

In des Pallières's case, the new image of thought emerges ineffably in the interstices created by a montage that incommensurably juxtaposes words on the horror spoken by a range of real-life subjects (survivors, intellectuals, novelists) and an apparently disconnected image track of contemporary everydayness but also painful beauty. Whereas des Pallières's eschewal of archival images seems to support the argument of the unimaginability (and thus unrepresentability) of the Holocaust—in line not only with Lyotard's discourse, but also, in filmic terms, with Lanzmann's—the incommensurable interstice between soundtrack and images gives rise to new images of thought, thus evoking the art historian Georges Didi-Huberman's argument that Auschwitz not only must be imagined but also is "only imaginable" (2008, 45).

The interstices of these two films are best understood as eloquent lacunae. In his rereading of Didi-Huberman's analysis of the four Sonderkommando photographs illegally taken in Auschwitz in August 1944 and then smuggled inside a tube of toothpaste to the Polish Resistance, Sven-Erik Rose directs our attention to Didi-Huberman's concept of the "image-lacunae" (lacuna-image), which refers to the incomplete, fragmentary nature of the

visual archive of the Holocaust. Didi-Huberman, however, equally draws from Walter Benjamin's notion of the dialectical image and from Siegfried Kracauer's concept of cinematic montage to theorize ways in which the "lacuna-image" may be made readable:

> Against those who declare the visual archive of the Shoah either irrelevant or taboo, Didi-Huberman insists on the possibilities for critical engagement with it through dialectical montage. In Didi-Huberman's conception, montage aims not to *assimilate* disparate elements into a *totality*, but rather much like in Benjamin's famous concept of the image that flashes up where dialectics reaches a "standstill," insists on historical singularities and therefore multiplicity. (Rose 2008, 130)

It is opportune to note that thesis, antithesis, and resolution are not what Benjamin intended to evoke with the term dialectical montage. As Kaja Silverman (2002) has suggested, the concept is closer to Baudelairean *correspondance*, which highlights resemblances by linking together temporally divergent moments that are thus allowed to enter into communication. These correspondences or similarities, then, "render null and void concepts like *progress, development,* and *cause* and *effect*" (Silverman 2002, 4). The cinematic metaphor of dialectical montage places much trust in film's ability to think and to move thought beyond its standstill positions and is thus apt to introduce the following discussion, in which I examine not only the role of montage in the films' thinking, but also that of other textual and communicative structures, all of which mobilize the interstice in productive ways.

RESPITE: THE LACUNA-IMAGE

The concepts of lacuna-image and dialectical montage are particularly germane to Farocki's *Respite*. The film shows Breslauer's rushes with a degree of manipulation and intervention that, at first sight, may appear to be minimal, especially because of the complete lack of sound—but that, in truth, is profound and meaningful. Instead of speaking over the images, as he did, for instance, with the archival footage in *Workers Leaving the Factory* (*Arbeiter verlassen die Fabrik,* 1995), Farocki interpolates white intertitles over black screens, which give information, attract attention to specific details, or offer interpretations. The intervention, especially when examined vis-à-vis Resnais's bold editing of some of the same footage in *Night and Fog*, seems highly respectful and almost philological.[2] However, the

2. For an analysis of the use of the Westerbork footage in *Night and Fog*, where it is mixed with footage shot both by the Nazis in the Warsaw Ghetto and by the Western Allies when they liberated the concentration camps in Germany, see Lindeperg (2007).

essayistic meanings emerge precisely from the montage of images and written comments.

As both Sylvie Lindeperg (2009) and Thomas Elsaesser (2009) have shown, *Respite* foregrounds (like much of the rest of Farocki's oeuvre) the theme of work and makes reference to the cinematic form of the corporate film. The footage, a rare example of Nazi-crafted filmic documentation of life in concentration camps, can be compared to *Theresienstadt: Ein Dokumentarfilm aus dem jüdischen Siedlungsgebiet* (*Terezin: A Documentary Film of the Jewish Resettlement*), the infamous propaganda film shot in 1944 in Theresienstadt in advance of a visit of the Danish Red Cross. However, the Westerbork film was initiated for the purpose not of deceiving a delegation, but of demonstrating the high productivity and efficiency of the camp. It is in this sense that the footage may be seen as the basis of a corporate or industrial film-in-the-making and, indeed, Farocki in *Respite* dwells not only on images showing inmates hard at work, but also on an astonishing "company logo" of the camp, dominated by a factory's smoking chimney (Figure 2.1).

Chillingly, the chimney, a symbol of industrial production, "is found at the centre of a chart signaling with arrows and numbers, 'entrances' and 'exits' (notably to the East) of the prisoners of the Dutch camp" (Lindeperg

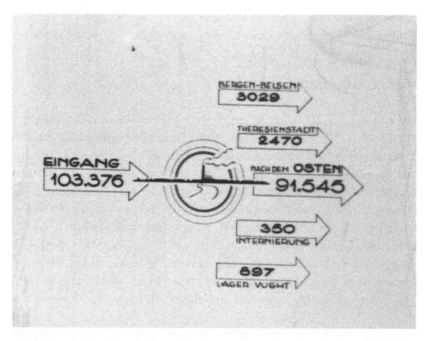

Figure 2.1: Westerbork's "company logo." Harun Farocki's *Respite* (*Aufschub*, 2007). Harun Farocki Filmproduktion 2007. Screenshot.

2009, 32). Productivity is thus linked not only to industrial and agricultural work, but also to the numbers of inmates processed and sent to extermination. With this film Gemmeker meant to prove how efficiently he ran Westerbork because he wished to avoid being posted to an extermination camp—something that SS officers regarded as a punishment; the film, thus, worked for him as a form of deferral.

In his analysis of Farocki's text, Elsaesser (2009) elucidates the many ways in which the film-in-the-making constituted a "respite," or a postponement of the journey east, for all involved—not only for Gemmeker, but also for the inmates: for the few months of the shooting, Breslauer and his "actors" kept deferring the order to board the next train. Thus, not only Westerbork as transit camp was a pause, an interval on the inevitable journey; the film was, too. In Elsaesser's words, "the film itself not only uses slow-motion, but in its somewhat disorganized, casual and non-linear manner also practices its own kind of deferral" (61). Slow motion, fragmentation, and nonlinearity are not aesthetic textual practices here, but become strategic in ways that imbricate the film-in-the-making with an ongoing act of resistance. Fragmentation and nonlinearity, it is worth noting, are also Benjaminian strategies in the approach to history, on which I will say more below.

Arguably, Farocki's dialectical montage makes order in this programmatic disorganization, while not betraying it. It is at this juncture of my discussion that it is possible to elucidate how transits and pauses become doubly relevant—on the one hand to questions of memory, testimony, and representation and, on the other hand, to textual and communicative strategies mobilized by the essayist filmmaker. In relation to the first set of concerns, Elsaesser has shown how Farocki's film proposes an "epistemology of forgetting" as a way to protect the memory of the Holocaust not from ignorance but from too much knowledge. Elsaesser's argument stems from the fact that, in his film, Farocki chooses to ignore what is known about Breslauer's footage; in particular, what is known about the face of a girl paralyzed by fear peeking from the open door of a boxcar and looking at the camera—an image that became an icon of the Jewish Holocaust, until she was identified as Settela Steinbach, a Sinti and not a Jew (Figure 2.2); and about the date of birth on the suitcase of a sick woman transported on a hand-cart, which allowed historians to date the footage at May 19, 1944.[3] By suspending or "pausing" our knowledge and, thus, by looking at the footage with new eyes, Farocki—Elsaesser argues—has made a film not about the Holocaust but about our knowledge of the Holocaust.

3. The rest of the footage, especially the parts devoted to everyday life and recreational activities, is infrequently screened.

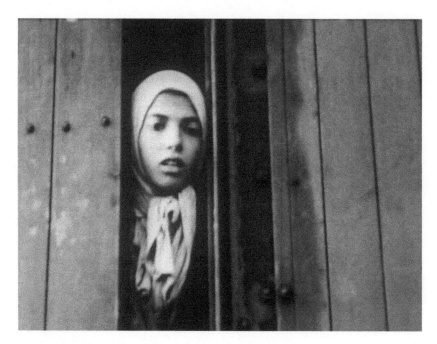

Figure 2.2: Settela Steinbach in the Westerbork's footage. *Respite.* Harun Farocki Filmproduktion 2007. Screenshot.

Farocki asks us to look at this famous footage through the lens of the industrial film, thus prompting us "to a revision and a rethink of what has so far prevented the majority of the footage from being shown: namely that these scenes of everyday life, of sports and recreation either did not fit the conventionalized Holocaust narrative, or seemed too unbearably ironic in their innocence and ignorance" (66–7). Thus, by "re-winding" the footage, Farocki creates respites or gaps into which the spectators may insert their own repertoire of images of the Holocaust. Furthermore, these respites "are meant to forestall the relentless logic of automatically attributed meaning" (67–8).

Timothy Corrigan (2011), who talks of departure as both a historical and a conceptual figure in Farocki's film, points at ways in which the actual transitions, which are documented by the images of the train leaving the station, also emerge as conceptual transitions in the film itself. Corrigan directs our attention to the manner in which, through the pausing of the image, Farocki attempts to rescue the historical subject that is erased "through the anonymity of its transitory image." In this sense, the film and the train's boxcar are both "passing," even if the film gives an illusion of presence and permanence (Corrigan 2011, 160–1). It is my intention here further to unravel these textual strategies of transition and passing, of pausing and replaying, highlighted by both Elsaesser and Corrigan, for the purpose

of interrogating what I see as Farocki's particular articulation of the interstice in *Respite*.

Respite is an unusual essay because Farocki's thinking in the film is not supremely eloquent, fluent, and fluid, as we generally expect from essays, but essential, economical, and somewhat discontinuous. The intertitles are short and intermittent; they offer information ("The film was never completed"), ask questions ("Are these prettifying images?"), point at details in the shot ("In the background, a watchtower"), or infer from the visible evidence ("Meaning: we are your workhorses"). It is clear that this laconic written text does not compose an essay; the essayistic meanings are thus mostly nonverbal and emerge from the juxtaposition and interplay of intertitles and footage (both original and modified by Farocki's interventions) and from the transitions that both separate and connect them.

Respite can be said to be composed of lacuna-images, both because Breslauer's is an unfinished and unedited film and because its images lack fullness—something is evidently, scandalously missing from them (the fully fledged horror, pain, death, the knowledge of the future). In Farocki's film of the footage, the effect of a series of lacunae and voids is further enhanced by the fragmentation of the visuals by the black screens, which is in turn accentuated and intensified by the intertitles. The black screens function, at one level, as pauses in the visuals and could thus be said to gesture toward the nature of interval and respite that the transit camp offered and that Breslauer's film itself embodied. As holes punctured in the footage, then, they suggest voids in the discourse of the film, arguably in a way that alludes at once to a falling silent before the incommensurability of the horror (a silencing further underscored by the "audible" silence of the film) and to an ultimate lack of meaning. The film creates pause and void also via other strategies: Farocki sometimes uses a freeze frame, or traces a circle around an important detail, or replays the images to further consider and ponder them (Figure 2.3). This slowing down of the progression of the film becomes particularly evident when, after little more than half of the film, the following intertitle appears: "These images can also be read differently." The film then "rewinds and replays" (Elsaesser 2009, 67–8) itself, now with intertitles suggesting new interpretations of the visuals.

If the black screens on the one hand hinder the film's progression, on the other hand they are productive lacunae, inasmuch as they move thought forward and provide spaces for new images of thought. Not only may spectators insert into these gaps their own "Holocaust memories"; but also the pauses have the dual function of voids to be filled and of transitions. They piece together fragments of footage, thus creating a montage; furthermore, by both suggesting and problematizing interpretations, by probing the visible, and by inviting the spectator to mentally

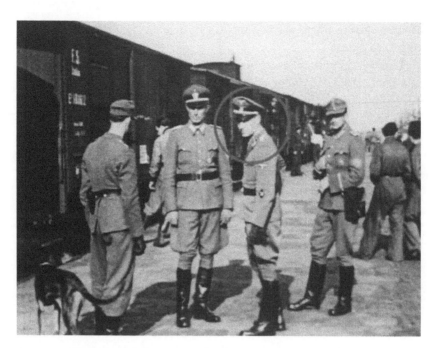

Figure 2.3: Optical reframing. *Respite*. Harun Farocki Filmproduktion 2007. Screenshot.

contemplate other and more dramatic images of the Holocaust that form part of our collective memory, they create an internal dialectic and engage the audience at once in an act of reading, in a dialogue with the enunciator, and in a process of creation of meaning. In other words, they both mimic and facilitate transitions of thought and of intellectual exchange. In his discussion of the film, Corrigan (2011) usefully reminds us of Farocki's own description of the movement of thought in terms of looking for an image that is "like a juncture, the way one speaks of a railway junction" (161). Such junctures and transitions connect moments in and of thinking; however, these connections arguably do not result in progress, in development, and in assignations of cause and effect—to refer once again to Silverman on the Baudelairean concept of correspondence. Development and cause/effect connections are not relevant because Farocki avoids constructing a flawless and fluent argument and thus producing an overarching narrative of the Westerbork camp, of the Breslauer film, or of the Holocaust. Conversely, what he does is focus, with tactful but insistent inquisitiveness, on some of the possible meanings provided by footage that consists in a moment of hindered transition toward the center of the Holocaust. Even more evident, what he does is offer the spectator the chance to direct a fresh and persistent gaze toward footage that is both highly familiar and completely opaque.

In the pauses and junctures of the intertitles and of postproduction intervention, Farocki's disembodied but distinctive enunciator puts himself forward in the first person, reaches out for the spectator, and engages him/her in a dialogue among equals. Most evidently outspoken in the intertitles, he uses them to direct questions at us ("Are these prettifying images?") and to put us on the same plane as he is, by associating us with his reflections and including us in his responses to the footage by using the first person plural ("We expect different images from a Nazi-German camp"). He involves us in his thinking and probing of the material and shares his hypotheses ("Perhaps the presence of the camera had a certain effect"; "I think that is why the cameraman Rudolf Breslauer avoided any further close-ups"). The intertitles work not as interpellations in isolation, but always jointly with the images as well as the postproduction labor that slows down and pauses those images. Furthermore, the enunciating subject problematizes his authorship and deconstructs his authority over the footage by attracting attention, via captions and postproduction intervention, to the agency of the two (distinct and dissimilar) subjects from whom the footage originated—Breslauer and Gemmeker—as well as through his continuous thinking of the past in relation to the present. In so doing and by choosing to work on archival footage only, Farocki positions himself— as I have argued he often does in his oeuvre (Rascaroli 2009, 44–63)—not as a producer of images but as a (critical) spectator of the "images of the world" and of the world as image. He thus places himself in a position from which he can create a dialogue and intellectual exchange with an audience that is equal to him, to the extent that it shares with him the same perspective and (almost) the same cognitive position.

Farocki's film is thus an essay that does not capitalize on fluidity and eloquence, but makes a virtue of intervals and voids. Pause is both an act of resistance, which mimics and amplifies the suspending function of Breslauer's footage, and a textual strategy that aims to engage the spectator in a dialogue with an enunciator who does not possess the images any less or any more than the audience does. The enunciator's fragmented thinking produces an essayistic dialogue through lacuna-images and image-junctures, all the time relativizing the results of his reading of meanings in the footage. These, indeed, are recognized as many times coded—because of the multiple subjectivities inscribed in the original footage; because of the footage's different, even antithetical functions and purposes; and because of the multiple stratifications of intervening historical and philosophical discourses. Montage is here given the task of overcoming the gridlock of dialectics produced by both the incommensurability and the excessive circulation of Breslauer's footage—the historical transit of certain images from the footage through multiple films and contexts. *Respite* offers

a form of thinking that does not aspire to totality and seamlessness, but whose strength is entirely in the (dis)junctures of montage.

DRANCY AVENIR: THE IMAGE-JUNCTURE

An early episode of *Drancy Avenir* is set in a classroom, where a history teacher is lecturing on the Holocaust while simultaneously reflecting in voiceover on his own teaching, on memory and history, and on his identity as a Frenchman and a Jew. Behind him, handwritten in white chalk on the blackboard, is the famous thesis IX from Walter Benjamin's (1968) influential 1940 text, "On the Concept of History," describing the "angel of history" who, as in Klee's painting of *Angelus Novus*, fixedly stares behind him with his mouth open, contemplating what we see as a chain of events and he as a single catastrophe, while being pulled away by the storm of progress (257). Some of the words the historian speaks come from the same text.

The sequence of the lecture is programmatic, inasmuch as *Drancy Avenir* is profoundly informed by Benjamin's ideas on history and on the dialectical image. The Benjaminian constellations of images that the film evokes and conjures up come not only from the history/memory of the Holocaust, but also from novels, fiction films, paintings, and music. A palimpsestic as well as a polyphonic film, almost all of *Drancy Avenir*'s spoken and written words come from published sources (as the spectator discovers, most likely with some surprise, reading the film's closing credits), including survivors' memoirs, philosophical essays, and novels by such writers as Walter Benjamin, Joseph Conrad, Robert Antelme, Annette Muller, Nissim Calef, Charlotte Delbo, Franz Kafka, Marguerite Duras, Claude Lanzmann, and Georges Perec. The quotations are often slightly rewritten by des Pallières (words are added, omitted, or altered), so old writing mingles with new, indeed as in a palimpsest. The many citations also include a sequence from the unfinished *The Merchant of Venice* filmed in 1969 by Orson Welles.[4] Other films and directors are also evoked, although more indirectly, so much so that the entire film can be considered a montage of citations from literature, philosophy, and the cinema, thus confirming the tendency of the essay to multimateriality and multimediality, as well as to nonlinearity, as investigated in Chapter 1.

One of the presiding authorities of *Drancy Avenir* is Jean-Luc Godard, evoked by des Pallières's strategy of layering strata of language, sound, and

4. Welles is one of the authors quoted by Deleuze (1989) in his discussion of the unthought and the interstice (175–6).

image, as well as by his conception of history and philosophical approach to issues of memory, trauma, and modernity. Godard's *Histoire(s) du cinéma* (1988–1998), in particular, presents points of contact with *Drancy Avenir*, and not only because Godard includes in his film a shot of the "Drancy Avenir" tram stop that gives its name to des Pallières's film. *Histoire(s) du cinéma* is a bold, radically experimental video essay on the history of both the cinema and its century. The features of this film that Kaja Silverman (2002) discusses in the following passage have an obvious relevance not only for *Drancy Avenir*, but also for *Respite*, so much so that it is worth citing Silverman in full:

> A sequence from part 1B of *Histoire(s) du cinéma* renders unusually explicit the Benjaminian imperative driving such formal experimentation. This sequence begins with a montage of train images, drawn from a range of films. With it, Godard invokes both the birth of cinema, begun, by many accounts, with the Lumière Brothers' *The Train Leaving the Station*, and the nineteenth century, which created public transportation. He then relates the nineteenth century and the whole of cinematic history to Auschwitz through a chilling shot of a deportee looking out of a partially open door in a German train en route to one of the camps. (6)

The image Silverman refers to is, evidently, that of Settela Steinbach, the Sinti girl who left Westerbork on May 19, 1944, on a train in transit toward her demise.

Images of trains and shots from trains and other vehicles are central to *Drancy Avenir*. One of its most striking moments consists in a frontal shot of a railway junction at Drancy. Two sets of tracks cross over and separate again before our eyes; some railroad cars slowly move toward us, only to swerve either left or right at the last moment (Figure 2.4). This literal image-juncture works, as in Godard's film and like all other images in *Drancy Avenir*, as a catalyst that subtly evokes other images in our mind, in this specific case, images that speak of technology and modernity, communication and dispersion, progress and destruction. Unlike *Histoire(s) du cinéma*, however, in which Godard juxtaposes and superimposes diverse, even contradictory images, creating constellations that are simultaneously amalgamated and fragmented by a complex dialectical montage, des Pallières achieves comparable but distinct effects by adopting a method closer to Farocki's in *Respite*. As I will show in detail, his harrowingly beautiful shots, like *Respite*, recall rather than show other images, thanks to an interstitial montage of visuals and soundtrack. However, whereas in *Respite* archival footage is made to conjure up in the spectator's mind much more tragic and violent images that are temporally copresent to it, in *Drancy Avenir* images of the present, of the most banal everyday, ineffably summon mental images from past horrors. Whereas *Respite* questions the past, *Drancy*

Figure 2.4: Image-juncture. Arnaud des Pallières's *Drancy Avenir* (1997). Arte Video 2008. Screenshot.

Avenir interrogates the present—and the future. It is here that des Pallières's film is profoundly Benjaminian and indeed actualizes Benjamin's (1968) pronouncement that "every image of the past that is not recognized by the present as one of its own concerns threatens to disappear irretrievably" (255).

Drancy Avenir makes of that threat its main concern. As the history lecturer argues, "work on the extermination has to be an investigation of the present."[5] In the section devoted to the young historian who plans to research Drancy, the theory of time of the British idealist philosopher F. H. Bradley (1846–1924) is mentioned. In opposition to the commonly held view of time as a river that flows from its origin toward us, Bradley's unconventional take on temporal transition suggests that it is the future that flows toward us; the point at which the future becomes the past is what we call the present. Immediately after this sequence, which is meaningfully filmed on a bridge crossing the railroad, we see a river and begin to hear a new narration. The text, on which more will follow, includes an explicit reflection on the river as time: "Going up that river was like travelling back to the beginnings of the world, so that you ultimately felt bewitched, detached from everything that had gone before." It is here that the film is most explicit about its method and that it comes closest to Farocki's strategy of "re-winding" time.[6]

5. This and all subsequent quotations from *Drancy Avenir* are drawn from the English subtitles of the 2008 Arte Video DVD edition of the film.
6. In his discussion of the film, Jacques Rancière (1997) similarly uses the French expression "remontée," with meanings such as "returning upstream," "rewinding," and "going back" (42).

Drancy Avenir's essayistic argument on time is poised, to use the words of Jacques Mandelbaum (2007), "between the absence of genocide in the visible world (deliberate eclipse of the event, weakening of the memory, disappearance of its witnesses) and the insistent presence of the voices and literary texts that haunts the devastating beauty and infinite calm of this film" (39). Just as I remarked on *Respite*'s distinctiveness as an "ineloquent essay," *Drancy Avenir*'s singularity as an essay containing almost no original words (bar the small adjustments made by des Pallières) must similarly be signaled. Yet, the film is undeniably an essay, which compellingly engages its spectator in a broad reflection on a set of themes including temporality, purpose, violence, testimony, memory, identity, displacement, power, civilization, and progress. But how can *Drancy Avenir* be an essay if the words that are spoken in it are not its author's, if the film not only is apparently devoid of original thinking and reflection, but also conjoins passages from such diverse texts by so many subjects?

Drancy Avenir's original thinking is not in the verbal commentary but is in its interstitial production of new images of thought. Images of ordinariness and even peaceful joy, like those of children playing in the snow, become almost unbearable because of the incommensurable gap between the voiceover narrating horrors from written memoirs and a visual track characterized at once by everydayness and by aesthetic excess. The film's thinking is, however, subtler and more complex than the result of juxtaposition of words by Holocaust survivors and either contemporary urban landscapes or interiors that allude to the presence/absence of the past. Several of the texts recited by the film's narrators are, in fact, far from evidently connected to the Shoah, if at all. Perhaps the most surprising example is the reading by an invisible narrator, called "the explorer" in the end titles, of passages from *Heart of Darkness* over images of a journey upriver.[7] Thus defamiliarized, Conrad's words, with their description of the dangers lurking in the forest, appear to mysteriously foreshadow the horrors that would devastate Europe. As Jacques Rancière (1997) has argued, "this voyage-meditation on the strange proximity of inhumanity mimes, in a certain sense, the movement of the film in the direction of this 'inexplicable' which, in any case, has come about" (42). It is also in this sense, I argue, that we can talk, as Richard Kearney does, of a "narrative margin" created by the film (Kearney 2002, 170n14). It is in this margin—between voice and image, sheets of time, actual image and virtual image, and written texts of different provenance—that the inexplicable surges.

7. For a postcolonial and post-Holocaust reading of *Heart of Darkness*, see Robert Eaglestone (2010, 190–219).

In fact, the film employs multiple strategies to make the image of the past flash in the present, thus actualizing it in unsettling ways and redeeming it for the future: narrative margins, dialectical montage, and other, utterly distinctive textual and communicative strategies are used. The film's soundscape—composed of classical music, of textured sounds and noises, and of the intense, searching voices of several narrators, young and old, male and female—is used to great effect for this purpose. The soundtrack has a depth and richness that is rarely experienced, especially in nonfiction cinema, and unfolds in parallel to the visual track, thus creating layers, fractures, and interstices between images and sounds. Voiceover is used to both present and explore thought, in conjunction with the allusiveness of the image and with the transitions between sounds and images. Furthermore, interpellation, a key strategy of the essay film, which looks for the dialogue with and even the coauthorship of the audience (Rascaroli 2009, 14–15, 35–6), is relentless. The spectator is summoned to take his/her place in the text by the absence of visible interlocutors. The narrators mostly muse in voiceover while alone or converse with unseen characters; in this way, the spectator is directly summoned and is asked to occupy the place of the partner in a conversation. On occasion, people stare directly into the camera lens, looking at us with searching eyes for long instants (Figure 2.5). During the history lecture, we are positioned among the students, sitting at the same level as they are. Through these strategies, we are constantly and directly addressed by the text, in a way that ensures we are repeatedly called into question. It could be argued that these gazes have the same function

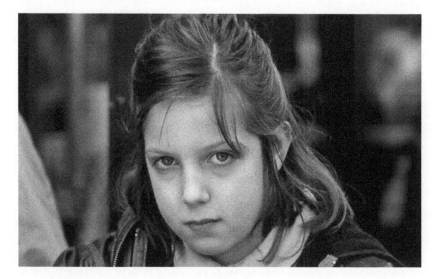

Figure 2.5: Direct interpellation. *Drancy Avenir*. Arte Video 2008. Screenshot.

as Farocki's black screens: they break the flow of cinematic time, drawing attention to the filmic apparatus, and asking us to position ourselves as reflexive spectators.

One technique in particular is exploited by des Pallières to great effect: slow traveling shots are a true signature figure of the film, evoking the practice of modernist directors and, in particular, Alain Resnais.[8] In Resnais's work, traveling shots can be said to function as a materialization of the meandering progression of thought and of memory (Rascaroli 2002, 2006). One film by Resnais especially is evoked by *Drancy Avenir: Hiroshima mon amour* (1959), a lesson in modern cinematic thinking applied to notions of unspeakable traumatic memory and of nonlinear temporality. Both films use tracking shots to explore the present of urban spaces with catastrophic histories. *Hiroshima mon amour* also privileges a Benjaminian approach to history and is one of the key modernist films in which the image of the past flashes in the present, to use Benjamin's expression, or in which sheets of past and present meet, to allude to Gilles Deleuze's conception (1989, 112–21).[9]

What is special about des Pallières's use of tracking shots, however, is that it is so extensive while their motion is so slow that it is almost unnoticeable. This is probably why Mandelbaum (2007) has written that *Drancy Avenir* "records a perpetual present at last revealed—through the tectonic movement of quotations and connections, words and locations—and the hallucination upon which it is based: the continued presence of the extermination" (39–40). The movement, however, is not just that of transits and transitions among quotations, images, words, and places. The film is characterized by a constant, calm but inexorable mobilization—of people (who often walk or travel), nature (a flowing river, clouds in the sky), and vehicles (metro, cars, trains, boats), but also of the images themselves. The shots, indeed, move because of the traveling camera; and when they are fixed, as is, for instance, the opening shot, the light changes so noticeably and dramatically while we watch that the image is profoundly mobilized despite the fixity of the camera. This shot of unusually long duration draws attention to changes we might normally overlook.

The most extraordinary example of this imperceptible tectonic mobility can be found during the history lecture in the first part of the film. At one point, the teacher stands up and erases the passage on the angel of history

8. Lanzmann's *Shoah* also makes insistent use of the traveling shot, however, in this case as a means to "evoke the sense of the journey of millions to their death" (Bruzzi 2006, 103).

9. The majestic traveling shots, the elegant framing and cinematography, the textured soundtrack, and the many references to classical literature, art, and music in *Drancy Avenir* are also at times reminiscent of Andrej Tarkovsky's work.

Figure 2.6: Benjaminian blackboard. *Drancy Avenir*. Arte Video 2008. Screenshot.

from the blackboard. The camera is fixed on the board, which it embraces frontally and in its entirety, as the teacher erases the chalk, then walks out of the frame, only to come back into it a few moments later. The wet sponge leaves on the blackboard swirly traces of chalk, which slowly dry out, turning progressively whiter; thus, the image gradually and almost imperceptibly mutates before our eyes (Figure 2.6). In voiceover, we hear Benjamin's words: "the authentic image of the past appears in a flash then fades forever. It's a unique, irreplaceable image that fades if the present does not see its relevance for it." The movement of the changing patterns of chalk on the surface of the blackboard (and of the screen) is a visually arresting materialization of the core strategy of this film and, equally, of Farocki's *Respite*: the transit of (true) images from the past to the present. The authenticity of these images is, of course, Benjaminian, rather than referring to a discourse that authoritatively asserts its veracity and truthfulness over other discourses. These images, in other words, are intense but transient moments in which we recognize the presence of a past that comes alive again, thus revealing its relevance for the current time.

EPILOGUE

Westerbork was totally demolished in the 1970s; nothing remains of the camp, bar the memorial monuments and, two miles from the former site, a museum. La Cité de La Muette was also almost entirely demolished in 1976, save for a large block, which, superficially repainted and refurbished,

Figure 2.7: La Cité de La Muette today in *Drancy Avenir*. Arte Video 2008. Screenshot.

is today once again a low-rent housing complex, as when it was originally built (Figure 2.7). The two transit camps' distinct destinies epitomize the different but ultimately equivalent ways in which the material traces of the Holocaust have passed, having being destroyed and erased by bulldozers or else reconditioned and beautified by a refashioning of architectural spaces. These places, now unrecognizable and yet uncannily familiar, continue to give rise to true images of the past. Although these images, as Benjamin has claimed, only flit by, film is particularly able to recognize and reveal them because of its aptitude for a dialectical montage that creates gaps and dis-continuities. The analysis of Farocki and des Pallières's films has shown how interstices (between images, between sequences, between soundtrack and image track) may be used to facilitate a Benjaminian transit of "true images" from the past to the present. Arguably, the cinema on the Holocaust that has the greatest impact on the present is a cinema that overcomes thought's impasse by letting a new image flash at the junctures of, and in the gaps between, passing images.

Genre

The Speck of Irony and the Ethnolandscape in Ruins

The crux of theorizing the essay film lies in its definition and thus in understanding its generic positioning and structure. From literary to film studies, all critics who have written on the essay have contended with this issue, and most of them have concluded that the essay is a hybrid form—or, in fact, not a form at all. Already for Ralph Waldo Emerson (1969), writing in 1839, in the essay "everything is admissible, philosophy, ethics, divinity, criticism, poetry, humour, fun, mimicry, anecdotes, jokes, ventriloquism" (265). For Theodor W. Adorno (1984), then, the essay "does not permit its domain to be prescribed" (152). This lack of compliance is theorized by Adorno as heresy of both form and thought:

> Therefore the law of the innermost form of the essay is heresy. By transgressing the orthodoxy of thought, something becomes visible in the object which it is orthodoxy's secret purpose to keep invisible. (171)

Ever since, the idea of transgression has been firmly associated with the essay. Writing in 1985, the literary critic Jean Starobinski espoused the concept that the essay "does not obey any rules" (quoted in Liandrat-Guigues 2004, 8). This avoidance or betrayal of rules informs John Snyder's (1991) conclusion, in his 1991 book on the theory of genre, that the essay is in fact a "nongenre" (12). Moving to the cinema, the film theorist Nora Alter (1996) agrees with Snyder and with this long literary theory tradition when she claims that the essay film is "*not* a genre, as it strives to be beyond formal, conceptual, and social constraint. Like 'heresy' in the Adornean literary essay, the essay film disrespects traditional boundaries, is transgressive

both structurally and conceptually, it is self-reflective and self-reflexive" (171; emphasis in the original). Timothy Corrigan (2011) similarly makes recourse to Adorno's idea of the essay form as "unmethodical method" and suggests, with Reda Bensmaïa, that the essay "may be fundamentally anti-generic, undoing its own drive towards categorization" (8).

Despite the widespread recognition of the essay's heretical and slippery nature, however, film critics have attempted to grapple with formal definitions. Most of these definitions invoke a generic in-betweenness. Often, indeed, the emphasis is placed on the essay's breach of the unwritten rules of documentary, to which it is otherwise linked by its nonfictional leanings and its hybridization with elements of fiction. In *Theory of Film Practice*, for instance, Noël Burch (1981) claims that the essay film is a "dialectics of fiction and nonfiction" (164), thus finding the essay film's distinctiveness precisely in the critical encounter and contraposition of the two traditions. Michael Renov (1989) similarly highlighted that essayistic films "can be said to resist generic classification, straddling a series of too-confining antinomies: fiction/non-fiction, documentary/avant-garde, cinema/video" (8). Thus, Renov broadens the concept to account for the essay's experimentalism, in terms at once of form and of medium. In an article by Paul Arthur (2003), the essay film is also located at the convergence of several traditions; for Arthur, "one way to think about the essay film is as a meeting ground for documentary, avant-garde, and art film impulses" (62). Arthur's "meeting ground," with its lack of distinctive boundaries and clear coordinates, is suggestive simultaneously of an open field and of negotiation; similarly, Burch's dialectics and Renov's antinomies imply contraposition but also a negotiation between fixed positions.

A meeting ground of different generic traditions, then, the essay film emerges from these analyses as occupying an uncertain, shifting position, characterized by a lack of generic fixity and by hybridism of form and materials. This chapter takes a focused look at the essay film vis-à-vis concepts of genre and aims to offer a clearer understanding of its generic positioning. Although it acknowledges, like most critics have done, that the essay is placed in a fluid and uncertain "somewhere" with respect to generic conventions, it does not limit itself to reading this as hybridism, as formal freedom, or even as critical dialogism. What it will claim is that the essay film chooses an interstitial positioning with respect to genre with the aim to generate (nonverbal) meaning that often consists in, or contributes to, a critique of generic conventions and their ideological underpinnings. By working between genres and traditions and their formal characteristics, the essay film adopts a skeptical stance vis-à-vis the same and draws specific attention to the confines of genre and the specificities of its conventions, precisely

by breeching and transgressing them from a position of in-betweenness. As such, I claim, the argument of the essay film is always also an argument on genre.

At a most immediate level, the essay film, indeed, always has something to say on documentary, on fiction, and on art film, on how these traditions intersect and diverge, on their commitments, and on their limitations. More specifically, then, the essay film may also comment, from its in-between position, on particular genres within those traditions. In a bid to elucidate this argument, I will concentrate in this chapter on one genre, ethnographic cinema. The case studies on which I will focus are Luis Buñuel's *Las Hurdes* (*Land without Bread*, 1933), Werner Herzog's *Fata Morgana* (1971), and Ben Rivers's *Slow Action* (2011). They are not, needless to say, straightforward ethnographic films because they are all essays, which position themselves in a paradoxical interstice between two genres: ethnography, intended as a discourse based on a scientific approach to the record of peoples, places, traditions, and practices strongly shaped by discourses of authenticity and of objectivity; and spheres of unreality/surreality as associated with both surrealism and science fiction. The ambiguity created by the meeting and clash of these opposing generic discourses is explosive and disorienting; irony is one of the most evident outcomes of an encounter that at once creates a generic impossibility and the opportunity for a deconstruction of ethnographic discourses. These films' in-betweenness causes the rise of paradoxical interstices, from within which the project of ethnography is satirized and deconstructed, and discourses of otherness, nature, culture, power, imperialism, ecology, and sustainability are both foregrounded and subverted.

Although they are separated by a gap of almost forty years, *Land without Bread* and *Fata Morgana* will be discussed together because I claim that landscape is similarly strategic to their statements on ethnography. Because of its profilmic material presence, nature is offered by Buñuel and Herzog as an element of authenticity and objectivity, but also as a charged discourse that at once conceals and discloses the constructedness of the ethnographic film's gaze on nature and people. Framing the environment simultaneously as raw reality and as nonsensical impossibility, these films unveil the ethnolandscape as the Foucauldian product of a set of scientific, cultural, technological, and ideological practices.

Ben Rivers's *Slow Action*, which alludes to both Buñuel's and Herzog's films, will be discussed separately because its discourse on the filmed ethnolandscape is even more radical. In *Slow Action*, I will argue, the potential mimesis of the profilmic natural environment is entirely eroded from within and revealed to be at once an ideological chimera and a filmic construction. The result is the presentation of a ruinous ecology of the environment, of

culture, of technology, and of the filmic medium itself, which frames the filmic ethnolandscape as wholly utopian and as wholly past.

ETHNOLANDSCAPE AS FRAMING DEVICE

I make recourse to the neologism "ethnolandscape" to highlight that the landscape of ethnography is a specific discourse, based on a set of conventions that, first defined through the practice of ethnographic writing (in its turn steeped in various scientific, artistic, and spectacular traditions), has developed in distinct ways through the genre of ethnographic film. It is important to clarify that I use the term "ethnographic film" here consciously to refer to a specific tradition of (audio)visual documentation of predominantly non-Western cultures, especially those perceived to be primitive, exotic, and endangered, which produced a particular "ethnographic gaze" projected onto the racialized Other. I will do so while being aware that what exactly constitutes an ethnographic film has been the object of debate and that the category is both broad and amorphous, containing as it does an array of diverse practices—all the way from uncritical and imperialist early colonialist travelogues to the reflective, politically aware, experimental work of people such as Jean Rouch, David MacDougall, Maya Deren, Chick Strand, and Trinh T. Minh-ha, among others.

Focusing on ideas shaped by the former tradition, rather than by self-reflexive ethnography, my argument here is that what we broadly intend with "ethnography" is a discourse that necessitates and rests on a framing device. To be understood as ethnography, a discourse on the Other must be framed as such; it must take place within a certain space—an ethnographic space, as defined by the Western imagination and by the tenets of ethnography as a Western science. The framing becomes entirely evident, for instance, in the case of the exhibition of artifacts in the authenticating spaces of the museum, an apparatus and a structure that qualifies things as cultural/artistic objects. It is this framing effect that was at once exploited and highlighted by Guillermo Gómez-Peña and Coco Fusco in their famous *The Couple in the Cage* performance, which toured various museums across Europe and North America in 1992–1993 and in which they presented themselves as Amerindians from Guatinau, a hitherto undiscovered island in the Gulf of Mexico.[1] But the ethnographic museum shares

1. As Coco Fusco (1994) clarified in an article on the performance, which aimed to create an over-the-top satirical commentary on Western concepts of the exotic, primitive Other, a substantial part of the audience believed in the authenticity of the "exhibits," arguably in great part because of the institutional framing.

the same DNA as ethnographic film, as Fatimah Tobing Rony (1996) made sure to emphasize in her study of cinema and the "ethnographic spectacle":

> At the height of the age of imperialism during the late nineteenth and early twentieth century in the United States and Europe, there was a tremendous proliferation of new popular science entertainments visualising the "ethnographic," such as the dioramas and bone collections of the natural history museum, the exhibited "native villages" of the world fair and the zoo, printed representations such as the postcard and stereograph or *carte de visite*, popular science journals such as the *National Geographic*, and, of course, photography and cinema. (10)

In fact, ethnographic film can be seen as an extension of the museum as an early-twentieth-century scientific practice, if one considers that "anthropology in Europe and the United States was still based in the museum" until the 1920s and "the first anthropologists who used film 'in the field' studied humans rather as zoological specimens" (Rony 1996, 63). As Ella Shohat and Robert Stam (2013) confirm in their study of multiculturalism and the media, "[c]inema in this sense prolonged the museological project of gathering three-dimensional archaeological, ethnographic, botanical, and zoological objects in the metropolis" (106). Hence, ethnographic film can be said to adapt and reproduce in moving images the framing devices that had already been established by the natural history museum and, of equal importance, by ethnographic writing—given that, as James Clifford (1988) has epigrammatically suggested, "ethnography is, from beginning to end, enmeshed in writing" (25). For instance, a recurrent and parallel gesture of both ethnographic writing and film is the travelogue trope of the panoramic view, the "monarch-of-all-I-survey" view—in the words of Mary Louise Pratt (2007)—used to present "discovery scenes" that suggested "the overcoming of all the geographical, material, logistical, and political barriers to the physical and official presence of Europeans in places such as Central Africa" (198). As again Rony (1996) has noted in her study of the Albert Kahn film archive (Archives de la planète), which was intended for use in research and lectures, its footage, in common with many commercial travelogues, "almost always includes panoramic views of the landscape, often from the point of view of an arriving traveller or an incoming ship or train. These views helped ground the representation of travel as penetration and discovery" (81–2). In other words, the trope of the panoramic view/shot taken from the perspective of the traveler contributes to the production of an ethnographic space, one that was clearly shaped by Western discourses and that "consisted of a gesture of converting local knowledges [. . .] into European national and continental knowledges associated with European forms and relations of power" (Pratt 2007, 198). The effects of this trope on

the reader and spectator are tangible. As Bill Nichols (1994) writes, "[t]he arrival scene and the distance required by the act of representation confirm the sense of otherness, strangeness" (73).

The ethnolandscape is a requisite framing device for filmed ethnography; we first recognize and identify filmed ethnography, I claim, through our recognition of landscape as the product of a specific gaze, stemming from a number of traditions and discourses that combine art, science, and popular entertainment, spectacle, power, and ideology. It matters to bear in mind that the genre of landscape itself was, in fact, born precisely as a framing device:

> It is certainly correct to say that landscape, in its significant early artistic manifestations, is born independently of the "subject," to which it is however necessarily tied [...] The invention of Western landscape coincides with the production of the "vista," a space that is internal to the painting but opens it to the exterior: it is the discovery of an adequate technique of framing and definition of depth that marks the invention of landscape as cultural space, visible in all its aspects. (Dubbini 1994, xvii)

Although entirely in sight, landscape as ethnographic discourse/frame is also invisible, not only because, as Jacques Derrida (1979) has posited in "The Parergon," a frame is "a form which has traditionally been determined not by distinguishing itself, but by disappearing, sinking in, obliterating itself, dissolving just as it expends its greatest energy" (26). The natural space of the landscape is given as a natural fact as well as a frame and is offered to the Western eye via a regime of authenticity that was historically linked first to discourses of exploration and discovery and then to the "myth of the fieldwork" (Clifford 1988, 24), as it became constituted in the 1920s. Both these discourses were based on the principle of presence, which is enmeshed in issues of power and of sight as power, and which can be summarized as follows: "You are there . . . because I am there" (Clifford 1988, 22)—and also, I would gloss, "You are there . . . because I am there *to see you.*" Corroborating this hypothesis, James Duncan (1993) proposes that two sets of rhetorical tropes are especially important in the representation of places within discourses on the racialized Other. The first set is what he refers to as tropes of mimesis, "which persuasively claim to represent accurately and objectively the nature of a place" and are based on motifs of physical presence and expertise (40). The tropes of the second set, in contrast, "attempt to assimilate the site being represented to the site from which the representation emanates by arraying both sites along a temporal continuum" (40). This set, in other words, presents the "real world of geographical difference and temporal co-presence" as two distinct worlds, which occupy both different spaces and different temporalities (40). In this

sense, the representation tends to present the racialized Other and his/her milieu as the past of Europe.

Produced by these practices and tropes, the ethnolandscape is at the same time productive—namely, of an ethnographic subject. The ethnographic subject's production by particular framing devices is compellingly captured by Rony (1996) as she describes her experience of watching from the outside, almost with a "third eye," the encounter between the white Explorer and the islander Savage in *King Kong* (Merian C. Cooper and Ernest B. Schoedsack, 1933): "With another eye I see how I am pictured as a landscape, a museum display, an ethnographic spectacle, an exotic" (17). The ethnographic subject is pictured as a landscape, which is itself at once framing device and part of the picture, scientific display and exotic spectacle (Figure 3.1). The spectacle and the display represent the merger of the aesthetic and scientific motifs that are at the basis of the ethnographic conception of landscape, a copresence that is already in evidence since the mid-1700s in both European literary and artistic landscapes, as a result of the input of writers, scientists, and artists who engaged in the exploration of new continents and regions (see Dubbini 1994, 66).

If painterly and literary landscapes are able to offer a persuasive mimetic experience, ethnographic film can do so much more effectively on the basis

Figure 3.1: Third eye: the islander Savage in *King Kong* (Merian C. Cooper and Ernest B. Schoedsack, 1933). Universal Pictures 2004. Screenshot.

of its photographic reproduction of reality—which is derivative of the same principles of *perspectiva artificialis* that governed the creation of the art-historical landscape. In 1996, Rony could still write that "[m]any anthropologists, although acknowledging particularly ethnocentric biases of the filmmakers, still do not dispute the status of ethnographic film as empirical record" (12). Although postcolonial anthropology has assimilated the crisis of ethnographic authority and has become aware of the need for ethnographic writing to "struggle self-consciously to avoid portraying abstract, ahistorical 'others'" (Clifford 1988, 23), film continues to offer itself as "a positivist tool for recording reality" (Rony 1996, 12). Indeed, it is the same representational crisis of anthropology that "has presumably boosted the significance of film-making as an alternative form of representation" (Crawford 1992, 66). George E. Marcus confirms that "[f]or the realist ethnographic writer ethnographic films are somehow more natural than written texts" (1995, 35). As Peter Ian Crawford (1992) noted at the start of the 1990s, a set of conventions, which were originally developed in observational cinema, "have almost become rules of ethnographic film-making" (77). These conventions include an emphasis on visuals rather than words and thus a very limited use of narration; the use of synchronous sound, long takes, and wide-angle lenses; the subtitling of indigenous dialogue; and improvised, unscripted filmmaking. It is obvious that these film-realist rules are intended to increase the ostensible, natural objectivity of the medium, whose positivism is enhanced by the conventions that have become associated with an observational technique. And yet film is always revelation at once of the reality it has observed and of the characteristic processes of its own technological apparatus that has shaped that image of reality.

BUÑUEL AND HERZOG: LANDSCAPE WITHOUT MEANING

My understanding of Buñuel's *Land without Bread* is close both to Catherine Russell's (1999) categorization of it as an experimental ethnography that "engages with quite a number of issues that go to the core of the politics of representation in anthropological cinema" (31) and to readings that have especially highlighted its provocative surreal attitude; but I rather place the accent on its essayistic qualities as a text that self-consciously locates itself in a generic in-betweenness to carry out a subversive critique of Western discourses of authenticity, science, technology, exoticism, imperialism, and race.[2] When it calls itself in its opening caption a "cinematographic essay of

2. For informative and incisive analyses in particular of the film's contexts and commentary on contemporary Spain, see Ibarz (2004) and Havard (2001).

human geography," *Land without Bread* is not lying, because it is precisely this: an essay film on people in landscape—and on sciences that are steeped in geopolitical concerns.

In particular, I am interested here in emphasizing the role of landscape in the film as a framing device that supports both the film's allusion to ethnographic representation and its actual critique. It is important to note how temporally close *Land without Bread* was to the establishment of the authority of the ethnographer: "In the 1920s the new fieldworker-theorist brought to completion a powerful new scientific ad literary genre, the ethnography, a synthetic cultural description based on participant observation" (Clifford 1988, 29–30). In this new genre, "[c]ulture was construed as an ensemble of characteristic behaviors, ceremonies, and gestures susceptible to recording and explanation by a trained onlooker" (31). *Land without Bread* mimics the newly established genre, to which it was close in more than one way, if we consider that "ethnography and surrealism developed in close proximity" (118) in the 1920s and 1930s.

After a caption describing that the film was shot in 1933, another caption follows, written in the first person plural, announcing that the filmmakers and the audience will visit Las Hurdes, a region that, "in the opinion of geographers and travelers," is inhospitable; its people must fight for their livelihoods, and the place was unknown even to the same Spaniards until 1922.[3] The next image is that of a map of Europe—a contrivance typical of both fiction and documentary films, which gestures toward myths of scientific objectivity and of expertise (Figure 3.2).[4] Simultaneously, cartography has a special place in, and thus evokes, the imperialist imagination for its ability to be at once a record of how things are and a "dream of hegemony" (Raffestin 2001, 20). The map suggests the mastery of space from above, precisely like the vista, the panoramic view so common to ethnographic writing and film.

Sébastien Caquard (2009) has argued that contemporary digital cartography was originally conceptualized in films, in particular in the

3. All translations from the film's dialogues and captions are mine. The original version of the film was silent; Buñuel himself provided a narration during screenings. In 1935, a soundtrack was added, including a voiceover and sections of Johannes Brahms's Symphony no. 4. In 1965, with the recovery of the censored scenes, a new version of the film was made, complete with a new soundtrack, probably under Buñuel's direction; "but since 1995–6 new versions have appeared that completely nullify Buñuel's original intentions. The oratorical tone of the voiceover is even more compassionate and at some points the Brahms music has been omitted" (Ibarz 2004, 27).

4. The map is not present in all versions of the film. I am describing here a Spanish version in Castilian (EPOCA Cine Clásico). The map was cut from both the English and the French versions of the film in 1936–37, as a result of protests from Upper Savoy in France, included in the map as another European "Hurdes." See Ibarz (2004, 27).

Figure 3.2: Likening Europe to an exotic land: the map in Luis Buñuel's *Land without Bread* (*Las Hurdes*, 1933). Epoca 2007. Screenshot.

cinematographic animated map, whose first emergence he traces in docu-dramas of the 1910s. Although the map in Buñuel's film is not literally animated, animation is suggested by a series of dissolves that mobilize the image and change the view from the broad continental perspective to a national and then a local one, evocative at once of a journey and a zoom-in. The connection between the "cinemap" and the depiction of faraway lands is evident in its early occurrences, for instance, the map created for the docudrama *Among the Cannibal Isles of the South Pacific* (Martin E. Johnson, 1918). As Caquard has argued, this map has two functions, a narrative one, because it increases the dramatic tension and provides narrative transitions, and an authenticating one, because "it reinforces the veracity of documen-tary discourse by grounding it in existing places and establishing what Conley [. . .] calls 'a fallacious authenticity of a place'" (47). In addition to authenticating the documentary on Las Hurdes, *Land without Bread*'s map has the estranging and subversive effect of likening Europe to an exotic land. The map also alludes to, and mocks, the alignment of early-twentieth-century cinema with imperialist discourses in its blending of "real geo-graphical places with fictional perspectives developed for and by a Western audience" (47).

The episode of the map introduces from the start of the film the two sets of rhetorical tropes that, according to James Duncan and as previously

discussed, are key to the racialized representation of places. If the map (fallaciously) promises an accurate and objective representation, the voiceover (cowritten by Buñuel and recited, in the version of the film I am here discussing, by Francisco Rabal) presents the racialized Other as the past of Europe. As the voice claims, indeed, "In some European locations, there exist enclaves of quasi-Palaeolithic civilization." What is subversive about this representation is that it undermines Europe's view of itself as the highly civilized, developed, modern continent that defines itself as opposed to a retrograde, prehistoric, exotic, faraway Other. As Mercè Ibarz (2004) has written, Buñuel did not "set out on a search for the Other/Different, as did the makers of travelogues or documentaries in the style of *Nanook* (1922). Buñuel went in search of the Other/Same" (31).

The captions and map are typical liminal elements that prepare and accompany the act of "entering" the film, but our meeting with Las Hurdes is further delayed by another liminal episode, set in La Alberca, a pueblo in the province of Salamanca, defined by the voice as an ancient village of almost medieval character. La Alberca in Buñuel's film is ideally placed midway between civilization (as the voice already established, we are only one hundred kilometers from Salamanca, "home of high culture") and the "quasi-Palaeolithic" Las Hurdes. If, on the one hand, the voice highlights the features of the local architecture and the visible markers of the villagers' Catholic faith, on the other hand, a "strange and barbaric" annual festival takes place in the main square, during which all the men who recently married must detach with their bare hands the head of a cock suspended over their heads while riding on horseback.[5] The voice points at the patent sexual subtexts of the ritual, but absurdly and ironically states that "we will not analyze them now." Commenting on the Catholic pendants decorating a baby's garments, then, the voice notes that they are reminiscent of the "amulets of savage peoples of Africa or Oceania."

Ready by now for our encounter with an exotic, barbaric, primitive, racialized Other, we are finally offered the first view of Las Hurdes: a sweeping panoramic shot taken from the top of the mountains that constitute the region (Figure 3.3). The expedition must first negotiate a "paradisiac valley" of lush vegetation, characterized by the ruins of a convent within a landscape of "savage beauty." At only five kilometers of distance, however, the landscape changes drastically, and we finally find ourselves in the barren, mountainous Las Hurdes (Figure 3.4).

The mountainous landscape frames the whole section of the film set in Las Hurdes. The film's narrative and visual rhythm is dictated by the

5. This episode also was subjected to censorship. See Ibarz (2004).

Figure 3.3: The first view of Las Hurdes in *Land without Bread*. Epoca 2007. Screenshot.

Figure 3.4: Las Hurdes's "savage beauty." *Land without Bread*. Epoca 2007. Screenshot.

alternation of scenes set in the village and on the mountains; and the vista from the mountaintop also returns during and at the end of the episode and closes the film. Mountain ranges were among the most sublime landscapes in the eyes of the Romantics, who described them with awe and wonder (see Nicholson 1997). Edmund Burke (1987) associated the feeling of the sublime elicited by mountains with the fears of death, dismemberment, terror, and darkness. Buñuel's film evokes all these feelings and openly describes and, indeed, shows death, sickness, infection, starvation, and idiocy, while also foreclosing sublimity through the deployment of the paradox, grotesque, and irony. The "monarch-of-all-I-survey" panoramic view typical of the discovery scene that characterizes so many written and filmic ethnographic travelogues is here an ambiguous trope, because although it certainly evokes the sublime vista held by the European, civilized traveler "conquering" an impressive, exotic landscape, it immediately replaces that vision with a stark view of a harsh, hostile, miserable environment inhabited by primitive, illiterate, barbaric Europeans. The mountain rage is also itself racialized, so to speak, by its description as a labyrinth and a maze—recurrent metaphors of the Orientalist gaze as well as of the Romantic sublime.[6] Ultimately, the landscape of Las Hurdes, although it is presented through the tropes of the Western discovery and conquest of an exotic panorama, subverts expectations because it disrupts Europeans' view of themselves as civilized and progressive and turns them into ethnographic subjects. This subversion is deeply surrealist—the film presents no romantic view of the Other as a more authentic or alternative culture; the depiction is provocatively absurd, violent, and ruthless, and the attention of the ethnographer/traveler/expert/filmmaker is on Western constructs and on regimenting institutions such as the Catholic Church, the school, imperialism, and capitalism, with its relentless exploitation of workers and the poor (the Hurdanos are presented as owing nothing, bar the surreally inhospitable land they inhabit, while their children are taught in school to "respect private property"). The unease with which the film has been received is also a consequence of its in-betweenness: Land without Bread is at once ethnography and surrealism. It is precisely its generic interstitiality that makes it so powerful; as Alberto Farassino (2000) has written: "any generic definition that attempts to bring it back within the realm of a descriptive or critical cinema will fail to remove Las Hurdes's strength as great tragic vision, as terrifying macabre painting, at once baroque and surreal" (136).

6. On the metaphor of the labyrinthine city see, for instance, Raymond (1994); on the Romantic image of labyrinthine mountains, see Colley (2010).

Released thirty-eight years after *Land without Bread*, in a completely different sociocultural context, Werner Herzog's *Fata Morgana* is also a text that, with its "shimmering opacity" (Vogel 2013, 44), is impervious to classification and that, similar to *Land without Bread*, gestures toward ethnography while placing itself in a radical generic in-betweenness.

Fata Morgana was shot in 1968–1969 over a thirteen-month period in Africa—in Kenya, Tanzania, Uganda; the Sahara desert, from Algeria to Niger; Central Africa (Ivory Coast, Mali, and Cameroon); and the Canary Islands. The film opens with a plane landing on an invisible runway immersed in fields and greenery. The potential of the sequence to be read as a traditional ethnographic "arrival scene" is, however, quickly dispelled; after an allusive title announcing the first "chapter" of the film—"I. The Creation"— another landing is shown, and then another, and another, for a total of eight landings. Although Herzog explained this choice as a way of testing the spectator's patience and thus selecting a germane audience (quoted in Cronin 2002, 48), the film's opening invites a traditional ethnographic reading that is immediately subverted. The sequence arguably places emphasis on technology, on the contrast between machine and nature, and on the gesture of landing in a foreign country seen at once as an act of conquest and of "creation"—in line with the imperialist trope of the virgin land coyly awaiting the fecundating touch of the colonizer (Shohat and Stam 2013, 141). In the film's first section, the voice of the German film historian Lotte Eisner reads passages from the sacred book of the Quiché Indians of Guatemala, *Popul Vuh*, about the first creation, after the failure of which the gods decided to wipe away the human race and start again. In the two subsequent sections, respectively titled "Paradise" and "The Golden Age," a male voice reads what sound like "increasingly absurd parodies" of *Popul Vuh* (Cleere 1980, 16). Western music from various epochs and styles (Handel, Couperin, Mozart, Blind Faith, and Leonard Cohen) is played throughout the film, creating the effect of dissociation between visuals and soundtrack typical of Herzog's cinema.

The music/image dissociation is but one of the gaps that are artfully created by the film to offset and subvert the discourse of primitivism hinted at by the visuals and, especially, by the sweeping panoramic and traveling shots of the desert, sand dunes, oases, villages, and animals, as well as by the archaic, mythological text on the creation of earth and of the human race read by the voiceovers. Other interstices become evident between the visuals and the written text, in particular in "Paradise" and "The Golden Age." Paradox and surrealism are invoked by the contrast between what we see and what we hear; for instance, the voice speaks in celebratory tones of the gods giving life to animals, while we are shown at close range some decaying carcasses—a choice reminiscent of *Land without Bread*'s cruel image of

a dead donkey covered in bees or the famous and much debated sequence of the goat that "throws itself" off the rocks in Buñuel's film (although it was evidently shot by the crew, as a puff of smoke at one side of the frame testifies).

The view of the landscape proposed by the film is equally paradoxical and surreal; while the voiceover describes in detail an uncontaminated, primeval, empty space, the camera shows us the incongruous remnants of an industrial era scattered in the desert—rotting machines, airplanes carcasses, burning oil wells, pipes, barrels, shacks; the statement, twice repeated at the start of the "Paradise" chapter, "There is landscape even without deeper meaning," hints at the surreal subtraction of sense from the image of an exotic environment that is at once framed as a typical ethnolandscape and as incoherent absurdity (Figure 3.5). The absurd introduces irony as discrepancy and gap; as Jonathan Smith (2013) has remarked in an essay on representations of landscapes: "In the landscape subversion is triggered by the fleck of irony that can make farce of any represented pretension. Irony is a representational discrepancy, a symbol out of place. Irony betrays the existence of representation in the purportedly presentational, and opens social convention to exploration and critique" (86).

Figure 3.5: A primeval landscape incongruously littered with postindustrial remnants. Werner Herzog's *Fata Morgana* (1971). Anchor Bay 2005. Screenshot.

Although in the 1970s new ethnography and ethnoscience strived to avoid portraying "abstract, ahistorical 'others'" (Clifford 1988, 23), Herzog (like Buñuel) represents an (apparently) historicized other, whose history, however, is evidently fabricated, displaced (*Popul Vuh* being Guatemalan), and incoherently primitive—resulting in a satirical critique of ethnographic and anthropological modes of representation. This critique also materializes through the display, in "Paradise" and "The Golden Age," of an anthropological eye that gazes at the Westerners met by the crew in the desert, many, if not all, of whom appear to be German, who are framed as exotic oddities—among them, a man who purports to be in the desert to study lizards; one who reads a letter received many years before from Germany, asking him how he is coping with the heat and whether he will ever go back; and a man who performs a trick with a small ball. The Westerners are as exposed as the locals to the fixed gaze of the camera, which submits them to uncomfortably long shots; they end up staring into the lens, absurdly performing for it, offering themselves as an ethnographic spectacle of sorts. Herzog's parodic attitude in filming humans as specimens grows as the film progresses and becomes paroxysmal in the last chapter, in which scenes of increasing Beckettian absurdity include those of a man and woman playing together on a gaily decorated but modest podium (and introduced as follows by the voiceover: "In the Golden Age man and wife live in harmony [. . .] Now, for example, they appear before the lens of the camera"); of a group of people performing or playing among sand dunes, from and into which they repeatedly appear and disappear; and of a man reading an excerpt of *Popul Vuh* parody in the presence of a man who laughs out loud while strumming a small guitar; meanwhile, a third man films them with his camera.

Once again with reference to the rhetorical tropes for the representation of "other" places identified by James Duncan, the obliteration of geographical and historical specificity in *Fata Morgana*, coupled with the mythical framework making reference to creation, paradise, and the golden age, evoke the typical discourse of the representation of the ethnolandscape and indigenous populations as the past of Europe. In contrast, *Fata Morgana*'s essayistic critique is articulated in the interstices of genre; in particular, the film locates itself between ethnographic travelogue and science fiction.[7] It must be noted that Herzog went to Africa precisely with the intention of making a science fiction film and only changed his mind on location, as he explained in interviews:

7. *Fata Morgana*'s science fiction element is not unique in Herzog's filmography: it also shapes his later *Lektionen in Finsternis* (*Lessons of Darkness*, 1992) and *The Wild Blue Yonder* (2005).

My plan was to go out to the southern Sahara to shoot a kind of science-fiction story about aliens from the planet Andromeda, a star outside our own galaxy, who arrive on a very strange planet. It is not Earth, rather some newly discovered place where the people live waiting for some imminent catastrophe, that of a collision with the sun in exactly sixteen years [...] But from the first day of shooting I decided to scrap this idea. (quoted in Cronin 2002, 47)

As Herzog points out in the same interview, however, *Fata Morgana* retains much of the original plan:

I liked the desolation and the remains of civilization that were out there, things that added to the science-fiction idea. We would find machinery lying in the middle of the desert—a cement mixer or something like that—a thousand miles from the nearest settlement or town. You stand in front of these things and are in absolute awe. Was it ancient astronauts who put these things down here? (quoted in Cronin 2002, 50)

The science fiction discourse introduces yet another temporal layer on top of those of the mythical, primeval past and of the synchronic present of Africa; this is a time that is at once past (the "ancient astronauts" of Herzog's quote) and hyperbolically future, as if *Fata Morgana*'s desert were located both before and after civilization—simultaneously a primeval land and an apocalyptic, postindustrial landscape, which Herzog would easily call "embarrassed" or "offended" (Cronin 2002, 49).

The same strategy of the opening sequence at once evoking and neutralizing the potential discovery of an exotic landscape characterizes the whole film. The camera is often placed on the roof of a van traveling for long stretches of time. These tracking shots create endless horizontality but also lack of meaning: the trip has no beginning, no destination, and no end. Although the camera pauses several times to look at people, animal remains rotting under the sun, relics of machines, or mirages, these encounters are bizarre and meaningless and do not find an explanation in the voiceover narration, which, in fact, if anything, subverts their meaning. Ultimately, no improved knowledge, no superior ethnographic understanding of the desert, is achieved. The same impression of lack of meaning and disorientation is conveyed by a number of aerial shots, which could potentially provide Mary Pratt's "monarch-of-all-I-survey scene"—the vista from a vantage point much exploited by colonial travel literature and film. Far from conveying the domination of the landscape, however, these aerial views do not shed any light on the configuration of the territory; at the opposite, they confound us, by showing a land of indistinguishable features—desert, sea, or ice; it is hard to know what we are looking at (Figure 3.6). The landscape is not transformed into a pleasing aesthetic artifact shaped by *perspectiva*

Figure 3.6: Subversion of the survey scene: unreadable landscape. *Fata Morgana*. Anchor Bay 2005. Screenshot.

artificialis and dominated by a human eye—it is an unattractive, meaningless, indistinguishable land, where our eye gets lost, and it could well be the setting of a postapocalyptic science fiction film.

SLOW ACTION: FILMIC RUINS

The relevance of the essay is that of anachronism. (Adorno 1984, 166)

Playing concepts of ethnolandscape against ideas of landscape irony, similar to *Land without Bread* and *Fata Morgana*, Ben Rivers's *Slow Action* has something in common with both films while developing a distinct argument that I will read under the sign of the ruin. The concept of ruination is, in fact, already present in both Buñuel and Herzog. Before arriving at Las Hurdes, the travelers in *Land without Bread* encounter the ruin of a convent, which is described by the voiceover in sublime terms, as an element of a landscape of "savage beauty"—this reference is, arguably, part of the film's strategy to evoke the tropes of the (imperial/Romantic) ethnolandscape, only to then empty them of meaning. *Fata Morgana* also engages with concepts of ruins and the sublime and, in fact, as suggested by Eric

Ames (2009), it "replays cinematically the Romantic fascination with ruins, as the camera lingers on traces of industrial detritus (abandoned factories, oil drums, plane wrecks, and so on), which are strewn about the land" (59). Herzog's ruins are at once postindustrial and science-fictional. While also being strewn with postindustrial and postapocalyptic ruins and detritus, some of which is decidedly sublime (especially in the "Kanzennashima" chapter), *Slow Action* is itself a filmic ruin, and this, I argue, is its most decisive contribution to the history of essayistic critiques of mainstream ethnography considered in this chapter.

Commissioned by Animate and Picture This, in association with Matt's Gallery, exhibited alternatively as a synchronous multiscreen installation piece and a sequential film, *Slow Action* overtly pays homage to *Fata Morgana*, and in interviews its author has also discussed its artistic debt to *Land without Bread* (Morgan 2015). Chris Marker's fictional ethnographies are of relevance too, as is an affinity with some of Peter Greenaway's early experimental films, especially his absurdist "encyclopedic" works *Vertical Features Remake, A Walk through H* and *the Falls. Slow Action* is divided into four chapters, each devoted to an island, which is geographically placed and described by two dispassionate narrators, a man and a woman—respectively played by the voice actor John Wynne and the film critic Ilona Halberstadt.[8] The text, written by the novelist Mark von Schlegell, constructs the islands as science-fictional, postapocalyptic, utopian worlds. As River has explained, the film

> was intended to play with memories of ethnographic filmmaking, observing human beings for records, and turn this on its head sometimes, so that the voices do occasionally become questionable, and even at the very end, first person. I wanted to give the impression that this was part of a much larger work, or "Great Encyclopedia"—that these are accounts from another fading race of humans, whose Utopia is a collection of other Utopias, and their accounts are trying to be as neutral as possible, but there are mistakes and slippages. (Morgan 2015)

Of the four chapters, "Eleven" was shot on the volcanic island of Lanzarote; "Hiva (The Society Islands)" on Tuvalu, a tiny Polynesian island nation; "Kanzennashima" on Gunkanjima, a Japanese artificial mining island; and "Somerset," ironically, in the county of the same name in southwest England.

8. As Ben Rivers has explained, "I wanted the two voices to sound, one a North American voice that could be heard on a *National Geographic* film from the 1950s, and an Eastern European sounding accent that sounded like Lotte Eisner narrating *Fata Morgana*" (quoted in Morgan 2015).

Slow Action's approach to the filmed landscape retrospectively throws into relief a key element of Buñuel's and Herzog's films, both of which show nature as an authentic profilmic presence and thus as objective materiality, one that is, however, simultaneously subjected to a framing saturated with the markers of specific practices and ideological discourses. The authenticity of landscape is profoundly in contrast to the ironic gap carved by the film's generic positioning in an interstice between ethnography and surrealism/science fiction. Buñuel and Herzog, thus, foreground discourses of photographic and scientific authenticity, and of presence and expertise, only to expose their constructedness, their production by an apparatus that their films are careful to foreground. *Land without Bread* does so, for instance, via a voiceover that explicitly refers to the filming crew; in *Fata Morgana*, the presence of the camera is highlighted by the gazes of the social actors looking into the lens and performing for it.[9] This strategy of exploiting the perfect realism of the photographic reproduction to expose its production by a specific apparatus and by precise ideological framing discourses is common to other films too—for instance, the already quoted *Letter from Siberia* by Chris Marker, with its famous sequence of workers repairing a road, repeated three times but with different soundtracks, suggesting three completely different ideological readings—a shot at the myth of the objectivity and transparency of filmed ethnography. Another relevant case in point is Lothar Baumgarten's *Der Ursprung der Nacht (Amazonas-Kosmos)* (*The Origin of the Night: Cosmos of the Amazon*, 1973–1977), which deploys a creation narrative by the Brazilian Tupi people, as well as the names of native tribes, animals, and vegetation, to evoke a rainforest setting, whereas the end of the film reveals that the perfectly mimetic images were in fact shot in the Rhein-Wälder forests near the artist's home in Düsseldorf, Germany (not too different from *Slow Action*'s "Somerset island").

Slow Action, in contrast, reveals its strategy from the start. The image never attempts a mimetic representation of reality. After a silent sequence made up of grainy close-ups of human faces from newspapers and books, suggesting a posthuman, posthistory situation, the film alternates black and white and color, even within the same sequence; the texture of the image is always in evidence and ever changing; and traces and marks that appear to be caused by the passage of time and the work of the elements are inscribed on the surface of the film, as are the flashes that suddenly turn

9. As well as by specific references, such as the statement that the man and wife of the Golden Age now "appear before the lens of the camera"; or the scene in which a man films his two friends toward the end of the film.

the image to red, blue, or white. Filmed in 16mm, in anamorphic ratio, the different textures and marks were obtained through hand processing of the film, "apart from the flashes and white-outs which are made by opening the camera back in between shots, or they are roll beginnings/ends" (quoted in Sicinski 2010, 22).

These effects contribute to carve a temporal distance between the time of viewing and the perceived time of filming, which further short-circuits with the spectator's understanding of the chronology of the story being told. On the one hand, the islands appear to be in our future rather than in our past, as suggested by the postapocalyptic atmosphere and by the science fiction elements of the story, such as holograms appearing in the sky, futuristic objects, and descriptions of alien-looking animals and people. On the other hand, the ethnographic gaze on landscapes and human beings evokes the traditional trope of primitivism, thus inscribing a past, even archaic temporality into the film (Figure 3.7). The confusion is compounded by the multiplicity of points of view: from what historical moment and geographical position do the narrators speak? When is their narration located with respect to the histories of the islands and to the record made by the mysterious curator of the Great Encyclopedia that is the source of all the information? And when and why was the footage shot, and how did it reach the narrators?

In an interview, Rivers has given an answer of sorts to the latter question: "I like to think of the films as ones that could be discovered in a dustbin in 200 years, as the last few survivors run a projector by dynamo to find out just where everything went wrong" (quoted in Sicinski 2010, 22). It is the idea of the found footage that is important to highlight here; and in fact the whole *Slow Action* gestures toward the *objet trouvé* and deploys its logic. The islands are found objects; the Great Encyclopedia is a found object; the footage also is—the sense of fragment, of incompleteness of the

Figure 3.7: Primitivism and archaic temporality in Ben Rivers's *Slow Action* (2011). Lux 2011. Screenshot.

Figure 3.8: Ruinous cinema: the "Kanzennashima" episode. *Slow Action*. Lux 2011. Screenshot.

record, conveyed by the film as a whole highlights just that.[10] The masks worn by the islanders in "Somerset" are also made with found objects. The film's soundtrack is equally recycled, reused:

> All the music used in *Slow Action* is taken from existing films, mainly sci-fi films from the 1970s. In "Eleven" it comes mainly from *Phase IV* by Saul Bass, which has similar otherworldly landscapes to "Eleven," and some bits of Penderecki used in *Je T'Aime Je T'Aime* by Alain Resnais. I usually record location sounds myself but this time I was very clear about only using sounds from other films: not just music but, for example, the jungle sounds in "Somerset" come from *La Vallée* by Barbet Schroeder, and the radio sounds in "Hiva" come from *The Seed of Man* by Marco Ferreri. (quoted in Morgan 2015)[11]

The aesthetic of the found object is a ruinous one; as Catherine Russell (1999) has argued, "[f]ound-footage filmmaking, otherwise known as collage, montage, or archival film practice, is an aesthetic of ruins. Its intertextuality is always also an allegory of history, a montage of memory traces, by which the filmmaker engages with the past through recall, retrieval, and recycling" (238). Although it is not an actual found-footage film, *Slow Action*'s collagist and recycling attitude, coupled with the postapocalyptic elements of its narrative and visuals, suggests a crucially contemporary context of environmental decay and ruination, of unsustainable economies and lifestyles (Figure 3.8). In addition, the original context of the film's production and exhibition places it within the phenomenon of the reentry of 16mm film in the art gallery that has taken place since the 1990s and that Erika Balsom (2009) has proposed to read as a shift to the exploration of history and the obsolescent: "Within the pristine and sanctified spaces of

10. The idea is, arguably, even stronger in the exhibition of the film as a four-screen art-gallery installation.

11. Furthermore, the music in "Kanzennashima" comes from Carl Theodor Dreyer's *Vampyr*.

art, 16mm film is employed as a precious remnant of a cinema in ruins, with the film print elevated to the status of a collectible objet d'art" (Balsom 2009, 414).

Unlike *Land without Bread* and *Fata Morgana*, *Slow Action's* "ruinous" collagist stance, in conjunction with the decomposing quality of the image and sound, excludes from the start the potential for a mimetic presentation of landscape, which is now entirely beyond reach, as utopian as the islands themselves—while also clarifying that the filmic ethnolandscape was always already technologically mediated. *Slow Action* is not nostalgic of economic and filmic imperialism (although it is nostalgic of 1970s science fiction); its landscapes are as ironic as those in Buñuel's and Herzog's films. The speck of irony is to be found, once again, in the gap between written text and image (especially wide here because the commentary was written by Mark von Schlegell independent of the filming and only matched to the visuals in postproduction); in the impossible realities of science fiction; in the surreal presence on the islands, on Hiva especially, of the waste of the developed world. But where *Slow Action* excels is in showing that we live today in a ruinous ecology not only of environment and culture, but also of film itself. In our postcelluloid era of perfect, unpolluted, nonindexical images, *Slow Action* is slow cinema—a layered, textured, blemished, collaged cinema that demonstrates how film's detritus, accumulated over the past century, preserves the traces of all the utopias of our culture—utopia of ethnolandscape included. As the voiceover recites during the "Kanzennashima" episode, "utopia cannot be in the future, nor can it be known in the present; utopia is the past—not the past as a golden age, but the past as ruins of its own ruins."

SUMMARY

Transgression of form has been repeatedly recognized as a distinguishing feature of the essay, be it literary or other. I argue that such transgression is an in-betweenness that becomes a vantage point from which to comment on cultural objects that include form itself. As a critical discourse on genre, then, the essay film places itself in generic interstices.

Land without Bread, *Fata Morgana*, and *Slow Action*, the three case studies of this chapter, are positioned not only between radically incompatible geographies and temporalities, but also between incommensurable generic conventions—between science fiction and ethnography, between documentary and fiction, between art film and popular entertainment traditions, between experimental cinema and parody. In so doing, they produce depictions that exploit the irony gap to reveal the constructedness

of genre and of its ideological underpinnings. In particular, by attracting attention to cultural and perceptual framings, they highlight discourses of medium transparency, tropes of authenticity, primitivism, and conflicting temporalities and critique the articulation of specific, historicized visual regimes. While doing so, they also reflect on the filmic medium itself, on its participation in the cultural and technological mediation of place and in the shaping of an ideology of the gaze, and, as of today, on its own revealing anachronism.

CHAPTER 4

Temporality

The Palimpsestic Road and Diachronic Thinking

History is the subject of a structure whose site is not homogeneous, empty time, but time filled by the presence of the now. (Benjamin 1968, 261)

OPENING: SOMETIME

Chapter 3 engaged with the gap produced by films that position themselves between not only incommensurable genres, but also incompatible geographies and temporalities. Further developing the theme of the essay film's reflection on history and geopolitics, the current chapter will focus on temporal in-betweenness, on the stratification of time, and on temporal interstitiality in the essay film. The analysis will pay attention in particular to the spatialization of temporality and thus to time seen "as one of the various distributive operations that are possible for the elements that are spread out in space" (Foucault 1986, 23). This choice of emphasis is in line with the book's argument on interstitiality as a spatial strategy of in-betweenness, exploited by the essay film to create nonverbal forms of signification.

The German photographer Wolfgang Hildebrand's work on visualizing concepts of time offers a useful introduction to the issues I aim to conceptualize here. In particular, his projects *Moment* and *Sometime* cause cognitive puzzlement in the viewer by joining together different instants within the same image.[1] *Moment* comprises photos of urban landscapes

1. Wolfgang Hildebrand's projects can be viewed on the artist's website: wolfgang-hildebrand.com/sometime/.

from around the world that combine different hours of the day, merging them seamlessly—so that we look at a place that, mysteriously, seems to exist at once in daylight and at nighttime. *Sometime* similarly presents images of places taken at different moments in time; however, in this case the moments are visibly spliced together and coexist side by side—the photos are indeed composed of superimposed "slices" of the same site, which take place at different times. The images are of public places populated by people who have all been on site, but not at once. The different instants are visualized as overlapping, so that the photographs can be said to be palimpsestic, because they bear the traces of visual inscriptions from subsequent moments. If the photographs of *Moment* convey the strange effect of an impossible temporality, in those of *Sometime* time is strongly spatialized, thus becoming a function of space; the "slices" in the image reveal temporal gaps, openings onto a plurality of moments that coexist in a paradoxical state of simultaneity. It is the latter project that interests me here. These pictures are at once present and past; and if this is ultimately the nature of all photographs—because photographs always are in the present time, in the moment of their taking place, a moment that is also, however, always already past—*Sometime* calls attention to the paradox and multiplies it by creating gaps in the picture. In the street, in the public square, on the footpath temporal gateways are opened, and the accumulated instances of all the uses of the place become visible. It is not so much the flow of time that is captured by *Sometime*, but its stratification. And it is in the slices and the interstices created by the cuts that the thinking about both the distinctness and the coexistence of present and past literally takes place. These photographs thus capture, in a strikingly condensed and expressive manner, some of what I wish to explore through my filmic case studies.

The photographs in Hildebrand's *Sometime* project are mostly images of streets and squares and of people walking through them; they give visibility to the temporal stratification created by the repeated uses that people, mostly on the move, make of spaces of transit. Similarly, the space that will be examined in this chapter is the road. In the filmic case studies that will be analyzed, the road is construed as a temporal palimpsest, in the gaps of which a diachronic form of thinking develops. The road is an emblematic space, not least because it compels us to think of those who have walked it before us. As such, roads are diffuse places of memory. I hesitate to use Pierre Nora's (2001–2010) expression *lieu de mémoire* because, unlike monuments or archives, roads were not purposefully fabricated to help us recall the past. Although equally open to wind and rain, the road is anything but monumental, yet it is a site where we often experience our proximity with cultures and peoples, of yesterday as well as of today. The essay films

I will discuss here through temporal interstices reveal the road as beaten track, as layered palimpsest of social, political, and cultural histories.

Temporality was a prominent theme of all previous chapters in this book and is, indeed, a strong feature of the book as a whole—not just because all of the films studied herein reflect on the temporality of history and of film as a medium, but also for the adopted methodology of studying together films old and new, thus bringing issues of pastness and presentness to the fore. My discussion in this chapter will set off precisely from the effects produced by looking at two texts side by side: I will begin my reflection by discussing diptychs. With this expression I refer to films that were either conceived as pairs at the time of their making or that became such when the filmmaker, after a pause, decided to return to the same topic or place and to create a second, complementary piece. My attention will focus on the latter case—on remakes of the same film, or returns to the same site, after an interval of time. The act of doing so highlights an interstice that is definable in temporal terms; and a new argument that was not necessarily in the first text (and that might not be in the second either, if seen in isolation) develops in a temporal in-between. This also demonstrates that the essayistic resides precisely in interstices because the revision or remake of the same film after a temporal gap transforms the two films into a composite essay, which only exists as extratextual in-betweenness.

DIPTYCHS: THE ESSAY IS IN-BETWEEN

A term originally describing any artifact composed of two plates usually conjoined by hinges, the diptych has existed in many cultures, made of different materials and having distinct uses, some of which are no longer entirely transparent to us and which included writing, celebration, representation, and devotion. With regard to the cinema, the expression has been used to refer to films that were either born as pairs or became such through the addition of a companion piece. The phenomenon interests at once mainstream cinema and art and avant-garde film. Well-known recent examples from art and mainstream film include Wong Kar Wai's *Chunking Express* (*Chung Hing sam lam*, 1994) and *Fallen Angels* (*Do lok tin si*, 1995); Clint Eastwood's Second World War diptych, *Flags of Our Fathers* and *Letters from Iwo Jima* (2006); and *The Wrestler* (2008) and *Black Swan* (2010), which have been referred to as Darren Aronofsky's "performance diptych" (Fleming 2013). There also exist single-film diptychs, which are composed of two equal parts, examples of which are Apichatpong Weerasethakul's *Tropical Malady* (*Sud pralad*, 2004) and Lars von Trier's *Melancholia* (2011). These films are, in a sense, even closer to the original conception

of the diptych because the two parts coexist within a single text and are thus conjoined, forming one single object. In either case, deep internal connections, correspondences, and/or reversals exist between these films or pairs of films, which mirror each other, present different perspectives on the same topic, or are sometimes connected in more opaque, mysterious ways. Highly "intentional" diptychs can be found in the realm of avant-garde or experimental film—for instance, *A Conceptual Film Diptych*, formed by *Part One: Donna Americana* and *Part Two: Le Déjeuner* (M. A. Alford, 1989); *Autumnal Diptych* (Rock Ross, 1989); *Diptych: Dialectic* (Gregory King, 2003); and Daniel Szczechura's *Dyptyk filmowy Daniela Szczechury* (*Film Diptych by Daniel Szczechura*), composed of *Fatamorgana* (*Mirage* 1981) and *Fatamorgana 2* (*Mirage 2*, 1983). Split-screen films can also be said to create a diptych. Examples of diptych-like essays are Agnès Varda's *Les glaneurs et la glaneuse* (*The Gleaners and I*, 2000) and *Les glaneurs et la glaneuse . . . deux ans après* (*The Gleaners and I: Two Years Later*, 2002) and Peter Thompson's *Universal Diptych*, composed of *Universal Hotel* (1985) and *Universal Citizen* (1986), two films that will be discussed in Chapter 7. Also *La rabbia* by Pier Paolo Pasolini, analyzed in Chapter 5, was distributed as a diptych along with a film of the same title by Giovannino Guareschi. The term diptych has also been used, with a somewhat weaker meaning, to define films that return after a gap to the same characters and story of a previous film—thus, as a synonym of "sequel." I am specifically interested here, however, in pairs of texts that are expected to work as diptychs by their makers and that—whether in a reciprocal relationship of sequel, remake, textual coexistence, or other—are explicitly connected to each other by profound correspondences, which are activated and become evident when the two films are viewed together.

But how do diptychs work, and how do they create their dialectics? In the case of the fine arts, the "activation" of a diptych, that is to say, the actualization of its effects and meanings, can be said to take place in the space between the two plates—as argued by Ivan Gaskell (2006) in his analysis of the *Carondelet Diptych* (Netherlands, c. 1478–1532) by Jan Gossaert, composed of a left panel representing donor Jean Carondelet and a right panel with the Virgin and Child, and exhibited in the Louvre. Like other similar objects, it was made to be transported and handled (its dimensions are 42.5 × 27 cm), and it thus existed in three states: closed, opening, and open (unlike in the museum, where it is always open). As Gaskell has noted,

> The holy figures and the real man can be thought of as sharing a fictive space, but it is not a straightforward space. They are presented at an angle to one another so that although Carondelet is in adoration, hands together, he is not literally looking across at the Virgin

and Child. It is as though the space implied as continuous between the two panels had expanded and distorted as the diptych was unfolded. (330)

The "literal spatial incongruity" of the open diptych had to be addressed by the viewer in his or her mind's eye, thus compensating for the distortion: "Viewers appear to be invited to constitute the implied pictorial space so that Carondelet and the holy figures face each other and thus are not side by side as at first they would seem to be" (331). It is in an implied pictorial space, therefore, that the painted diptych is actualized, rather than in the two distinct plates. All diptychs invite a dialogical reading—including film diptychs. Their argument is not to be found in any one of the two parts but in the dialectics between them. As Eric Dean Wilson (2014) has written, "[a] dialogue emerges, something like a silent Platonic dialogue, in which ideas are presented, expounded with evidence, challenged, and left unresolved. The diptych is a wrestling" (6).

The diptych and the essay share a similar dialogic structure. As I have claimed in my analysis of the communicational commitments of the essay film, by putting forward ideas, by performing an open line of reasoning, and by raising more questions than providing answers, the essay film strives to establish a dialogue with its spectator, who is called on to engage in a process of shared thinking (Rascaroli 2009). Such strategy is brought to light by the diptych's dual structure, which sets up a dialogue that is in need of a third party to be actualized. As Eric Wilson (2014) proposes, with an interesting metaphorical reference to the third panel of painted triptychs,

> the two panels of the diptych begin an investigation that must continue in the viewer, whose mind becomes the third, middle, focal panel. The transaction is silent, but the viewer receives responsibility in the investigation. The viewer is needed. The viewer completes the diptych. The viewer of the diptych becomes maker. (6–7)

A dialogue that requires the active participation of the viewer, the film diptych becomes actualized in an in-between space, which is at once a temporal gap. Issues of time, in fact—the time of the making of the films, the time of the gap between them, and the time of their viewing—are key to the experience and to the meaning of the diptych.[2] Even a split-screen film that synchronically shows two image tracks side by side will generate a textual gap (the "incongruity" mentioned by Gaskell) that is at once spatial and temporal and that requires negotiation by the viewer. As Gilles Deleuze (2003) has written of the triptych form, "[a]n immense space-time unites

2. For an incisive discussion of temporality in the triptych form, see Sánchez (2014).

all things, *but only by introducing between them the distances of a Sahara, the centuries of an aeon*" (60; emphasis in the original).

THE WALL RELOADED

The case study that will allow me to further unfold this spatiotemporal in-betweenness is provided by a pair of films by the British-born, Berlin-based filmmaker Cynthia Beatt, *Cycling the Frame* (1988) and *The Invisible Frame* (2009), both of which follow the actor Tilda Swinton while she cycles the 160-kilometer route along the Berlin Wall, before and after its fall, respectively. *The Invisible Frame*'s relationship to the previous film, made twenty-one years earlier, as well as to the absent Wall, incorporates a significant temporal gap that is at once material, historical, and ideological. Beatt's experiment bears a resemblance to James Benning's *One Way Boogie Woogie/27 Years Later* (2005), which, filmed in Milwaukee's industrial valley and composed of sixty one-minute static shots, remakes and incorporates Benning's earlier film, *One Way Boogie Woogie* (1977), also reusing its old soundtrack. What I find particularly compelling in Beatt's diptych, however, is that the temporal gap is spatialized through the route twice covered by Swinton and that the road is thus temporally construed along the descending axis of the beaten track and of the palimpsest, of depth and of stratification.

Beatt's films may, of course, be viewed separately and independent of each other. Made for television, *Cycling the Frame* was initially a stand-alone film; when Beatt decided to revisit it two decades later, it was decided that *The Invisible Frame* would also stand on its own. As the director explained in an interview, "For me it was perfectly clear: this film is not a repeat, a remake, a sequel. It had to stand independently of the first film. Tilda expressed it eloquently: the print of a second foot, twenty years and a wall's fall later" (Beatt 2009). Although each film exists independent of the other, the two are profoundly linked, and Beatt's statement simply implies that it should be possible to watch, understand, and enjoy *The Invisible Frame* without having seen *Cycling the Frame*. Yet, when watching the two films one after the next, as a diptych, further meanings are activated that form the core of an essayistic intervention that only truly works as textual in-betweenness.

Cycling the Frame and *The Invisible Frame* map onto each other, insofar as they follow in a similar fashion the same route, starting and ending at the Brandenburg Gate, Berlin, covered by bike by the same person. Yet the two films are very different, starting from the fact that the more recent one is twice as long (sixty minutes compared with the twenty-seven minutes of the first film). The journey is the same, but the filming did not always take

place in the same locations, although some recur; the locations themselves have changed in the course of twenty years—and the second film takes advantage of the freedom to shoot in the eastern side of the city. As Beatt (2009) has clarified, "A few locations happened to be the same as in the first film, or close, because they were in the former East, on the other side of the Wall-line. Naturally I stumbled on places where I had filmed before, some of which I didn't recognize immediately." Both films are punctuated by Swinton's voiceover, but her musings are not identical—although the topics are similar and ideas of borders and partitions are at the core of the commentary in each film. Shot on digital video, *The Invisible Frame* comes across as a much more polished film, although it does maintain the fragmentary approach and the alternation of fixed camera and tracking shots that characterized *Cycling the Frame*.

The most significant difference between the two films is the Wall itself, which is still standing in the first work (made only one year before its fall) and long gone in the second. In *Cycling the Frame*, Swinton often rides right next to the Wall, other times at some distance from it, so much so that once, finding herself on a beach, she comments, "The Wall is gone, it looks like it just sank into the ground." Much of her voiceover musings are directly about it, for instance, when she wonders whether the border guards on their towers suffer from a sight illness such that, when they go home, they must look at their families through binoculars (Figure 4.1); or when she speculates what if the Wall just went on forever, or again what if the Wall just came down, as trees do. She also improvises doggerel, one about her beloved friend the bee ("I'd like to take a biggish gun and blow a hole quite through that wall and see the hole and through it run to save my little bee one day") and one about the "uppity wall" ("it would be funny if you would fall"). Elsewhere, the thinking is more reflexive, as when she wonders about the many people who feel the need to leave a written statement on the Wall or on the pavement near it, or again about the fact that West Berliners seem to studiously ignore the Wall and the paradoxical imbalance between its Western invisibility and the extraordinary attention paid to it in the East by the men in the watchtowers.

In *The Invisible Frame*, Swinton's stream of consciousness begins with a question that acknowledges the existence of the first film and that places emphasis on the narrator's personal experience: "What have I learnt in twenty-one years?" Swinton nods at the difficulty of making a film about something missing when she reassures herself by saying, "All I have to do is stay on this bike and keep my eyes and ears open and keep my mind as free as I can." The purpose of the second tour appears to consist in finding out "what the Wall was like from the other side"; however, the mood is not celebratory, and the narrator quickly reminds us that "they are building another

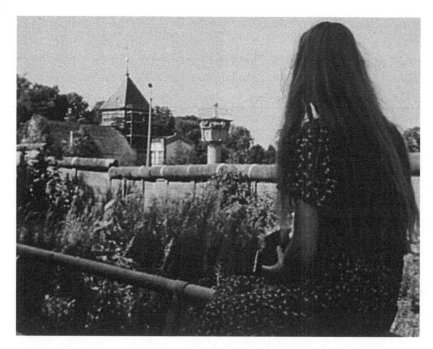

Figure 4.1: Looking at the watchtowers. *Cycling the Frame* (Cynthia Beatt, 1988). Filmgalerie 451 2009. Screenshot.

wall somewhere else right now." In fact, she eventually notices the fences and barriers, of smaller entity and significance, yet equally based on the principle of segregation, which are erected where the Wall once stood. The film, as the final caption explains, is dedicated to the people of Palestine and thus to all those who continue to suffer from enforced separation and containment today. Also, the narrator realizes that twenty years earlier, "the Wall felt much more invisible than it is now"; what has become especially evident with its disappearance is its sheer brutality, "because one can see that what it divided was just space, just land, just trees, just family, just community, just nation." The Berlin Wall, furthermore, continues to be relevant. Realizing that she does not always know whether she is standing on the eastern or western sides of the former Wall prompts Swinton to ask, "Does it matter?" Her answer to herself is that it does, because knowing it implies a whole history, a point of view, a perspective, that continue to shape what we are today.

The voiceover in the second film, as in the first, is not limited to rational thinking; it is a true stream of consciousness that includes private references, "to-do" lists, puns, hummed songs, poetry, and literary citations (from Robert Louis Stevenson, W. B. Yeats, and Anna Akhmatova). Although there is more spoken text in *The Invisible Frame* than in *Cycling the Frame*, where Swinton was overall more silent, the soundtracks of both films are

comparable and were in fact both signed by Simon Fisher Turner—who also collaborated with Derek Jarman on films like *Caravaggio* (1986), *The Last of England* (1987), *The Garden* (1990), *Edward II* (1991), and *Blue* (1993). The soundscapes of both of Beatt's films are allusive, layered, experimental, and, on occasion, deeply enigmatic. Music and original sounds merge in ways that are never predictable and that emphasize the mental "I-space" in which the film plunges us. This is even truer of the first film, in which sounds and noises are more complex and prominent—one example is a sound of feet walking on broken glass, which has no direct connection with the image track, showing Swinton cycling by an industrial area.

Taken individually, the two films have more than something in common with Situationist *dérive*, described by Guy Debord (2006) as a "technique of rapid passage through varied ambiences" (62), an operation that aims to produce a psychogeographical drift guided by the attractions of the area itself and by occasional encounters. The *dérive* in Beatt's films results in first-person musings from the point of view of an aware, reflective narrator/tourist/drifter focusing on the physical, psychological, everyday impact of the Berlin Wall before and after its fall, on issues of political and ideological segregation, on the artificiality of borders, on freedom, on control, and on censorship. As a diptych, however, the films broaden the reflection and together deliver an essayistic argument that develops between the two texts. It is to this intratextual essay that I will now turn my attention.

First, by being a pair, with the second film being a remake—or a reshuffle, rerun, reload—of the first, *Cycling the Frame* and *The Invisible Frame* attract attention to a series of dualities that are brought into being by their contraposition, including past and present, before and after, presence and absence, memory and oblivion. An essayistic discourse on these topics powerfully emerges when viewing *The Invisible Frame* straight after *Cycling the Frame*; the twenty-year gap produces a cognitive shock that emphasizes the visible evidence of the passing of time—of material things, practices, ideologies, histories, human lives. This discourse is particularly effective in, and true of, the scenes shot in the same locations in both films; some of these were purposefully remade for *The Invisible Frame*. In them, we are given to see how life has returned to areas once transected by the Wall, in the shape of either vegetation or built environment that "grew" to fill the once empty, dead space.[3] The opening and closing sequences of the two films are a case in point. In the

3. Another essay film that highlights a temporal lag by showing the "filling" of the dead space between the two Berlin walls, this time through the superimposition in postproduction of images filmed in the same places but at different times, is Hito Steyerl's *The Empty Centre* (1998). Steyerl's film not only follows the process of reconstruction of Potsdamer Platz since the fall of the Wall, but also investigates ideas of exclusion and segregation of both immigrants and minorities, seen as the necessary counterpoint in the construction of a powerful national "center."

opening scenes of each film, Swinton approaches by bike the Brandenburg Gate and then swings left (Figure 4.2). However, the appearance of the monument, and of the street that leads to it, changes dramatically in the second film—partly because of the many cars that are now parked all along the route, an overcrowding that is typical of contemporary European cities and that clearly marks the temporal gap, most significantly because the Wall is no longer there (Figure 4.3). Tourists are now standing all around the monument, and Swinton is able to ride her bike almost right up to it before turning clockwise. The closing sequences of the two films see Swinton arriving back at Brandenburg Gate, at the end of her circular route. In the first, she rides along the Wall and then, holding her bike, she turns to look at the Gate. In the later film, however, now unimpeded by the Wall, she rides right through the Gate, walks past it pushing her bike, and then stops and turns, this time facing the Gate from its eastern side. In both scenes, Swinton muses in voiceover. In the first she wonders, as she cycles and then stops to observe the monument, "What am I going to do? I am all right; I'm absolutely fine. I am really ok. Everything will come out in the wash. Everything will be as it should be, and that is it. *Finito*. Closed." In the second she exclaims, while walking away from the monument and looking at the Eastern side of the city (turning toward the Gate only when uttering the last item of her list): "Open doors, open eyes,

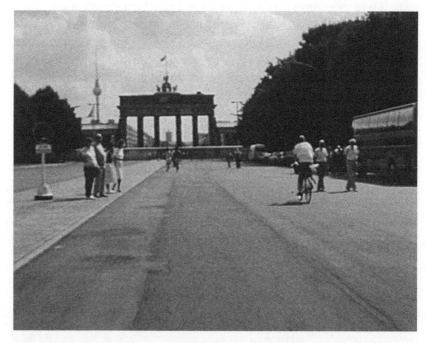

Figure 4.2: Approaching the Brandenburg Gate in *Cycling the Frame*. Filmgalerie 451 2009. Screenshot.

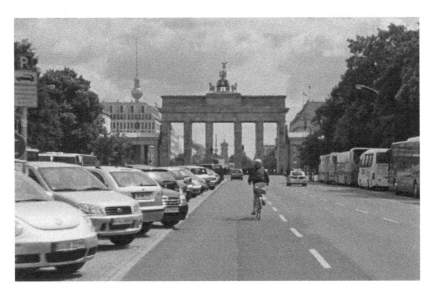

Figure 4.3: Approaching the Brandenburg Gate in *The Invisible Frame* (Cynthia Beatt, 2009). Filmgalerie 451 2009. Screenshot.

open ears, open air, open country, open season, open fields, open hearts, open minds, open locks, open borders, open future, open sky, open arms, open sesame!" The two final shots are almost identical, framing Swinton from behind, while she stands by her bike and looks toward the Gate, but from its two opposite sides—in the first, the Wall dissects the frame, partially blocking the view; in the second, as the "open sesame!" formula suggests, the Wall is gone, almost magically. The effect is stronger when the films are watched in close succession; the absence of the Wall would certainly not be as powerful and affecting if viewing *The Invisible Frame* in isolation.

The films could equally be viewed in reverse chronological order—the more recent film first, then the earlier one; and it is indeed in this way that Cynthia Beatt asked the 2014 Berlin Art Film Festival to screen her films. According to the festival's website, this order of screening emphasizes the idea of a travel back in time and "is a very enlightening way of dwelling on how the past might influence the present, or might be forgotten instead" ("*The Invisible Frame/Cycling the Frame*" 2014). In particular, what is resurrected is "the potential feeling of immediate danger," which in *The Invisible Frame* is such a distant memory that Swinton muses in voiceover,

All these odds and ends, these bits of walls, watchtowers, binoculars, uniforms and photographs, they are like the archaeological remains of some long, long, long dead civilization, sort of pre-1300, maybe Byzantine. So far, so prehistoric, that there is no way of really understanding how it worked.

The temporal gap that makes it impossible to understand the former "civilization" can be bridged by watching *Cycling the Frame*, a viewing that becomes an investigation into something that is by now so obsolete as to be unfathomable.

Although viewing the two films in chronological or reverse order will generate two rather different sets of ideas and effects, the 2009 Filmgalerie 451 DVD edition of *The Invisible Frame* contains among its extras a "Parallel Scenes" feature, subtitled "A Leaf [*sic*] in Time 1988–2009," which shows simultaneously, paired and synchronized, the few scenes from the two films that were shot in the same locations (Figure 4.4). Two screens are positioned side by side, actualizing the operation that the spectator is normally invited to perform mentally, thus facilitating the building of the essayistic argument between the two. In this case, the simultaneity of the viewing allows the spectator to behold past and present at once—at least visually, because only one of the two audio tracks can be heard at any given time. It is significant that the filmmaker felt the need to create a third text, a split-screen short that actualizes the diptych form implicit in the relationship between the two films. Although "Parallel Scenes" does not fully encapsulate and exhaust the meanings of Beatt's "Wall diptych," it certainly invites the spectator to view the two films as one.

"Parallel Scenes" also places in a different light the intention, expressed by Beatt in the above-cited interview, that *The Invisible Frame* would not be a remake but would "stand independently of the first film." *The Invisible Frame* is not independent of *Cycling the Frame*, as it refers to it throughout, and directly replays it. It could be said that Beatt tried to make her new film independent of its model, not by overcoming it, however, but by

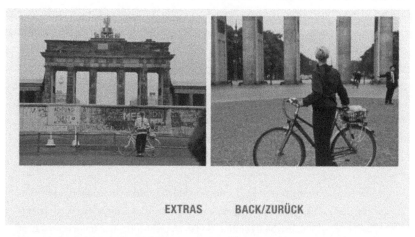

Figure 4.4: The endings of the two films in the extra "Parallel Scenes" in the Filmgalerie 451 DVD edition of *The Invisible Frame*. Filmgalerie 451 2009. Screenshot.

incorporating it—so as to remove the need for the spectator to watch the first film to make sense of the second. The "reloading" of *Cycling the Frame* within *The Invisible Frame*, the retracing of the same route, and the remake of some of the same scenes are all ways of including the earlier film into the second, the past in the present. The circumstances have profoundly changed, and the two films are separated by a wall. In its attempt to reload the earlier film, *The Invisible Frame* constantly highlights the lost object and its absence and the impossibility of reproducing it. In the same interview, quoting Swinton as we have already seen, Beatt invoked the concept of the second film as "the print of a second foot, twenty years and a wall's fall later." The idea of the footprint is especially relevant and vivid because the entire *The Invisible Frame* is an archaeological dig, a search for traces. If the road traveled by Swinton in the first film is just a road and the true object of interest is the Wall it borders, the same road in the second film takes on far greater importance and becomes the film's true focus as its "archaeological site." So, Swinton often looks for signs of the Wall where it once stood; these are sometime physically there—like the row of cobblestones that now marks its former location in the central areas of Berlin (Figure 4.5). On her bike, Swinton sometimes rides beside or cuts across this stone line, so when the same gesture is repeated across other lines of all types marked on the road, even if they are not actual traces of the Wall, its presence/absence is instantly, and metonymically, evoked. If in the earlier film the road is a frontier, the last portion of accessible, free space (which, however, unavoidably

Figure 4.5: The cobblestones marking the former site of Berlin Wall. *The Invisible Frame*. Filmgalerie 451 2009. Screenshot.

evokes the antithetical concept of the "end of the road," of the final limitation), in the later film it is a text that must be deciphered, a digging site wherein to look for the tenuous traces of the past. Such traces, however, exist only in relation to a past that must be pictured, made present, reloaded. The cobblestones, the fragments of Wall that still stand, the watchtowers that are now open to the public, are a dead letter, tourist sights, an open-air museum, traces of "a long, long dead civilization, sort of pre-1300, maybe Byzantine." And then again, the road itself as a metaphor, as "beaten track," and the circularity of the route taken intimate the repetition of history, the return of the repressed, the eternal recurrence. It is the living image of the Wall still standing, still menacing, still impervious in *Cycling the Frame* that actualizes and awakens the vague, dead vestiges of *The Invisible Frame*; and it is the archaeology of the latter work that inscribes in the Wall of the former film the shock of the passing of time and the erasure of materiality and of meaning that is caused by it. The essayistic discourse develops between the two films; and the diptych takes shape in the incommensurable gap that at once separates and conjoins them.

THE ROAD TWICE TAKEN

The Invisible Frame and *Cycling the Frame* are linked together by a strong intertextual relationship. In its simplest form, intertextuality occurs in *Cycling the Frame* as citation—from the film's title to the sequences that were closely remade; hence, in the definition of Gérard Genette (1997), following Julia Kristeva, as "actual presence of one text within another" (5– 6). This presence is so fundamental that *Cycling the Frame* literally incorporates the first film and is, thus, a palimpsestic work, which furthermore alludes to the palimpsest metaphorically, by construing the road around the former Wall as an archeological site strewn with footprints, traces, and relics. The film's palimpsestic rendering of the Wall chimes with Andreas Huyssen's (2000) urban and architectural reading of new Berlin as "a disparate city-text that is being rewritten while earlier texts are preserved, traces restored, erasures documented" (3):

> Berlin as palimpsest implies voids, illegibilities, and erasures, but it offers also a richness
> of traces and memories, restorations and new constructions that will mark the city as
> lived space. (5)

Similarly, Davide Ferrario's *La strada di Levi* (*Primo Levi's Journey,* 2007) is an intertextual work that retraces the route once traveled by the writer Primo Levi on his return to Italy after his eleven-month captivity

in Auschwitz. Some passages of *La tregua* (*The Truce*), Levi's book on his liberation and journey home first published in 1963, are read in voiceover, along with other texts by Levi;[4] most of the voiceover commentary in *Primo Levi's Journey* is, thus, intertextual in nature. In fact, and acknowledging all the necessary distinctions between literature and film, the relationship between the two texts is so deep that *Primo Levi's Journey* can be seen, in Genette's (1997) terms, as a hypertext—a text derived from another, preexisting text without which it could not exist (3). Hypertextuality is a form of intertextuality, but it is distinctive in that, according to Genette, the process that links the hypertext to its hypotext (in Genette's primary example, Joyce's *Ulysses* to Homer's *The Odyssey*) is a transformation, a "saying the same thing differently" (6). *Primo Levi's Journey* does not just quote from *The Truce* and is not a remake of it in another medium—as is, for instance, Francesco Rosi's *La tregua* (*The Truce*, 1997), a film based on the book, with John Turturro in the role of Primo Levi. Ferrario's *Primo Levi's Journey* is a transformation of the earlier text, a saying the same thing differently. Furthermore, and similar to *Cycling the Frame*, *Primo Levi's Journey* is a palimpsestic text. Not only are words from the book cited in the film, but also the itinerary once covered by the writer, which is at the basis of his travelogue, is traveled again by the filmmakers, sixty-two years later. Hence, both a prior text and a road are a double palimpsestic presence in *Primo Levi's Journey*; this parallel textuality opens a gap in Ferrario's film, more precisely, a temporal gap that is spatialized as a route. It is in this gap that the essayistic discourse of *Primo Levi's Journey* is developed, and its temporal incommensurability will be at the center of my discussion of the film.

The title of Levi's book makes reference to the concept of truce, which is a liminal period, an interstitial time. The truce in the book is at least twofold: it is the period that goes from the end of the Second World War in 1945 to the beginning of the Cold War in 1947; and, for Levi personally, the interval between the horrors of Auschwitz and his return home, with the ambivalent feelings implied by it (discovering what was left after the war; beginning a life as a survivor and a witness). Hence, the journey, which started on January 27, 1945, with the arrival of the Red Army in the camp and ended on October 19 of the same year, when Levi finally arrived back in Turin, was for the writer a liminal experience, in which time slowed

4. Andrea Cortellessa (2010a) lists passages "taken from *La Tregua*—not only from the 1963 edition but also from the notes added by Levi himself to the edition for schools published two years later; some poems from *Ad ora incerta* and, more patchily, passages from *Se questo è un uomo* (*If This Is a Man*), *La Chiave a Stella* (*The Wrench*), *L'altrui mestiere* (*Other People's Trades*), *I sommersi e i salvati* (*The Drowned and the Saved*), and finally from the essayistic pages collected in *L'assimmetria e la vita* (*The Black Hole of Auschwitz*)" (171).

down—not least because of the long, tortuous route that, after a month spent recovering in a Soviet camp, brought him home through Poland, Russia, Ukraine, Romania, Hungary, and Austria. Levi's journey unfolded through a Europe that, having emerged "from the nightmare of war and of Nazi occupation, was not yet paralyzed by the new anxiety of the Cold War" (Belpoliti 2010, 45). Ferrario's *Primo Levi's Journey* begins, perhaps unexpectedly, with images of Ground Zero in New York; the film in fact reads the period from the collapse of Berlin Wall to the end of the Cold War as another truce, which ended with 9/11.[5]

As in 2009, when Cynthia Beatt felt the need to return to the site of the former Berlin Wall to assess the results of its fall, two years earlier Davide Ferrario, together with Levi's scholar Marco Belpoliti, decided to explore the new Europe that emerged from that same event and from the dissolution of the Soviet Bloc. Following its Ground Zero prologue, the text is divided into eight episodes/chapters, each corresponding to a stage of the journey and each associated with a particular theme: "Poland: Work," "Ukraine: Identity," "Belorussia: A World Apart," "Ukraine 2: The Plague," "Moldavia: Emigration," "Romania: New Horizons," "New-Old Europe: From Budapest to Monaco," and "Italy: The Trial." Filmed between January and October 2005, the episodes were shot in chronological order and in the same months as in the book, thus strengthening the overall impression of a real journey through the effect of the changing season; they are rather diverse, and the correspondences with the book are subtle and sometimes ineffable, rather than of real substance. At the start of the film, Ferrario explains in voiceover that the film's intention is to read the future through the unanswered questions of the past; hence, the focus is contemporary, but whereas most of the visual track is in the present and for the most part independent of the book's content, Levi's description of the immediate postwar period carves a temporal in-betweenness within which compelling questions on the inheritance of both Fascism and Communism, on the return of the past, and on old and new Europe are allowed to incessantly rise and fall.

The palimpsestic vocation of the film is not limited to the intertextual presence of Levi's words and journey, but translates into a complex structure that includes an "archeological" attitude comparable to that found in *Cycling the Frame.* As Andrea Cortellessa (2010a) has written,

5. Although the attack on the Twin Towers symbolically marks the beginning of a new, "hot" global war, the film does not focus on it directly but explores instead a geographical area that, as Davide Ferrario has explained, finds itself somewhat in the rear of the West; thus, like Levi, the filmmakers here look at what is essentially a moment of truce, although we are already at war again (Cortellessa, Belpoliti, and Ferrario 2010, 195).

The underlying thread of the film is the deep essence, the emotional palimpsest (also in Lotman's sense of "cultural emotions") of the "truce" experienced by these "mid-European" countries from the fall of Berlin Wall till today: the end of a society, of a utopian perspective and, in many cases, of the idea itself of the future; the issue of whether to react to this end in the sign of a final interruption—a petrification—or, at the opposite, of the effort to set complex social and productive realities in motion again; the search for memory and its processing, which in some cases includes its "consumption"; in other words, the meaning or the many significant meanings of the end of Communism. It is a collection of debris, an interrogation of traces, an exploration of the ruins of recent history. (175)

On occasion, such traces and ruins are visible and tangible, as well as resurrected through archival footage. Among them are the site of the former Auschwitz camp, as shown in television footage from a visit paid by Levi in 1983 (Figure 4.6), and from the official commemoration of the sixtieth anniversary of the liberation of the camp in 2005; old factories and street signs of Nowa Huta, Poland, the "ideal town" of Communism, which was planned by the government in the postwar years as a heavy industry center to be mostly inhabited by factory workers; the abandoned houses, streets, and fairground of Chernobyl, Ukraine, which was rapidly evacuated in 1986 after the notorious nuclear plant disaster; and the Communist statues in Memento Park, Budapest, an open-air museum collecting sculptures formerly held at various sites in Hungary (Figure 4.7). Other traces of the past are imperceptible, but are ineffably brought to the surface by the encounter of Levi's text with images of the present. In meeting contemporary faces, stories, and places, Levi's words create unpredictable resonances resulting in an uncanny commentary on the present time. In a published conversation with Ferrario and Belpoliti (Cortellessa, Belpoliti, and

Figure 4.6: Primo Levi's 1983 visit to the site of the former Auschwitz camp. *Primo Levi's Journey* (*La strada di Levi*, Davide Ferrario, 2007). 01 Distribution 2007. Screenshot.

Figure 4.7: Memento Park, Budapest. *Primo Levi's Journey.* 01 Distribution 2007. Screenshot.

Ferrario 2010), Andrea Cortellessa has resorted to the concept of the short circuit to describe the effects of this voice from the past superimposed on the present, citing an emblematic episode of the film, from the Ukrainian chapter, which can be seen as a symbol of this method: the encounter of the filmmakers with the camel of an itinerant zoo in the same area where Levi had seen a camel from his train window in 1945—an episode that he found deeply striking and that compounded his geographical and cultural alienation:

> That's how one reconnects to Levi's story: there is the image of the camel, but the con-
> text has completely changed. Although minor, this episode vertiginously recounts a
> piece of the history of the century. This short circuit between past and present linked
> to an image, to a word by Levi is [...] the cipher of the film. (Cortellessa, Belpoliti, and
> Ferrario 2010, 230)

The film is palimpsestic in at least one more way, namely by its incorpo-
ration of visible traces of the historical evolution of cinema technology and
of film styles, which creates a striking effect of temporal layering—as if the
film contained the imprint of previous films, like unconscious memories
that occasionally come to the surface. Mixing media as diverse as 35mm
celluloid shot in CinemaScope, digital video produced with both profes-
sional and amateur cameras, and the original formats of the archival foot-
age, *Primo Levi's Journey* is indeed a compendium of film history, starting
with the opening sequence from Ground Zero, which, shot with an ama-
teur digital camera, was then treated and "scratched" in postproduction so
as to look like Super 8—and to convey the "feel" of New York in the films of
Andy Warhol, Stan Brakhage, and the New American Cinema (Cortellessa,
Belpoliti, and Ferrario 2010, 196). The Polish episode incorporates black-
and-white footage of Polish and Soviet propaganda, in its turn contained

in *Czlowiek z marmuru* (*Man of Marble*, 1977) by Andrzej Wajda; Ferrario, then, has recognized that the already mentioned episode of the itinerant zoo and the camel is Felliniesque (Cortellessa, Belpoliti, and Ferrario 2010, 230), that the Moldavia section, with the children playing in the mud and the hens in the streets, imitates Italian neorealist cinema's gaze on the poor realities of the postwar era (232), and that a chance meeting with a farmer in Belarus evokes Eisenstein's way of shooting Soviet workers (215). Images of a diorama, then, allude to the prehistory of film (Figure 4.8). These citations are often subtly or overtly parodic, rather than deferential; especially ironic is the Belarus chapter, in which an Ideological Commissar of Alexander Lukashenko's secret police suddenly interrupts the shooting to take the filmmakers in for questioning, subsequently becoming a constant, attentive presence on set, observing and influencing everything that is done and said. Ferrario comments on this episode—which incidentally ends convivially, with a shared meal and a toast to friendship—by producing an amusing parody of Soviet propaganda cinema to describe the institution of the kolkhoz, the collective farms maintained in Belarus even after the end of Soviet rule, and responding to an unusual syncretic approach between socialism and capitalism. As Marco Belpoliti has noted, the film's journey is also a journey through the cinema, thus demonstrating that the image Westerners hold of other realities is always already shaped by the images of those realities that they have absorbed; hence, "the cinema is reused not so as to enunciate a truth, but to display the ambiguity of the truths that we take as contained in the images we already have" (Cortellessa, Belpoliti, and Ferrario 2010, 216).

One of the elements of the book that the film emphasizes is the map, which Levi included at the end of his text and which Ferrario uses both at the start of the film (after the prologue in New York) and at the beginning of each episode. The film's animated map shows the progression of the journey

Figure 4.8: Regimes of vision: diorama. *Primo Levi's Journey.* 01 Distribution 2007. Screenshot.

(of Levi, but also of the filmmakers) through Europe (Figure 4.9). In her discussion of tourism practices in Berlin, remarking that Beatt's *Cycling the Frame* and *The Invisible Frame* include several images of Swinton looking at her map and at maps on road signs, Tania Rossetto (2012) has observed that Beatt's films "give the map a truly 'emotional life'" (17) and that this produces an affective spectatorial experience: "the filmspace, resulting from the translation of the map into the concrete landscape, deeply impacts the embodied affect of the viewer in a 'tactile dialogue' [...] with the cinematic images" (17–19). This is also true of *Primo Levi's Journey*, in which the map is zoomed in repeatedly at the start of each chapter and is thus transformed into a living image, which also revives the experience of the past and brings the spectator affectively closer to it. What is especially interesting in terms of the map in Ferrario's film is that, by collapsing two trips that are separated by no less than a gap of sixty-two years, as well as by such a profound change of conditions as that generated by the collapse of the Soviet Bloc (not to mention everything else that has shaped Europe from the year of Levi's trip to the end of the millennium), the film makes explicit and tangible all maps' function "of making the axis of time and the axis of space meet on a plane: and thus of the cultural and political decoding by human communities of the spaces they happen to inhabit or traverse" (Cortellessa 2010b, 5). The map constantly attracts attention to the deep relationship between human experience and the space in which this unfolds, but also to the double, split temporality of the journey in the film. And the film truly is a road movie, even more so than Beatt's diptych. Whereas Tilda Swinton's bike emphasized the idiosyncrasy and fragility of her personal journey vis-à-vis the impenetrable authority of the Wall and of history, *Primo Levi's Journey* fully embraces the aesthetics of the road movie genre, with many shots of open roads and moving landscapes taken from a vehicle's windshield, with

Figure 4.9: Animated map. *Primo Levi's Journey.* 01 Distribution 2007. Screenshot.

a fragmentary approach dictated by stopovers, casual encounters, and territory and weather conditions and with the use of music to express emotional states excited by the exhilaration of the forward motion and by the beauty of the mutating landscape. The road works here as a Bakhtinian chronotope, an artistic creation in which space and time come together in an indissoluble relationship—for Bakhtin (2002, 15), time in a chronotope becomes the fourth dimension of space. The road in *Primo Levi's Journey*, as in Beatt's films, is therefore a temporal palimpsest and an archeological site, strewn with relics of the past. In this, the journey of *The Truce* and the journey of the film are not comparable. Levi's textual journey was a return home, one that condensed a number of literary and cultural topoi such as Ulysses's ordeal, but also the journey of exile, the journey of purification (from the poisons of Auschwitz) and of rebirth, and of course the diaspora of the Jew. The Europe Levi traversed was one of widespread destruction but also of openness, of renewed hope, and of possibility. In the film, the journey is an archeological dig by which to seek the roots of the evils of the present day, to understand the future that awaits us, and to identify the inheritance of the past, while equally being the discovery of a Europe that only recently has become more open and accessible to the West. However, whereas the journeys of Levi and of Ferrario are characterized by vastly different reasons and meanings, they do superimpose in extraordinarily fecund ways; and so the essayistic argument of the film develops in the gap between the two trips, where, suddenly, the image of the past "flashes up" (Benjamin 1968, 255).[6] Like the slashes in the photographs of Hildebrand's *Sometime* project, Levi's words open temporal gateways, so that incommensurably different moments can coexist in a paradoxical state of simultaneity and short-circuit with each other. And if each of the film's eight episodes can be read as a small independent essay—on themes including the end of work and of the working class in postindustrial Europe; the reemergence and (re)creation of national identities in the former Soviet bloc; the ruins of the Communist dream; new emigration and new conditions of employment after the fall of the Berlin Wall; the neocolonialism of Western entrepreneurs in the East; and the reemergence of Nazism in Germany—it is in the temporal gap that the overall essayistic stance of the film emerges. This stance is born of a practice of fecund ambiguity; ideas, words, and situations from both the present and the past are juxtaposed, so that meanings that may seem obvious are probed and subverted interstitially. The method is Benjaminian insofar as it is based on the emergence of "constellations" through which our epoch comes into contact with an earlier one (Benjamin

6. The concept was engaged with more extensively in Chapter 2.

1968, 263). So, if an overall meaning is conveyed by *Primo Levi's Journey*, this is about a way not only of looking at the present through historical open questions, but also of doing history from a now that is pregnant with the tensions of the past. The thinking of the film takes place diachronically; it is a "leap in the open air of history" (261), which vertiginously unfolds against an incommensurable temporal interstice—against Deleuze's *"centuries of an aeon."*

SUMMARY

The current chapter has focused on temporal interstitiality in diptychs and in hypertextual films in which the argument, at once intellectual and affective, emerges as incommensurable in-betweenness that engages the spectator in a process of progressive readjustments of an intratextual "incongruity" (Gaskell 2006, 331). The road as beaten track, as Bakhtinian chronotope, and as digging site is, in the chosen case studies by Cynthia Beatt and Davide Ferrario, a visual element and organizational principle that spatializes time (whereas in Aleksandr Sokurov's *Elegy of a Voyage*, explored in Chapter 1, it was the museum that spatialized time and history, and the road was a metaphor of mobility and liquidity).

This chapter thus further brought out and expanded the focus on historicity that is at the basis of this book and that underlay the structure of the previous chapters. It also attracted attention to the book's methodology of viewing side by side texts made at different times as a historicizing strategy, which counterpoises the abstracting potential of a discussion merely focused on rhetorical and formal textual strategies such as those of the disjunctive interstice of the essay film. The following chapter will maintain this focus, while specifically addressing nonverbal meaning-making at the level of sound images.

CHAPTER 5

Sound

The Politics of the Sonic Interstice and

the Dissonance of the Neutral

In the essay the persuasive aspect of communication, analogously to the functional transformation of many traits in autonomous music, is alienated from its original goal and converted into the pure articulation of presentation in itself; it becomes a compelling construction that does not want to copy the object, but to reconstruct it out of its conceptual membra disjecta. (Adorno 1984, 169)

The role of voice has been central to the definition of the essay film as an object of study. As an intellectual form that derives from, or at least has profound connections with, a literary genre, much importance has been placed by its critics on speech and on voiceover, which is frequently used to convey essayistic thinking in film.[1] This tendency is already in evidence in early critical contributions that have been highly influential in setting the parameters of the form, from Alexandre Astruc's (1948) notion of the camera-pen to André Bazin's (2003) review of Chris Marker's *Letter from Siberia*. As David Oscar Harvey (2012) has argued, then, the essay film's current critical reception overwhelmingly equates it with a specific tradition embodied by filmmakers who made extensive use of voiceover—including Chris Marker and other "Left Bank" French directors (Alain Resnais, Agnès Varda)—with the result that its object of concern can be defined, following Michel Chion (1999), as "vococentric."

1. On the "importance of recognizing an overlooked literary heritage in this particular film practice," see Corrigan (2011, 5).

With reference to the types of film that contemporary critics widely think of as essays, Harvey asserts,

> first, they are vococentric in the sense intended by Chion: that is, their soundtracks are dominated and arranged around the human voice. Second, the very rhetoric of film, its framework, is constructed by the logic and nature of the voiceover. (7)

The centrality of speech to definitions of the essay film has prompted debate because of the predominantly negative reception of voiceover in documentary film theory, in turn a result of the critique of the omniscient, imperialist, patriarchal connotations of what has been described as the "voice of God."[2] Following Michel Chion's (1999) discussion of the "acousmêtre" (an acousmatic voice that is not yet visualized) in fiction cinema (17–29), documentary voiceover has predominantly been understood as inhabiting an extradiegetic space, from which it comments on the diegesis, thus controlling the spectator's reading of the film and imposing unequivocal meanings that potentially distort both the indexical truthfulness of the images and the authenticity of the words of witnesses. Its extradiegetic positioning has been indicated as the primary cause of its perceived authoritarian, even threatening features. The argument is thus summarized by Pascal Bonitzer (1976):

> Voice-off represents a power, that of disposing of the image and of what the image reflects, from a space absolutely other with regard to that inscribed in the visuals. Absolutely other and *absolutely indeterminate*. In as much as it arises from the field of the Other, the voice-off is assumed to know: this is the essence of its power. (33; emphasis in the original)

Theorists who follow Bonitzer, such as Mary Ann Doane (1980), opine that voiceover derives its authority from its particular positioning: "It is precisely because the voice is not localizable, because it cannot be yoked to a body, that it is capable of interpreting the image, producing its truth" (42).

When one pauses to consider examples of documentary voiceover from a spatial perspective, however, things often seem more complicated. The extradiegetic space from which a voiceover speaks often is not a wholly separate plane interacting with the visuals in an entirely unidirectional, linear manner. Layering and stratification (both of sounds and of the effects and meanings that are produced by the voiceover's engagement with the image track and the soundtrack) in many cases are more credible spatial models to account for the interaction between voiceover and other elements of the film. Even disregarding this, the voiceover of the essay film is hardly equal to a voice of God, at least in the meanings and effects attributed to the latter by the

2. See, for instance, Nichols (2010, 59–60).

above-described critical tradition. It is, in fact, a searching and often skeptical voice, which probes its object rather than imposing a closed, perfected commentary and which is in a complex relationship with the visuals and with other sounds, tending to problematize not only them but also itself and its authority (Rascaroli 2009, 44–63). In terms of space, this voice does not come from an out-of-field that can be defined in any "institutional" way (with reference, for instance, to discourses of journalism and news reporting, historical account, or scientific popularization) and, thus, it is not positioned in relation to the image track in the same way as the traditional voice of God is—when this is thought of as located at an explanatory space-level, which frames and controls the image and which anchors its potentially free-floating meanings, imposing a univocal and "institutional" reading. The voiceover of the essay film, thus, does not inhabit the same off-screen space as the voice of God of traditional documentary, because it does not ascribe to and, indeed, it undermines its position of separation and the unidirectionality of its approach.

The interstice may help us to define the space that an essayistic voiceover is capable of creating and exploiting. It is indeed productive to think of essayistic voiceover in light of Gilles Deleuze's (1989) concept of "sound image," which is not linked to an out-of-field, but which "is born, in its very break, from its break with the visual image" (251). For Deleuze, in time-image cinema "the sound itself becomes the object of a specific framing which *imposes an interstice* with the visual framing" (180; emphasis in the original), and the irrational interval that separates sound and image relates to the autonomy of both and to their autonomy from their externality, from the out-of-field. In Delezue's own words, "There are no longer even two autonomous components of a single audio-visual image [. . .] but two 'heautonomous' images, one visual and one sound, with a fault, an interstice, an irrational cut between them" (251). As D. N. Rodowick (1997) has glossed, "'[h]eautonomous' means that image and sound are distinct and incommensurable yet complementary" (145).

Such incommensurable complementarity will be at the center of this chapter, which, however, proposes to focus not exclusively on voiceover, but on sound more comprehensively. In his above-mentioned article, Harvey invokes the possibility and, indeed, the desirability of broadening the scope of the category "essay film" to include nonvococentric texts, in which the "vehicles of expressivity [. . .] are moored not to language, the mind, or conventional processes of human ideation, but rather to modes of perception and affect" (2012, 14). I agree with Harvey that essay films can express their reasoning and create "an individuated or expressionistic document of the world and the subject, or the subject in the world" (14) in other ways than by using voiceover. I also believe that affect is an important sphere of meaning-making that has often been neglected in relation to the

essay film and one that must be explored further. Although they do not exactly belong to the same category as the one imagined by Harvey and are not entirely devoid of words (some are included in the form of captions), I have discussed a silent essay film in Chapter 2 of this book: Harun Farocki's *Respite*. In the current chapter, however, my focus will be somewhat different. By inviting an understanding of essay film's soundscape that does not stop at voiceover, but extends to all the elements of a complex environment also made up of music, nonverbal sound, noise, and silence, I intend to move beyond the traditional logocentric approach to the essay film, and beyond the debate on voiceover in nonfiction, and explore more broadly the disjunctive interstice of the sound image and thus the set of meanings and effects produced by an essayistic soundtrack.

Artistic experiments with sound can be traced back to the historical avant-garde movements and specifically to futurism and Dada and have been at the center of artists' concerns for decades (from John Cage's 1952 pivotal silent three-movement composition, 4'33", to the neo-Dada noise music of Fluxus, to the sound installations of Max Neuhaus). Even this thumbnail genealogy of sound art—which, incidentally, has been acquiring unprecedented prominence over the past decade, culminating in major exhibitions including the Museum of Modern Art's "Soundings: A Contemporary Score" (2013)—clearly points at a modernist gesture, which emphasizes a politics of sound that is intentionally disjunctive. Experimental cinemas have also used sonic disjunction and, for instance, an epitome of modernist experimentalism such as Jean-Luc Godard has extensively worked on the interstice dividing sound and image and on the irrational sound cut. Bearing this history of experimentation in mind, I will now begin to reflect on the relationship between sound and image in the essay film, while asking Deleuze's (1989) question: "What happens when the irrational cut, the interstice or interval, pass between visual and sound elements which are purified, disjunctive, freed from each other?" (249).

My first case study, Lawrence Abu Hamdan's *Language Gulf in the Shouting Valley* (2013), which calls itself a "sound essay" up front, was born as an installation for "Ten Thousand Wiles and a Hundred Thousand Tricks," an exhibition held at the Beirut Art Center and organized as part of the seventh edition of the multidisciplinary contemporary arts festival Meeting Points (September 2013–June 2014). Abu Hamdan's work, in his own definition, focuses on "the relationship between listening and politics, borders, human rights, testimony and truth" (Abu Hamdan 2015a). Layering sounds from different sources, languages, and times and places of recording, alternating (some) images and a black screen, and using a few captions, *Language Gulf in the Shouting Valley* places its audience in a

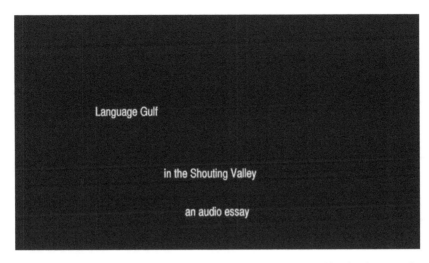

Figure 5.1: The opening screen of Lawrence Abu Hamdan's *Language Gulf in the Shouting Valley* (2013). Lawrence Abu Hamdan 2013. Screenshot.

complexly imbricated auditory space (Figure 5.1). The visuals are minimal; like flashes, some images irregularly emerge from darkness to periodically and irrationally rupture a predominantly black screen. Bearing comparison to some extent with the unmatched experimentalism of Derek Jarman's *Blue* (1993), with its single blue shot lasting the entire seventy-nine minutes of its running time, *Language Gulf in the Shouting Valley* is a rare example of an essay that radically subordinates images to sounds, to the extent of reducing the visuals to spare fragments—thus demonstrating by comparison that most essay films, as well as being logocentric and vococentric, are also distinctly image-centric. Its radical privileging of sound can be measured, for instance, by comparison with *British Sounds* (1970) by Jean-Luc Godard and Jean-Henri Roger, an agitprop essay that foregrounds sound and speech (including a text by Friedrich Engels read in voiceover), but where images are nevertheless present (including the famous ten-minute tracking shot along a car factory assembly line). Although by its eclipsing of the image Jarman's *Blue* emphasizes the affective and evocative dimension of music and noise and favors the spectator's intimate identification with the narrators' "I-voices,"[3] and although *British Sounds* through irrational cuts at once establishes and disrupts the link between a multitrack sound and a disjunctive image track, *Language Gulf in the Shouting Valley* plunges its audience in a near-total darkness that subtracts most visual coordinates and radically inhibits identification and even orientation, thus enhancing one's

3. Recorded with close miking, the voices sound as "consciousness" voices.

sense of hearing and emphasizing sound as the true vehicle of the meanings (not all of which are logocentric).

Language Gulf in the Shouting Valley is, thus, an ideal text to begin to think about the workings of the essay film's soundtrack. Equally, it is an optimal choice to start to reflect on the off-screen as the space of the sound image and on the disjunctive relationship between essayistic voiceover and image track—the film's *membra disjecta*, to use an expression of Adorno (1984), out of which the essay, analogous to "autonomous music," constructs its argument (169). Finally, because it reflects on voice and sound as political agents, *Language Gulf in the Shouting Valley* allows me to introduce a reflection on the potential political value of sonic disjunction, which will be at the center of the entire chapter.

A SOUND ESSAY: MEANING AND AFFECT IN *LANGUAGE GULF IN THE SHOUTING VALLEY*

Language Gulf in the Shouting Valley is concerned with a Druze community living between Palestine/Israel and Syria and, in particular, with the Druze soldiers who work as interpreters in the Israeli military courts in the West Bank and Gaza and the Druze who gather on both sides of the Israeli/Syrian border in the Shouting Valley, Golan Heights, to communicate with family and friends by calling across the frontier. The film presents two voiceovers, one male (speaking in standard Arabic) and one female (speaking in English), which share the auditory space with many other voices, sounds, and noises, including ambient sounds and the voices of the Druze gathered in the Shouting Valley, but also more mysterious sounds, like a cigarette lighter, distant barking, an alarm, the screeches of a microphone, and what sounds something like a saw cutting metal. The first to speak is the man; the voice actor Maan Abu Taleb begins by reading the film's title (also appearing in a caption) and then goes on to describe the Shouting Valley and its troubled history. The voice is distorted and metallic at first and then becomes clearer, turning progressively distorted again toward the end of its speech. This speech is abruptly followed by images that suddenly pierce the blackness: a shaky take of the valley accompanied by shouting. The connection between shouting voice and vision is established from the beginning, even before the voiceover is first heard: the film starts with a black screen; sounds are heard, then a voice shouts and a trembling image of the valley simultaneously appears, lasting exactly the duration of the shouting, as if an eye and a mouth opened in unison to look and scream and then closed again. After two iterations of shouting and of the trembling subjective vision that accompanies it, a telephone's ringback tone is heard, and a

voice says hello to Lawrence. The voice belongs to the academic Lisa Hajjar, "a sociologist who spent many years researching the Israeli military courts in the West Bank and Gaza," as the male voiceover clarifies. Speaking in English, Hajjar explains why and how Druze soldiers work as interpreters in the Israeli military court system and details the conditions of their practice. As Jim Quilty (2014) has summarized,

> As they are heterodox Muslims, the Israeli regime has "Orientalized" the Druze as "non-Arab" collaborators. The only Palestinians eligible for Israel's military draft, while still subject to its arbitrary land confiscation, young uneducated Druze men are employed in intermediary roles—translators in the occupation's military courts, for example—that Israel's Arab–Jewish citizens are discouraged from playing. Druze conscripts face unusual pressure to demonstrate their loyalty to the occupation regime. In performance, the Druze translators are so aggressive and uncooperative during land-confiscation hearings that Palestinian plaintiffs are reduced to mere objects.

Hajjar's voice, which shares the same auditory space with other sounds, is abruptly interrupted several times by more instances of images and shouting, each lasting a few seconds (Figure 5.2). After one of these interruptions, the male voiceover resurfaces and makes an observation, based on the description of the translation activity given by Hajjar. With reference to the military courts and the Shouting Valley, the narrator observes, "In both these cases Druze bodies inhabit the border zone, and it is their voice which becomes a mode of affirming, negotiating, and sometimes transgressing this border." The "vocal border" between Israel and Palestine that becomes manifest in the courtrooms through the bilingual voice of the Druze is thus compared to the Israel/Syrian border that they make distinctively audible by calling to each other across the valley. We are then invited to listen to this oral border, in which we can simultaneously hear, as we are told, "the collaborator and the traitor, the translator and the transgressor." Finally, the voiceover describes "a different act of transgression" that took place on May 15, 2011, the anniversary of the Nakba, when more than just voices crossed the border: 150 Palestinian protesters from Syria broke into Israeli territory; 4 of them were killed. As the narrator describes the events, the voices of the protesters in the background become progressively louder and literally drown his voiceover, which is further challenged by the screech of a microphone or loudspeaker. There are no images now, only a black screen; completely devoid of visual coordinates, we find ourselves immersed in a deeply unsettling auditory space filled with screams, calling voices, whistling, chanting, pleadings ("Stop! Enough!"), and anxious warnings ("There are land mines!"). In the absence of images, the captions themselves begin to vibrate with the intense emotionalism of the voices.

Figure 5.2: Shaky mobile phone footage ruptures the black screen. *Language Gulf in the Shouting Valley*. Lawrence Abu Hamdan 2013. Screenshot.

The film ends with the cacophony of the shouting and the screech of a microphone.

Thus, exploiting the multichannel possibilities of digital technology, the film produces a layered sound to query a technocratic state that strives for the ideological restriction of truth and meaning through the technolegal control of voice and speech (both of the Druze and of the Palestinians) and for the physical restriction of their bodies through the enforcing of borders. Issues of legal, state-controlled spaces—the military courtroom, the frontier—are brought to the fore and subverted through the provision of an essayistic space in which voices defy containment by the images or otherwise, exposing the methods of both ideological and physical harnessing. The nature of this space is typical of the essay, as I have conceptualized it in this book—it is a space based on disjunction rather than on seamless suturing. The film is interstitial from the title itself, with its reference to gaps and voids: a gulf and a valley. The images and the shouting at times work in unison, at times against each other; when they come together, they are even more dissociated than I have described them thus far. The shots, lasting only a few seconds, are shaky and partial; the images are mobile phone footage that the artist acquired from an anonymous source at the 2011 Nakba Day (Abu Hamdan 2015b), and the sources of the shouting are never explicitly revealed (although we do see bodies, no

synchronization is ever achieved between sounds and images). The images and sounds of the 2011 events, thus, are fundamentally disjointed within the timeline of the film. When they are not entirely separate or clashing, image track and soundtrack work together as compatible incommensurabilities. The sources of the two voiceovers are also not revealed because they are never associated with images, although one of the two speakers is named and is thus clearly individualized. In contrast, Maan Abu Taleb was explicitly chosen to deliver an industry-standard sound of male voiceover actor speaking in nondialect Arabic. This voice therefore occupies a space quite different from that of the other voices in the film. In Abu Hamdan's (2015b) own words,

> it was the very intentional space that this voice needed to occupy within of the spectrum of voices heard in this work. Contrasting the shouted and screamed highly local and untranslated Arabic with this borderless and textual voice was particularly central to the use of his voice.

Although the male voice is the only "borderless" one, it is also highly mediated and far from being normalized by the framing; it is, in fact, audibly delivered through a microphone, and it periodically turns distant and metallic. The effect is one of distance and estrangement.

Discussing the soundtrack of time-image films, Deleuze (1989) observes,

> the notion of voice-off tends to disappear in favour of a difference between what is seen and what is heard, and this difference is constitutive of the image. There is no more out-of-field. The outside of the image is replaced by the interstice between the two frames in the image. (180–81)

The shedding of the out-of-field is so radical in *Language Gulf in the Shouting Valley* also because of the scarcity of images and their interstitial status. Furthermore, although the two voiceovers are highly mediated and the shouts reach us in an apparently more direct and, thus, "natural" way, these also do not belong to a traditional on-screen space—because there simply is no significant on-screen space in this film dominated by a black shot, by a void. If the black screen, which is mostly associated with the voiceovers, can be described as a space of rational discourse, the shouting episodes irrationally interrupt the logical speech of the voiceovers and rupture their space. Although the shouts carry precise linguistic messages, they are much more overtly emotional than the two voiceovers; together with linguistic meanings, they mobilize much anxiety, fear, desire, hope, and horror. Because they are coupled with shaky images, then, which we as audience have been trained to associate with a frightened human subjectivity, and on

the strength of their effective disruption of rational discourse, they inscribe affect in the film in powerful ways.

What is especially compelling with regard to this sound essay, then, is that its argument is not exclusively logocentric. Shouting voices, unsettling ambient sounds, and fragmentary images are used to introduce not the expected documentary evidence in support of the line of reasoning delivered by the voiceovers, but another argument, which is based on the mobilization of affect and which sees the Druze as victims and not just as perpetrators. Invisible borders become perceptible and collaboration and transgression are exposed as two sides of the same coin, two products of the same enslavement. The political discourse of the essay film thus materializes at once as intellectual speech and as emotional cry; voices, sounds, and images open a series of tears in the orthodoxy of the state-controlled meanings, but also of logical and academic discourse. There is no compact, sutured, closed argument, but a space of disjunction and multivoicedness. To say it with Adorno (1984), "By transgressing the orthodoxy of thought, something becomes visible in the object which it is orthodoxy's secret purpose to keep invisible" (171)—and also, we would like to add, inaudible.

POETIC *RAGE*: ANOTHER MUSIC

Genus irritabile vatum [The irritable race of poets]. Horace (1989, 2, 102)

The relationship among sound, politics, and affect is central to a number of essayistic films that have made their statements on society and history while activating meanings that are not exclusively logocentric, but that also draw from the sphere of music and musicality broadly intended. One could indeed postulate an entire category of essay films with a distinct musical approach. One of these films will now be at the center of my attentions, Pier Paolo Pasolini's controversial *La rabbia* (*Rage*, 1963), which will also be discussed in relation to Santiago Álvarez's *Now!* (1964) and Erik Gandini's *Surplus: Terrorized into Being Consumers* (2003), two films that will be used for contrapuntal purposes. Other examples that could be included in the category of musical essay films include *La hora de los hornos* (*The Hour of the Furnaces*, 1968) by Octavio Getino and Fernando Solanas, which, as Nicole Brenez (2012) has written, "conjoins the powers of didacticism, poetry, and agogy (the agogic qualities of a work concern its rhythmic, sensible, physical properties—a notion suggested by the French aesthetician Etienne Souriau)"; *Handsworth Songs* (1986) by John Akomfrah and the Black Audio Film Collective, including both archival footage and images of the riots of 1985 filmed in Handsworth and London and presenting

examples of intellectual montage cut to music; and Mark Leckey's *Fiorucci Made Me Hardcore* (1999), an essay on the clubbing culture and underground music scene in the United Kingdom from the 1970s to the 1990s that uses sound in experimental ways. It is worth beginning to emphasize the role of the rhythm of both music and montage in these "musical" essays and thus to acknowledge their relationship with those early Soviet montage essay films that in 1930 Béla Balázs (2010) described as "the intellectual apogee of the silent film" (127):

> the greatest emphasis is placed on the rhythmical and purely musical, decorative effects of montage. Here, the most irrational cinematic elements become the chosen mode of expression of the most intellectual. Rhythm becomes the expression of scientific thought. (128)

Pasolini's is a particularly rich text to analyze to reflect further on the sound interstice in the essay film. First, it is helpful to remark that, although he did not have formal musical training, Pasolini was heavily involved in the creation of his scores, as testified by the credits of his films, which often specify that the music was edited by the director, either alone or in collaboration with composers such as Ennio Morricone and Carlo Rustichelli, and also the novelist Elsa Morante (who was, however, openly accredited only for *Medea*). Pasolini also coauthored a number of songs included in his films. His attention for soundtracks is, thus, a prominent feature of his work.

La rabbia was born of a commission. In 1962, the Italian film producer Gastone Ferranti was looking for a way to use the footage from *Mondo libero* ("Free World"), the weekly newsreel of Italian and world events he had produced between 1951 and 1959. Initially, he thought of a film in episodes, each made by a different director, held together by the narrative pretext of a group of Martians coming to earth to observe human life. Pasolini was first contacted as one of the possible directors, but the original project soon transformed into a full-length feature to be assembled by Pasolini himself. Originally planning a journalistic work mainly addressing a left-wing audience, as suggested by his choice to present his project in the Marxist periodical *Vie nuove*, after viewing the material in the autumn of 1962, impressed by his discovery of some beautiful fragments of filmed reality and some footage of historical value, Pasolini changed his approach and decided to add a poetic commentary (Chiesi 2008, 9–10). However, it must be acknowledged that talking of *La rabbia* as an auteur film is not unproblematic. The production was troubled; after seeing Pasolini's original cut, which he considered unmarketable, the producer decided to ask a second intellectual, of opposite ideological views, to make another film, which would be distributed together with a shortened version of Pasolini's

montage, as in a diptych.[4] Bound by the contract, Pasolini reluctantly accepted the involvement of Giovannino Guareschi, a right-wing intellectual and writer, famous in particular for his popular *Don Camillo* series, who had publicly scorned Pasolini and mocked his homosexuality. When Pasolini finally saw Guareschi's section, however, he was so outraged by its reactionary content that he decided to withdraw his name from the film. Therefore, not only the current version of Pasolini's film is halved compared to the original cut (originally of one hundred minutes, the film was shortened to fifty-four), but also Pasolini himself—as Roberto Chiesi (2008) has stressed in the booklet that accompanies a recent DVD re-release and hypothesis of reconstruction of the lost sections of Pasolini's film—did not consider this creative work, but rather a work of journalism. Chiesi has suggested that Pasolini used what he regarded as "the most 'contemptible' audio visual material of the time (1950s newsreels and magazines), but reworked in such a way as to assume an entirely new significance" (3). For Chiesi, Pasolini's operation gave new meaning to the original footage, thus profoundly transforming it, while on some occasions preserving it, for the purpose of highlighting the hypocrisy and adulterations that are typical of news reports. Famously, Pasolini was suspicious of journalism and, in particular, of the journalism of the newsreel and actuality film, as this frequently cited passage from *Vie nuove* demonstrates:

> I know to what extent the practice of journalism is based on falsity: from reality it extracts isolated eye-catching excerpts, whose meaning can be immediately obvious and become formulaic; then it poorly stitches them together with a moralistic "tone" purely designed to satisfy the reader. The bourgeois journalist never even considers the idea of purveying the truth, of being in some way honest—which means personal. He depersonalizes himself entirely in order to allow a hypothetical audience to speak in his place; an audience that he regards as right-minded but idiotic, normal but ferocious, blameless but cowardly. (Pasolini in Chiesi 2008, 3)

This passage serves to highlight, by contrast, how Pasolini's own "journalism" in *La rabbia* is decidedly personal; it is made so, for instance, by the choice of expressing personal opinions and of selecting events that the author (and not the "conformist audience") subjectively regards as important.[5] We know that Pasolini called *La rabbia* "an essay in film journalism" (cited in Chiesi 2008, 36) and that he did not consider journalism a creative

4. Despite the producer's attempts to increase the marketability of the film, *La rabbia* did poorly at the box office and was quickly withdrawn; see Viano (1993, 114).

5. It is also worth noting that, in the same year, 1963, Pasolini made another film of reportage and journalism, *Comizi d'amore* (*Love Meetings*), which he shot between March and November. By analyzing a number of unpublished documents, including some of Pasolini's preparatory

act: "a film based on repertoire material [...] A journalistic rather than creative work. An essay rather than a story" (in Chiesi 2008, 36). Yet *La rabbia*, even in its shortened version, creatively challenges generic boundaries and is at once journalism and elegy, pamphlet and poem. Pasolini himself seemed to be ultimately aware of its ambition when he said "My aim was to invent a new film genre" (Chiesi 2008, 37).

Although it was not utterly new at the time of its release as a film that combines intellectual montage with a poetic voiceover commentary, *La rabbia* stands out as a particularly innovative experiment in its use of sound disjunction to create essayistic meaning. What is especially compelling about the film in the context of the current chapter is its sound politics, with reference to both music and voice, which I will read in terms of an overall effect of radical dissonance and, thus, of a particular type of "musicality." Dissonance, intended as lack of harmony not only between musical notes but also more broadly between elements of a text, is an effect often sought by modern art. As Daniel C. Melnick (1994) has argued with reference to modern fiction, for instance, "[d]issonance is [...] the form narrative achieves when modern novelists undertake to musicalize fiction" (10). With *La rabbia*, we can say that Pasolini sought to musicalize the essay film. *La rabbia*'s dissonant musicality (intended not only as music but also with reference to all effects that relate to it) is a disjunctive form that creates gaps within which the argument of the essay film is allowed to surface. What I am especially interested in highlighting is the film's interstitial sound practice, which operates paradoxically between rhythm (and thus euphony) and cacophony.

The disorderly experience of the text that some critics have remarked on testifies to the discordant nature of the film.[6] Dissonance erupts at multiple levels in *La rabbia*—including those of music proper, of voices and linguistic registers, and of subject matter. With regard to content, the shortened, official version of the film starts with the Soviet invasion of Hungary in 1956 and moves on to, among other events, demonstrations

drafts and manuscripts, Mauro Giori (2012) has argued that *Comizi d'amore* should not be taken as a straightforward example of *cinéma vérité*—as the film has always been framed and as suggested, for instance, by the official trailer and by the film's first caption, which presents Pasolini as animated by "the most sincere objective to understand and report faithfully." Rather, Giori invites us to look at the film as a hybrid that is neither *cinéma vérité* nor television chronicle, because of the many authorial interventions on "material that was presented *as if* it were just a spontaneous collection of testimonies" (101). Despite the lack of Pasolini's voiceover commentary, therefore, *Comizi d'amore* was more than journalism or, at least, was "subjective journalism." Similarly, *La rabbia*, made in January and February of the same year, was a version of the same practice.

6. See, for instance, Mira Liehm's (1984) description of *La rabbia* as "a rather confused montage of film footage commenting on political issues of postwar Europe" (352, n24).

in Rome, Madrid, and Paris in the same year; images of Italian refugees after the Second World War; the Suez crisis; the Congo crisis and the imprisoning in 1961 of Patrice Lumumba, the hero of Congolese independence; images of Gandhi and Nehru, of Sukarno, the first president of Indonesia, and of Nasser, the second president of Egypt; the Cuban revolution; Ava Gardner and Sophia Loren; the workers' Unions in Italy during the economic boom; paintings (Renato Guttuso's social realism versus Jean Fautrier's abstract Tachism); the coronation of Queen Elizabeth II; the nomination of Dwight D. Eisenhower at the Republican Convention of 1952; the funeral of Pope Pius XII and the election of Pope John XXIII; images of Leninist Russia; an exhibition of socialist realist art in Moscow; the end of the Algerian War with De Gaulle's retreat; the death of Marilyn Monroe, intertwined with images of the tragedy of the mine in Morgnano, Italy, where twenty-three workers lost their lives in 1955 (Figure 5.3); and images of atomic explosions; finally ending with footage of the Soviet cosmonaut Gherman Titov celebrated by Nikita Khrushchev after his successful return from space in 1961. The selection of footage and topics overall comes across as idiosyncratic; there is no conspicuous logic in the choice of topics and no strict chronological order (for instance, images from the Second World War as well as of the coronation of Queen

Figure 5.3: Mining accident in Morgnano, Italy. *La rabbia* (Pier Paolo Pasolini, 1963). RaroVideo 2008. Screenshot.

Elizabeth II in 1953 come after footage of the Soviet invasion of Hungary in 1956). No eminently obvious line of reasoning emerges from Pasolini's montage of events (although it can certainly be hypothesized), and the overall approach could not be further from that of a traditional documentary of historical analysis.

The film's soundscape, then, is deeply disharmonic. The film is, first, radically multivocal. Some excerpts of the original voiceover commentary are preserved—they embody the tradition of the documentary voice of God, as well as of what Pasolini considered, as we saw, the lowest spectrum of journalism. Furthermore, two distinctive male voices read Pasolini's written texts: the Italian novelist Giorgio Bassani is the poetry narrator, and the painter Renato Guttuso is the prose narrator. Bassani and Guttuso are two intellectuals who, for their ideological affinities with Pasolini, can be seen to function as alter egos of the author and thus to represent two modes of Pasolini's production (as such, Pasolini's own essayistic commentary and subjectivity come across as split and multiple). The two voices alternate according to a logic that remains indiscernible. *La rabbia*'s speech, accommodating at once the high register of poetry and of an intellectual commentary and the low register of gossip journalism, is made up of rhetorical incommensurabilities. Bassani and Guttuso's voiceovers, then, carve a distinct gap with the images; their tone, sometimes mournful and sometimes pungent, is always deeply reflective and metahistorical and thus perceptibly asynchronous, distant from the immediacy and urgency of the footage.

The complexity of the film's composite, plurivocal commentary commands attention, but must be placed within a broader understanding of the film's soundscape that includes all the elements of a rather overwhelming environment also made up of music, noises, and silence. With regard to music, some basic distinctions must be made, at least between the classical and popular scores used by Pasolini and between the Western and non-Western music and songs. The variety of the score is impressive; the list of musical pieces and citations in the film is long and includes many dances, bands, songs, orchestras, choruses, concerts, and compositions, but also silence, bells, sirens, electronic music, and noises. Noise is indeed often used like music, and music is sometimes replaced by noise, for instance, the ominous rumble of the airplanes that fly above Algiers in a sequence on bombings during the War of Independence (Figure 5.4).

Music has such a prominent, structuring role in the film that, in his brief notes on the screenplay, Giuseppe Magaletta (2010) was motivated to observe, "music is what carries the story, both in the tragedies of war and in the fatuity of national-popular events" (142). It is helpful to read this observation against the backdrop of Pasolini's conception of the function

Figure 5.4: Airplanes flying above Algiers. *La rabbia.* RaroVideo 2008. Screenshot.

of music in film; for Pasolini, music is what clarifies the theme of the film, which can be either conceptual or sentimental:

> But for the music this is indifferent: a musical piece has the same pathetic force whether applied to a conceptual or to a sentimental theme. Indeed, its true function is to conceptualize feelings (by synthesizing them in a motif) and to sentimentalize concepts. (Pasolini in Magaletta 2010, 340)

The function of film music for Pasolini is, in other words, at once intellectual and affective. One of the ways in which music works affectively is through rhythm. Magaletta indeed remarks that music in *La rabbia* is used to "give rhythm to the text" (145), a notion that must be further investigated, however.

Rhythm in *La rabbia* is not only an effect of music; it is also produced by poetry. The film contains much poetry by Pasolini, including "Marilyn."[7] Written in 1960, Pasolini's poem "La rabbia," instead, only shares a title

7. Interestingly for my argument, Walter Siti included "Marilyn" among Pasolini's "Poems for Music"—indeed, it "made its first appearance when sung by actress Laura Betti in the recital *Giro a vuoto no. 3*, which premiered at the Teatro Gerolamo in Milan on November 12, 1962" (Sartarelli 2014, 472), soon after the Hollywood star's death.

with the film; yet it demonstrates that the concept of "poetic rage" was key to Pasolini's thinking in that period, as Georges Didi-Huberman (2013a, 2013b) also has emphasized. In his discussion of *La rabbia*, Didi-Huberman attracts attention to the rhymes in Pasolini's film, which he locates in the deployment of contrasting concepts, including, for instance, "the winners and the mediocre" or "good and bad"; in the use of actual verbal rhymes, such as "beauty/richness" (rhyming in Italian: *bellezza/ricchezza*); in refrains (for instance, the frequently repeated expression: "To die in Cuba"); and also in the images of the film, where he recognizes gestural, symbolic, and formal rhymes. The film itself is based for Didi-Huberman on variations of motifs, among which he highlights the violence of man against man. In a complementary way, in her analysis of the film Maria Rizzarelli (2011) has noted that "[t]he syntax that that ties words with images, but also images with images and words with words, is constantly marked by the presence of rhetorical strategies typical of poetic language" (274). Rizzarelli recognizes the figure of anaphora, for instance, in the repetition of identical verbal and visual syntagms, which motivate her to talk of a "prevalent poetic language of Pasolini's *decoupage*" (275) and almost of a "filmic embodiment of the poet's point of view" (276).

These analyses persuasively flesh out *La rabbia*'s poetic qualities beyond the verses read by Bassani's voiceover. However, by paying exclusive attention to the rhyming elements of the spoken text and of the image track, they may be said to overemphasize the orderly and elegiac component of the film and the harmonies of the montage. If, however, one pauses to consider the overall "musicality" of the film, the effect of dissonance becomes much more evident. The rhymes are an element of symmetry within an overall cacophonic structure, which is characterized more acutely by the irrational cut between images and sound images than by an orderly, harmonious structure. The film is not a poem; it is not even an angry (that is to say, a political) poem. Pasolini (2011) himself called it "an ideological and poetic essay" (3067); his definition already points to a generic schism and thus to the gap between the film's components. And what make this film an essay are precisely the gaps—which are at once thematic, temporal, and structural. In particular, the musical imprint of the film is dominated by difference, which is a product of montage—and Pasolini described the work of montage for *La rabbia* as "grueling" (3067). The grueling work of irrational cuts in *La rabbia* has a quasi-musical quality to it, although one based on dissonance—it is an avant-garde musicality. *La rabbia* as a whole can, in fact, be said to produce an experience akin to an avant-garde music piece. Although Pasolini's film is not, strictly speaking, an experimental film, it is

useful to remember that dissonance and dissociation of image and sound become particularly important at this time in experimental cinema:

> The dialogue between sound and image becomes central to experimental film in the 1960s, when the influence of John Cage and of musical minimalism, the availability of home sound technology, and the possibilities afforded by new electro-acoustic instruments prompted unprecedented sonorities and image-sound articulations." (Suárez 2013, 298)

Cage's own influence and that of the *musique concrète* movement can be strongly felt, for instance, in the experimental use of sound made by Michelangelo Antonioni in the same years, as evidenced by his trilogy of the early 1960s (see Nardelli 2010). Pasolini's approach in *La rabbia* is less obviously experimental in terms of music choice, although, as noted again by Magaletta (2010, 146), a piece of electronic music was chosen in Pasolini's screenplay to accompany a sequence of footage of Nazi concentration camps and mounds of corpses in Buchenwald.[8] A long sequence depicting the announcement of the end of the Algerian War, then, is modernistically accompanied not by music or voiceover, but by the ominous sound of repeated machine guns and explosions. Total silence, in contrast, is used for footage of atomic mushrooms (Figure 5.5).

Magaletta is of the opinion that the choice of music in *La rabbia* rather uncomplicatedly reflects the content of the images; for instance, a chant of the Algerian fighters sang by M'Bareck Nouira is used over sequences of the Algerian War, and Cuban songs by Celina González and Reutilio Domínguez and by Eduardo Saborit are associated with 1959 Cuban footage (Magaletta 2010, 417, 419). Although this is true, the correspondence in tone is not always obvious, and indeed the music can deeply contradict the content of the footage. Brutal images of the arrest of Lumumba in Congo, for instance, are accompanied by a fast and upbeat piece of West African music played on a wooden xylophone (which then extends over footage from India, Indonesia, and Egypt); images of fear, death, and destruction in Cuba are paired with *Décimas de la Revolución*, a song of the Cuban revolution characterized by a danceable Latin rhythm. The schism between music and images is strong in these cases, as also in the recurring example of "a static shot of a man holding a skull, accompanied by wild jazz music" (Léger 2013, 57) (Figure 5.6). Elsewhere, the pairing of Tomaso

8. Magaletta comments, "It is interesting to note that, in 1966, Venetian composer Luigi Nono composed *Ricorda cosa ti hanno fatto ad Auschwitz* (*Remember What They Did to You at Auschwitz*) for a four-track magnetic tape" (146). The sequence does not appear in the final cut; the "corpses of Buchenwald" are, however, summoned by the voiceover over images of a painting by Renato Guttuso (*Pausa dal lavoro*, 1945), accompanied by a popular Russian song, *Kasbek*.

Figure 5.5: Atomic mushroom. *La rabbia.* RaroVideo 2008. Screenshot.

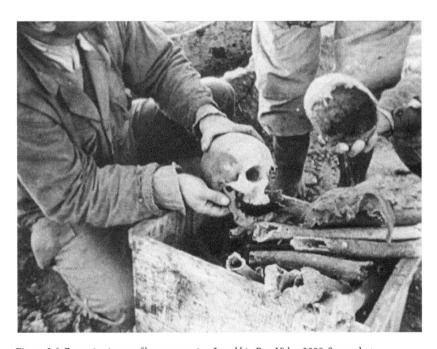

Figure 5.6: Recurring image of human remains. *La rabbia.* RaroVideo 2008. Screenshot.

Albinoni's elegiac Adagio in G Minor is more syntonic with images of death and mourning. In the famous Marilyn Monroe sequence, then, Albinoni's piece gives some coherence to an otherwise deeply disjointed montage of profoundly diverse images simply juxtaposed through straight cuts (of Monroe, atomic explosions, ruined buildings, a religious procession, a beauty contest, a fire, and more). Although the music does not always contradict or deny the image track, however, the prevailing overall impression is one of disharmony and disjunction. Such disjunction operates in a particularly evident way at the level of syntagms; it is between different sound images that the film articulates a series of incommensurabilities, thus making its distinctive essayistic contribution—a political argument on history and society conveyed in ways that are not exclusively centered on word and image but are also affective.

Pasolini often used music to introduce dissonance in his films; it suffices to think of the clash between the sacred music chosen to accompany images of the most miserable lumpenproletariat in his early works, *Accattone* (1961) and *Mamma Roma* (1962), which date from the same years as *La rabbia*. Yet, aural variety and musical dissonance in *La rabbia* are much more pronounced and experimental. All elements of the film are in strident contrast. The register, grain, and tone of the voices keep shifting; the image track alternates radically different images without transitions—from victory, joy, and hope to terror, torture, and violent death; the music keeps changing, from the elegiac composition to revolutionary songs, from folk music to tribal dance, from jazz to pop; the topics cover the entire range from the sublime to contemptible gossip; the approach goes from mournful to satirical; the register constantly rises and falls. No transitions are ever signaled or softened; everything is juxtaposed and no effort is made to suture the various, clashing elements of the film. The resulting cacophony, the vast cultural and geographical diversity of the events we witness, exacerbated by the fragmentation of the footage and the scant documentary information with which we are provided (a field that would normally be occupied, literally filled, by a traditional voiceover), produces a veritable attack on the senses.

The musicality of the film provides Pasolini with a nonnarrative way to express essayistic concepts, while also giving rise to a distinct affective experience. In his book on Pasolini's realism, Maurizio Viano (1993) has noted the nonnarrative aspect of the film and has attracted our attention to a meaning that exceeds verbal discourse:

> Pasolini is testing the possibility of writing an essay in cinematic form in order to convey a different kind of message than that which we expect from words. His intention is to establish a communication that exists apart from that verbal spectrum, escapes

> definition and yet *is* there, thus opposing the logocentric tradition in which nothing
> exists which is not definable. (115; emphasis in the original)

Although Viano does not investigate further the indefinable essence of the communicative project whose presence he rightly senses in *La rabbia*, I claim that it is through a dissonant musicality that Pasolini explores expressive margins, communicative interstices in which a nonexclusively logocentric intellectual discourse is developed.

A film of montage, *La rabbia* replays existing footage in radically new ways. As Catherine Russell (1999) has argued, the intertextuality of montage film "is always also an allegory of history, a montage of memory traces, by which the filmmaker engages with the past through recall, retrieval, and recycling" (238). Recall, retrieval, and recycling are indeed strategies at work in *La rabbia*, which replays the archival footage in ways that evoke ideas of musical reshuffling. *La rabbia*'s musicality, however, is a dissonant one, despite the rhythms, the variations, and the anaphors that are undeniably present. The distinctive, complex musicality of *La rabbia* emerges most clearly when we compare Pasolini's film to other montage documentaries that, making political statements, reshuffle existing images and place musicality at the center of their communicative projects. Two examples of such films are the already mentioned *Now!* and *Surplus: Terrorized into Being Consumers*. The first is coeval to *La rabbia*; made only one year after Pasolini's film, *Now!* is a powerful critique of racism in the United States and a call for action:

> Using mostly photographs clipped from American magazines such as *Life*, Álvarez creates a dynamic montage of images in juxtaposition with the lyrics of "Now" sung by Lena Horne to the tune of the Jewish folksong, "Hava Nagila." The resulting film, *Now*, which is the exact length of the recorded song, is a remarkable precursor to the music video format, 20 years ahead of its time. (Rist 2007)

Now!'s intellectual montage works in unison with the song, both lyrics and notes; the lyrics anchor the meaning of the images, and the music's rhythm accompanies and leads the montage. Álvarez, who had directly experienced racism when living for a period in the United States, recognized that his method and argument in this film were directly shaped by music: "The filmic structure emerged in the editing room around Lena Horne's song, in front of which I reacted in accord with all those previous experiences" (Álvarez in Kristi Wilson 2013, 414). Indeed, his whole work is deeply musical, as emphasized by Kristi Wilson (2013):

> His arsenal of artistic strategies includes violating copyright, remixing iconic images, and a unique use of song as argument that both evokes a particularly Cuban history of

musical counterpoint and reaches out in a transcontinental way toward what he hoped
would become a newly-literate, reinvented, revolutionary public. (410–11)

A way in which the music structures *Now!* is in relation to timing, rhythm,
length, and duration of shots. As Wilson has noted, for instance, "The beat
of the song slowly speeds up as the images zoom in and out on the guns,
batons and dogs used by police officers to curb what is clearly a rising tide of
social unrest. [...] As the film races toward its conclusion, the music speeds
up and the images become more violent" (415). Both rational/logocen-
tric and affective meanings are produced in the coupling and amalgamation
of image track and soundtrack, but there is no dissonance in the meeting
of images, voice, and music in *Now!*. Indeed, the two work in harmony,
euphonically, as in a music video; the pulse of the music enhances the affec-
tive dimension of the agitprop qualities of the film (Figure 5.7).

A much more recent example of political film that can be usefully com-
pared to both *Now!* and *La rabbia* is Erik Gandini's *Surplus: Terrorized into
Being Consumers*, an exploration of issues of late capitalism, enslavement
to consumer culture, and the antiglobalization movement, literally set to
music by the composer Johan Söderberg. Including an interview with the
American anarchist John Zerzan; using lip-synching to satirical effects over
footage of several world leaders, including George W. Bush, Jacques Chirac,

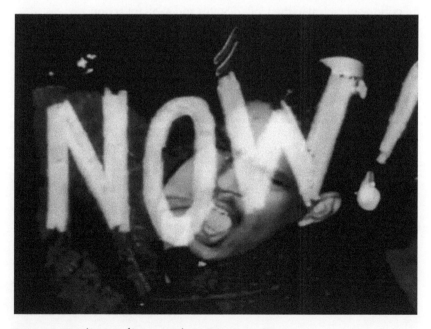

Figure 5.7: *Now!* (Santiago Álvarez, 1964). YouTube. Screenshot.

Vladimir Putin, Silvio Berlusconi, and Tony Blair; and exploring the principles of an anarchoprimitivist philosophy, the film uses its soundtrack to suggest repetitive rhythms that function as a commentary on both images and voiceovers, either by reinforcing ideas of regimentation and the disciplining of bodies imposed by consumerism and by work in late capitalism or by mocking the words of powerful political leaders. The film opens with footage of violent protests at the 27th G8 Summit in Genoa, Italy (2001), a perfect example of its strategy that has learned equally from Álvarez and from MTV. The beat of the soundtrack accompanies images of urban guerrilla of increasing anarchy and destruction, while a superimposed Fidel Castro speech touches on, and connects, issues of imperialism, exploitation, and impoverishment (Figure 5.8). Interestingly, some reviewers have remarked how "Erik Gandini's approach through *Surplus* is to portray this issue from an emotional rather than a factual perspective" ("*Surplus*" 2015). The film indeed conveys its logical argument also in affective ways, through a rhythmic montage of images and sounds.

Although the strategies of both *Now!* and *Surplus: Terrorized into Being Consumers* are predicated on a synchronous and symbiotic rapport between soundtrack and image track, mostly based on rhythm—intended as the pulse of both the music (sometimes replaced by noises) and the montage of images—after considering these examples, the unmitigated dissonant complexity of *La rabbia*'s musicality is even more in evidence. In Pasolini's film, the irrational cut between syntagms, units of images and sounds, dominates to the point that the whole film, taken together, comes across as pure noise

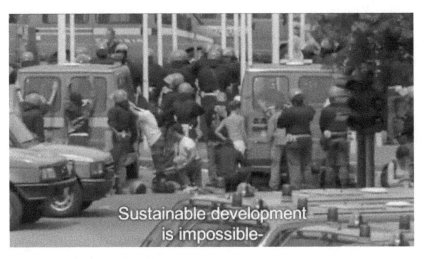

Figure 5.8: Images of the protests at the 2001 G8 Summit in Genoa, Italy. *Surplus: Terrorized into Being Consumers* (Erik Gandini, 2003). Documentary Storm 2003. Screenshot.

(rather than noise turned into music, so to speak, domesticated, to achieve rhythmic musical effects)—as if Pasolini had wanted to capture the "noise" of the twentieth century. The collagist accumulation of sound images means that difference and cacophony prevail over harmony and unity.

La rabbia's wayward soundtrack may be said to be the queering element of the film, which works to disturb and subvert paradigmatic meaning. I understand this queerness in terms of disjunction. As Juan Antonio Suárez (2013) has claimed of sound in the Brazilian experimental artist Hélio Oiticica's expanded cinema work, "[w]hat is queer about it all is the refusal to blend the ingredients into a seamless whole. Something always sticks out and prevents aural suture" (308). Such queering lack of aural suture creates in Pasolini's film a nonexclusively logocentric argument that is a position of protestation, one that, as the prose voiceover states at the start of the film, does not "follow a chronological order, and perhaps not even a logical order, but only my political reasons and my poetic sentiment." Not a line of reasoning, hence, not a logical argument as such, but a sentiment, an affect that is, however, political and that takes on a position between mourning and rage.

The film does contain a logocentric argument that can be reconstructed and is in line with Pasolini's project of ideological critique, whose targets "were many and distributed across the political spectrum," as Kriss Ravetto-Biagioli (2012) has explained: "globalisation, mainstream neoliberalism, the Catholicism of the Italian Communist Party (PCI), the students' bourgeois intellectualism, and Operaismo—the Italian Marxist workerism movements" (93). In La rabbia, indeed, as Roberto Chiesi (2008) has written, Pasolini "stigmatizes neo-capitalism and consumerism as 'diseases of the future,' but also expresses a clear refutation of socialist realism and demonstrates a sorrowful awareness that 'Stalin's sins are our sins too' " (3). Ravetto-Biagioli has persuasively proposed to read Pasolini's heretical ideology, as it becomes manifest in a number of his works, in light of Deleuze's concept of the unthought:

> Pasolini did not position himself within Marxist or radical political movements, but pursued an interest in radical otherness that did not support one type of political party or practice over another. [. . .] His engagement with radical otherness developed into a critical practice that forced him to confront what is unthought in thought. (94)

This practice brought Pasolini to "put forward a critique of conventional dichotomies between North and South, East and West, Left and Right" and to "unthink the deleterious narratives enabled by such dichotomies"

(Ravetto-Biagioli 2012, 95). Pasolini did so, for Ravetto-Biagioli, through the mediums of both cinema and poetry, which he saw as "powerful genres to unthink the discursive moves of both the Right and the traditional Left and expose the madness of dialectics" (96).

As well as in terms of the Deleuzian unthought, then, *La rabbia*'s exposition of the "madness of dialectics" can be understood in relation to what Roland Barthes (2005) has named the Neutral. For Barthes, the Neutral is not a position of neutrality, of undecided grayness, but is that which challenges and "baffles the paradigm" (2005, 6)—where the paradigm is seen as the opposition of two virtual terms, one of which must be actualized to produce meaning, because Barthes shows how meaning always rests on conflict, as it depends on a binary opposition of terms: for instance, A/B, For/Against, Masculine/Feminine. The Neutral for Barthes is a possibility of suspension of a given structure of discourse, where competing ideas are in play; it is a suspension of the arrogant conflicts of meaning, it "embodies the refusal to dogmatize" (10), it is a way of escaping and undoing the binary oppositions that structure Western thought and discourse. The Barthesian Neutral is, for Réda Bensmaïa (1987), what positively characterizes the fragmental nature of the essay as "a text that is capable of integrating the contradiction" (48) and is responsible for the collapse of the economies of textuality as a classical rhetorical system. The multivoicedness of *La rabbia*, its alignment with radical otherness, its refusal to "support one type of political party or practice over another" (Ravetto-Biagioli 2012, 94), its fragmentariness and its dissonant musicality are all strategies that elude the binary construction of meaning. Not only Pasolini worked to unmake binary meanings within his own section of the film; let us not forget that *La rabbia* was construed and marketed precisely as a paradigmatic binary discourse: Pasolini and Guareschi, two intellectuals chosen to represent two opposing ideologies and political sides, were asked to respond to the same question; that is to say, they were expected to take on two opposite stances and answer from within a Left/Right binary paradigm. The film was explicitly promoted as a polemic through the headline "Two ideologies, two opposing tendencies answer a dramatic question: Why is our life dominated by discontent, by anguish, by the fear of war, by war?" Unlike Guareschi, who, in his section of the film, in Pasolini's own words, used "the weapons of mediocrity, of indifference, demagogy, and common sense" (in Chiesi 2008, 14), Pasolini's rage was all but reactionary. Through the interstice, by avoiding aural suture, Pasolini chose to resist the arrogant conflict of meaning; he chose the Neutral—which

does not mean he did not hold a position—in fact, it was a passionately intense one.

The Neutral, indeed, can refer for Barthes (2005) to intense, strong states, because outplaying the paradigm "is an ardent, burning activity" (7). So, the Neutral is not the absence of a position, but an active value, because it displaces the prevailing positions in relation to which an issue finds itself debated. As such, and as Nicholas de Villiers (2006) has argued, it marks a queer desire—namely, in Barthes's own words, the desire "to give imprecise answers to precise questions: this imprecision of the answer, even if it is perceived as a weakness, is an indirect way of demystifying the question: for every question [. . .] can be read as a situation of the question, of power, of inquisition" (107). The Neutral has a baffling, disorderly, even scandalous aspect that appeals to Barthes and that lies in its queerness, in its nonvirility. Meaningfully, Barthes resorts precisely to Pasolini to describe the nonvirility of the Neutral: he quotes the end of his poem "Una disperata vitalità," where the poet with a stammer associates himself with a "desperate vitality." Barthes explains:

> It's this difficult, incredibly strong, and almost unthinkable distance that I call the Neutral [. . .]. In the end, its essential form is a protestation; it consists of saying: it matters little to me to know if God exists or not; but what I know and will know to the end is that He shouldn't have simultaneously created love and death. The Neutral is this irreducible *No*: a *No* so to speak suspended in front of the hardenings of both faith and certitude and incorruptible by either one. (14)

Shunning both faith and certitude, Pasolini's rage in the film is a form of protestation that, by refusing the semantic coherence of a sutured verbal and nonverbal sound, works to subvert the inquisition implied in the interrogation at the origin of the film (which ultimately equates to the question "Who are you?"). In the sonic interstice, meanings emerge in a wayward, queer manner. To use an expression of Barthes himself, "today I myself hear, in fleeting moments, another music" (13).

SUMMARY

The discussion in this chapter of sound or "musical" essays such as *Language Gulf in the Shouting Valley* and *La rabbia* has evidenced further interstitial strategies of dissociation and of dissonance, introducing an analytical emphasis that has allowed me to move beyond the vococentrism and logocentrism of much existing scholarly and critical work on the essay

film to uncover affective components of the essay's intellectual discourse. Sound—noise, music, and vocalizations—has been discussed in light of its power to produce meaning that can contradict as well as complete verbal intelligence, contributing to the politics of the essay film as a practice that unsettles the paradigm. Roland Barthes's category of the Neutral has been mobilized to explain how such unsettling supports ideas of dissociation and in-betweenness, in a way that gives account of the textual integration of contradiction as an element that undoes the classical rhetoric of the system itself of the text. As such, sound in the essay film has been discussed as a queering element of great political potential. In the next chapter, the attention will again turn to voice, in this case as a function of narration, seen as a fundamental site of the essay film's articulation of meaning and discourse.

CHAPTER 6

Narration

Epistolarity and Lyricism as Argumentation

[T]o me, narration and argumentation are still very closely linked. I strongly hold that discourses are a form of narration. (Farocki and Hüser 2004, 313)

A s outlined in Chapter 5, the prevalent understanding of the essay film is colored by a logocentric perspective. This is in no small part a result of its derivation from the literary essay, as well as the influence of a specific tradition, that of French 1950s and 1960s "Left Bank" cinema, best embodied by Chris Marker with films like *Sans Soleil* (1983). In his early contribution on the essay film, André Bazin (2003) wrote indeed of Marker's approach: "I would say that the primary material is intelligence, that its immediate means of expression is language, and that the image only intervenes in the third position, in reference to this verbal intelligence" (44). This book positioned itself differently and moved beyond the emphasis on verbal intelligence, as well as the classificatory urge to define the essay film on the basis of a series of generic features, bringing the issues of functioning, rather than of essence, to the fore. The current chapter will nevertheless engage with voiceover, but as part of the narrative function that is present in all essay films, even in the least logocentric ones. Narration in the essay film has normally been linked to the expression of subjectivity and most directly to the narrating "I." As Timothy Corrigan (2011) has suggested,

An expressive subjectivity, commonly seen in the voice or actual presence of the filmmaker or a surrogate, has become one the most recognizable signs of the essay film, sometimes quite visible in the film, sometimes not. Just as the first-person presence of

the literary essay often springs from a personal voice and perspective, so essay films char-
acteristically highlight a real or fictional persona whose quests and questionings shape
and direct the film in lieu of a traditional narrative and frequently complicate the docu-
mentary look of the film with the presence of a pronounced subjectivity or enunciating
position. (30)

Whereas in a previous study of the essay film I devoted significant attention
to the enunciator and to the expression of subjectivity through voiceover
(Rascaroli 2009), here, in line with the specific aims and concerns of the
current investigation, I will focus on problems of usage and on the func-
tioning of narrative operations in light of strategies of in-betweenness
and gap. I argue that narration, intended as the act of telling a story via
specific narrative structures, is not to be seen as a separate layer, as the
superimposition of a fictional element on documentary matter—a lay-
ering that has often been characterized as the essence of the essay film.
I argue, indeed, that the essay film is not merely a hybrid, a documentary
film with a nonfictional component; rather, it is a specific form of textual-
ity, and narration is a constitutive element of its epistemological and sig-
nifying strategies. Argumentation and narration, in fact, are one and the
same; as Harun Farocki (Farocki and Hüser 2004) has rightly remarked,
"discourses are a form of narration" (313). Consequently, my aim in this
chapter is to unravel how narration expresses argumentation by capital-
izing on the essay form's disjunctive ethos. More in detail, this chapter
coincides with an investigation of the fragility that is intrinsic to the essay
form, of its potentiality for breaking down, for disassemblage—which was
first explored in the introduction via an engagement with work by theo-
rists such as Adorno, Deleuze, Burch, and Bensmaïa. The chapter will also
deal with counternarration, that is, with strategies that sabotage narrative
structuring.

Narration is not simply equivalent with narrative voice; narrative form
and style, point of view, focalization, ordering of events, and temporality are
some of the textual elements that participate in the process of telling a story.
Taking all these elements into account, this chapter will explore two case
studies of narration and counternarration in the essay film. The first is the
letter. Janet Gurkin Altman (1982) defined epistolarity as "the use of the let-
ter's formal properties to create meaning" (4), and this is precisely the focus
of the first part of the chapter. My aim will be to investigate how epistolary
narratives shape essayistic meaning, as an example of the range of narrative
forms on which the essay film may draw. The second part of the chapter will
reflect on a counternarrative mode: lyricism. I refer to lyricism as counter-
narrative for its propensity to fragmentariness, incompleteness, and lacuna
and for it being a force that produces meanings associated not to story or

rational discourse, but to affect. The aim is to show how argumentation can be constructed also through poetic affect and aesthetic form.

Overall, the aim of this chapter is to explore some of the ways in which narrative too is a field of disjunction in the essay film. This is a potentially contested notion, because narrative normally is what keeps a text together; it is its fabric itself. The task, therefore, is to show how narration contains the possibility of its own undoing and how this equates with meaning-making in the essay film.

DEAR SPECTATOR: ADDRESS, DISTANCE, AND
SELF-EVALUATION IN THE FILM-LETTER

The letter is to be found at the heart of the tradition of essay filmmaking that may be said to originate with Chris Marker. Many of Marker's films are, indeed, epistolary, including *Letter from Siberia*, in which the male narrator addresses an unidentified recipient who comes to coincide with the spectator; *Sans Soleil*, with a female narrator reading letters that were sent to her by cameraman Sandor Krasna, an alter-ego of the director; *Le tombeau d'Alexandre* (*The Last Bolshevik*, 1992), made in the form of six video letters posthumously addressed to the late Soviet filmmaker Alexander Medvedkin; and *Level Five* (1997), in which a woman addresses her disappeared lover and, through him, the spectator. Marker's repeated choice of this narrative mode, sometimes coupled with the travelogue, has at least two implications that are worth highlighting for the purposes of the current discussion. The first is the connection between Marker's films and the philosophical epistolary essay. This long-standing tradition, which goes back as far as the Hellenistic age and philosophers such as Epicurus, flourished among the Romans, counting examples such as Cicero and Seneca—for whom "the epistolary essay [. . .] became a literary type of the highest order" (Hassler 2012, 478); it then continued in the Middle Ages and the Renaissance (Alexander Pope, Voltaire), through to the eighteenth and nineteenth centuries (Edmund Burke, Thomas Malthus). Meaningfully, one the key theorizations of the essay form, by György Lukács (2010), was written in the form of a letter to Leo Popper.

The second aspect uncovered by Marker's use of the form is that the reflective stance in epistolary essays is coupled with a particular form of address; to quote Catherine Lupton's (2006) description of *Letters from Siberia*'s voiceover, this "uses the intimate and seductive address of the personal letter to draw the viewer directly into the scene" (54). In other words, the choice to debate philosophical issues via the epistle generates an intimate, shared space, in which argumentation takes on a personal and

inviting tone. This may be best seen in Marker's *Level Five*, in which the protagonist addresses her missive "to her absent lover as viewer or perhaps also to her viewers as distant discursive lovers" (Murray 2000, 119). Arguing that epistolarity is what links Marker to Henri Michaux, indeed, Raymond Bellour (1997) wrote that "[t]he letter, for Michaux, is only the crystalline form of a larger manner of always addressing the reader, of calling upon him with all the means of the language" (111).

Although Marker frequently positioned his work between the traditions of the philosophical essay, the travelogue, and the letter, epistolary cinema is a form frequently used by displaced, exiled, and diasporic filmmakers— such as Atom Egoyan, Chantal Akerman, and Jonas Mekas, among many others. Accordingly, the epistolary form in film was most thoroughly explored by Hamid Naficy in his work on accented cinema. Letter-film is the term introduced by Naficy (2001) to describe films that "are themselves in the form of epistles addressed to someone either inside or outside the diegesis" (101) and that are distinguished from films that inscribe the diegetic characters' act of writing and/or reading letters. Naficy's investigation sets off from the observation that "[e]xile and epistolarity are constitutively linked because both are driven by distance, separation, absence, and loss and by the desire to bridge the multiple gaps" (101). The position from which the narrative emanates in epistolary cinema is one of distance, which is at once emphasized and overcome by the intimate address. The adoption of an epistolary address is, indeed, particularly apt to inscribe a disjunction that deeply colors the narration, and I will argue in what follows that this is precisely what its use has to offer to the distinctive practices of the essay film.

Naficy has also explored the complex dialogical relations in epistolary films, where addresser and addressee can be diegetic, extradiegetic, or both, and has highlighted how self-reflexivity and self-referentiality are frequently to be found at the core of their project: "Epistolary filmmaking also entails a dialogue with the self by the filmmaker, as well as self-evaluation" (2001, 104). This is another element of the epistle that is germane to the essay film. Finally, the letter is, like the diary, a form that radically mixes and merges private notations and commentary on public matters, the record of both everyday life and momentous events, thus lending to the epistolary essay film its hybrid approach.

All these elements will be emphasized and explored in the discussion that follows, which focuses on the case study of an epistolary essay film by Nguyễn Trinh Thi. Other examples from both past and recent productions include, in addition to Chris Marker's films, Roger Leenhardt's *Lettre de Paris* (1945), an epistolary portrait of Paris in 1945; Pier Paolo Pasolini's *Le Mura Di Sana'a* (*The Walls of Sana'a*, 1971), a plea to UNESCO to protect

Yemen's endangered cultural patrimony; Jean-Luc Godard and Jean-Pierre Gorin's *Lettre à Jane* (*Letter to Jane*, 1972), a critique of a photograph of Jane Fonda in Vietnam; Jean-Luc Godard's *Lettre à Freddy Buache* (*A Letter to Freddy Buache*, 1981), an exploration of the director's inability to make a film commissioned by the city of Lausanne on the occasion of the five-hundredth anniversary of the town's founding; Eric Pauwels's *Lettre à Jean Rouch* (1992), an essayistic discussion of the inheritance of Jean Rouch and of the essence of the cinema itself; Pauwels's *Lettre d'un cinéaste à sa fille* (1998), an exploration of memory and storytelling; Rebecca Baron's *okay bye-bye* (1998), which, through an epistolary address, examines issues of memory and history in the context of the Cambodian genocide; *Life May Be* (2014), a cinematic exchange between Mark Cousins and Mania Akbari; and Eric Baudelaire's *Letters to Max* (2014), a correspondence of the filmmaker with his friend Maxim Gvinjia, focusing on the post-Soviet, unrecognized country of Abkhazia.

THE EPISTOLARY ESSAY FILM AND THE RIGHT DISTANCE: *LETTERS FROM PANDURANGA*

Lettres de Panduranga (*Letters from Panduranga*, 2015), by the Hanoi-born filmmaker and media artist Nguyễn Trinh Thi, is a thirty-five-minute video essay in the form of an epistolary exchange between a woman and a man, who write to each other from two different Vietnamese provinces they are visiting; the letter format, thus, merges here with the travelogue. The woman (voiced by Nguyễn Trinh Thi) is in Ninh Thuận, formerly Panduranga, the only remaining area of the ancient Hindu culture of the Cham. The man (Nguyễn Xuân Sơn) is north of where she is, in Central Vietnam, first in Trường Sơn or Long Mountain, famous for the Hồ Chí Minh trail, which, used during the Vietnam war, is considered one of the great achievements of military engineering of the twentieth century; then in Đà Nẵng, near the ruins of Mỹ Sơn, the Hindu temples erected by the Cham kings between the fourth and fourteen century AD, today a UNESCO World Heritage Site and host to a Cham museum; finally, he writes from "the future," as he says, in Quảng Trị, northern Central Vietnam, an area where landmines are still present today, decades after the war, and are made to explode every day.

The former Champa kingdom referenced in the film peaked in the seventh to tenth centuries and came to an end after wars with both the Khmer and the Viet; its last remaining parts were annexed to Vietnam in 1832. Not recognized as an indigenous population but merely as a minority, the descendants of the ancient Cham have seen their history, cultural heritage, and religious practices being progressively threatened and erased, both

in historical accounts and in material ways. Their living conditions, then, are substandard when compared to those of ethnic Vietnamese, pointing at issues of discrimination and unequal access to resources. The film was sparked by the decision of the Vietnamese government to build the country's first two nuclear power plants in Ninh Thuan by 2020—and by the absence of public debate on this program. As Nora Taylor (2015) has written, for a long time the Cham were subjected to colonialist discourses that tended to present them as "an inferior race, diluted by foreign cultural influences, inauthentic, unlike the pure and original Chinese and Indian civilizations" (57). The same strategy of presenting Champa as a land of the distant past, even a mythical place, already discussed in Chapter 3 in relation to what I called ethnolandscape and to colonialism, has shaped for Taylor the Vietnamese scholarship on the region, so much so that "[t]he land of Champa was detached from its history" (59). It is precisely this absence that is at the core of *Letters from Panduranga*. As the man remarks over images of the temples of Mỹ Sơn, the place was made a UNESCO site as evidence of an Asian civilization that is now extinct, and so he ironically wonders whether the Cham his friend is meeting in Panduranga are evidence of the same extinction. The film addresses a range of problems and tensions, including neocolonialism and enforced assimilation, the control and erasure of cultural identities, the preservation of cultural heritage versus its touristic exploitation, ethnography and the ethics of speaking on behalf the other, gender, and self-determination.

The film opens with an image of water, over which the woman's voice recites, "I'm writing you this letter from what seems like a distant land. She was once called Panduranga"—a direct citation of the opening address of Marker's *Letter from Siberia* ("I'm writing you this letter from a distant land. Its name is Siberia"). The reference is repeated because, as in Marker, the line is spoken again later in the film, in slight variations. The direct citation inscribes the film in the epistolary travelogue tradition and is a nod to Marker's lifelong reflections on travel, culture, history, and ethnography, as well as to *Letter from Siberia*'s approach to the "distant country" as one perched between myth and history, past and modernity. It is significant that, at the start of the film, rather than a landscape view of the region from a vantage point, the image of a shifting expanse of seawater is offered—on which a single person floats on a small boat, capturing the impression of a lonely and fragile existence, as well as suggesting the filmmaker's reluctance to assume a position of power over her subject matter. The film presents, indeed, the Cham as an ethnic and cultural island that has undergone processes of silencing and erasure, containment and dispossession.

The two geographical areas visited by the narrators, in southern and central Vietnam, respectively, are juxtaposed throughout. Images are shown

of Cham people, shot as in portrait photography, individually, in couples, or in groups; these alternate with images of landscapes from both regions. The narrators debate the two different approaches and discuss the ideology behind modes of portraiture. At one point, the man refers to an article he once read in the *National Geographic*, analyzing the photos of non-Western people the magazine had published over the years:

> They said that those who are culturally defined as weak—women, children, people of color, the poor, the tribal rather than the modern, those without technology—are more likely to be depicted facing the camera while the more powerful or "sophisticated" are to be represented looking elsewhere.

Questions of the ideological and power structures of looking at and photographing people and landscapes are discussed throughout the film; at one point, the male narrator references the landscape theory of Masao Adachi (director of *AKA: Serial Killer*, 1969) and other radical Japanese filmmakers of the 1970s who, influenced by Marxist film criticism, posited that every landscape contains power structures—although, replies the woman over images of a quiet landscape at sunset, she is unsure that the landscapes she is seeing reveal such a thing.

Another essay film quoted in *Letters from Panduranga* is Alain Resnais's collaboration with Chris Marker *Les Statues meurent aussi* (*Statues Also Die*, 1953), a critique of colonialism that discusses Sub-Saharan African statues as museum pieces, separated from their original cultural, religious, and spiritual values and lived contexts—a similar reflection is present in *Letters from Panduranga*, which pauses on the equally "dead" sculptures in the Cham museum. Issues of tourism, seen as a form of control, dispossession, and exploitation, are also discussed in relation to the temples of Mỹ Sơn: "Culture is being vulgarized; invisible beauties are forced into hiding in the name of tourism," comments the woman in one of her letters. One of the statues discussed in the film, however, tells a different story: a replica of the Statue of Liberty in Hanoi, erected by the French colonial government, was toppled in 1945; the man reports that, in an ironic twist, it was melted down to cast a bronze of Buddha.

The epistolary dialogue between the two subjects shapes the whole narrative. The letters are read out by their authors; however, there is some ambiguity as to whether they are written letters or if they are audiovisual texts exchanged by the two correspondents—and, so, whether they are to be considered part of the diegesis, in the first case, or if the whole film is made up of fragments of letter-films (to use Naficy's terminology) and fully coincides with them. The narrative ambiguity in *Letters from Panduranga* also pertains to the characters, which are not identified by their names or

specific roles; they could be two filmmakers, intellectuals, activists, photographers, or media artists—or a combination of the above. Although the details of their status and relationship are never clarified, the two address each other on the basis of deep reciprocal familiarity, as collaborators, colleagues, or friends, who share similar interests and practices.

In temporal terms, the narration is chronological; yet, it is difficult to tell exactly how much time elapses between letters, which are not dated. Because only parts, sometimes fragments, of letters are read, the exchange seems instantaneous and comes across as a close dialogue; once, however, the man remarks that some time has elapsed since he received her previous letter. The narrative plausibly lasts a few weeks; in his first letter, the man says he has two weeks to travel along the Hồ Chí Minh trail on his old motorbike. Temporality in the film is complex, however, not least because the present is seen as a symptom of various layers of pastness, which are examined in their historicity and in their being shaped by ideological discourses of containment and control: the mythical substratum, the distant historical past of Panduranga, and the recent, conflictive history of Vietnam. At one point, the man says he writes from the future—probably that of the nuclear power plants to be built, to which the futuristic uniform worn by a person seems to allude (Figure 6.1).

The two correspondents are the two main narrators; only one other point of view is expressed directly by somebody else: a Cham intellectual who comments on his people's history and present state, quoting Nietzsche. With the exception of this sequence and, to a lesser extent, of two sequences in which first a man and then a woman sing the same Cham

Figure 6.1: The future: *Letters from Panduranga* (Nguyễn Trinh Thi, 2015). Screenshot.

popular love song, all information in the film is filtered through the two main narrators; because they speak in the first person and the images we see are a direct visualization of their speech, they are the focalizers of all sounds and images and of all the knowledge that is conveyed to the spectator. There are, however, moments when the presence of a separate level of enunciation becomes tangible; for instance, when female hands appear on screen manipulating photographs and objects, even if the male narrator is speaking; or when the woman and the man speak in turn, one after the other, over the same images, which contradicts the way in which the rest of the narration is organized. In such moments, the split between the textual figures is felt most strongly, and the source of the narration and focalization is problematized.

These moments of uncertainty, in which a gap appears more evidently in the narration and between its levels, echo the broader questions that are raised by this highly disjunctive text on who speaks, who sees, who knows, and who is addressed. Disjunction is, indeed, the cipher of a film in which dualism is pervasive. Not only two are the narrators, a woman and a man, and two the locations from which they write to each other; but also a whole series of binaries are highlighted—such as portrait versus landscape, foreground versus background, past versus present, close up versus distance, looking into the lens versus looking out of frame, and so on. Some of the figures of two emphasized in the film are the pairs of stones under which the Cham Bani bury their dead (Figure 6.2), the two power plants to be built in the two-thousand-year-old civilization, and the paired photographs and paired images of statues; as well as the postproduction interventions

Figure 6.2: The Cham Bani's cemetery. *Letters from Panduranga*. Screenshot.

that visualize duality, such as the superimpositions of images or, even more striking, the split screens showing the same place from two slightly divergent angles or two slightly different moments in time (Figure 6.3). These split screens create the uncertainty of optical illusions because the two shots are often joined in a way that tricks the eye, concealing the "joint" and suggesting an impossible continuity, which is both emphasized and violated by bodies moving in and out of frame. Elsewhere, the same shot appears twice but separated by an imperceptible delay—our understanding of the sequence's temporality being further challenged by the fact that the clip is run backward, suggesting the evocation of the past of the Cham, as well as their obliteration.

All this epistemological uncertainty chimes with the doubts voiced by the female narrator, who repeatedly alludes to her problem of how to relate to the story she came to tell: "I'm still struggling to find a way in," she admits at one point. "I have made friends," she acknowledges; "still, I can't help but feeling conscious of being an outsider." Being outside the story one wants to tell is a problem with which the man also grapples; after he describes being interrogated by the police about some footage of women he took one day, he comments that, finally, this time he found himself inside history. The importance of this issue is clarified when the man observes, "You are trying to access the story of another culture, another people, and I the story of the past, of history."

The question of where the essayist should be positioned in relation to the story to be told is central not only to this film, but also to the essay film *tout court*, because querying the narrating stance and its ethos (its proximity to/distance from the story) is part of the essay's self-evaluative process. As the woman clarifies, "I'm trying to avoid speaking on behalf of the other." This effort produces self-doubt, which is expressed, for instance, by the woman as a question on the functions and motivations of the essayist: "I want to leave. I am not an ethnographer systematically studying the Cham's ways of life, traditions, rituals; nor am I a journalist who could write about issues directly. I don't know what I'm doing here." Neither ethnographer

Figure 6.3: A split screen in Mỹ Sơn. *Letters from Panduranga.* Screenshot.

nor journalist, the narrator admits to having explored different methods of documentary and fiction, but "nothing seems right." The advice of her correspondent is to "work at a distance"; as he comments, "I think there's a point for you to use fiction in the Cham story. It gives you a bit of a distance. Documentary is often too close." If documentary is too close, however, fiction can be too far; as he adds, "reality is more exciting than fiction," because "it's full of holes, gaps."

Narration in the essay film is thus portrayed in *Letters from Panduranga* as the process of finding the right distance: as in a meaningful sequence in which a hand holding the picture of a standing stone slowly moves closer to the lens, so that the image, which was initially out of focus, becomes progressively sharper (Figure 6.4). In essay films, which are essentially performative texts incorporating a trace of the process of thinking, these progressive readjustments are often visible; they coincide with the film's own narrative development. A state of narrative in-betweenness is identified as the best distance, the best way to tell the story of an interstitial place: "I write to you from what seems like a distant land. Her name is Panduranga. She lies somewhere between the Middle Ages and the twenty-first century. Between the earth and the moon, between humiliation and happiness."

Developing between two correspondents, the epistolary form is inherently intermediate. It highlights a distance and a lack and at once offers temporal and geographical proximity. The intimate address of the letter compensates for the ethical distancing of the essayist from her subject matter, creating the ideal positioning between participation and detachment. But the apparent equilibrium of such a narrative form is deeply problematized in *Letters from Panduranga*. The pervasiveness of the figure of the

It's full of holes, gaps,

Figure 6.4: "Reality is full of holes, gaps." *Letters from Panduranga*. Screenshot.

double in the film points, in fact, to a schism, a disjunction—at once of the Cham from their past, their culture, and their land and of the subject from itself. The dualism of the narrators hides, indeed, a split subjectivity. As Nguyễn (2016) has confirmed, talking of her two narrators,

> They are my self-portraits. They are both mostly myself, or to be more precise my differ-
> ent selves, my selves of different times and spaces. For example, in a way, the woman's
> voice can represent my thinking and approach of a few years earlier, and the man's voice
> represents the shift in my approach (shifting to the background, etc.). Or the woman's
> voice represents my tendency when I was close to the scene, or being in the field; while
> the man's voice represents my other self when I come back home from fieldwork, gaining
> a distance, and starting to do reflections.

This subjectivity split in time and in space, with two parts of the "I" taking the form of correspondents who cinewrite letters to one another, is at the basis of a narrative strategy of profound disjunction, barely concealed by the stratagem of the intimate epistolary exchange. Letters always weave a fragile textuality, one dependent on the next epistle being written, reaching its addressee, and being read and understood; the whole text is perched on the continuation of a dialogue that is deeply contingent and subject to a range of material and emotional conditions. In *Letters from Panduranga*, in turn, the split self is at the origin of an added risk of textual dissolution that, however, is also the necessary condition for the creation of that in-betweenness that, I have argued throughout this book, is at the core of the essay form. As Nguyễn (2016) has meaningfully commented, "I usually find myself being pulled by different impulses and desires. And I find myself typically being in some kind of in-between spaces." It is this split and this in-betweenness that the epistolary narrative most distinctively has to offer to the essay film and its disjunctive practices.

THE LYRIC ESSAY, FROM LITERATURE TO THE CINEMA

Just as narrative forms such as epistolarity, with their fictional structures, seem to openly clash with the nonfictional ethos of the essay, lyricism seems to run contrary both to rational argument and to the workings of narration. Yet, the lyrical is clearly distinguishable in the history of the essay film. Most obviously associated to the cinema of poets, such as Forough Farrokhzad with her *Khaneh siah ast* (*The House Is Black*, 1963), Jean Cocteau with *Le Testament d'Orphée* (*Testament of Orpheus*, 1960), and Pier Paolo Pasolini with *La rabbia*, it has also been associated with the work of essayists such as Chris Marker, Alain Resnais, Joris Ivens, Jonas Mekas, Rithy Panh, and

Aleksandr Sokurov. The term is adopted with increasing frequency by critics and by filmmakers alike to describe a diverse range of films.

In literature, the term "lyric essay" first emerged when the magazine *Seneca Review* began to publish a section thus named in 1997. Although a lineage of work using an allusive, evocative language and approach perceived to be closer to that of poetry than of prose can be traced from the ancient times to the age of the Internet, before doing so it is important to acknowledge that the lyrical is in fact at the core of the essay form, if we consider that linguistic eloquence is one of its constitutive features, so prominent that some, like Max Bense (2012) in a 1947 contribution, have described the literary essay as existing precisely on the frontier between prose and poetry (72). In "On the Nature and Form of the Essay," in turn, Lukács (2010) refers to poetry as the "sister" of the essay (29) and, indeed, of essays as "intellectual poems" (34).

More specifically, the adoption of a lyric approach to convey an argument may be said to spring from the end of the code of strict separation of genres prescribed by classical doctrine and from the emergence of hybrid forms such as the prose poem and the poetic prose. Horace's (65 BC–8 BC) work, especially his *Epistles* and *Ars Poetica*, are early examples of philosophy and literary criticism in verse; among his many imitators, Alexander Pope (1688–1744) is worth citing for his didactic poems *Essay on Criticism* and *Essay on Man*. Thomas de Quincey (1785–1859), Virginia Woolf (1882–1941), and Aleksandr Blok (1880–1921), in turn, are often cited as prominent examples of authors who wrote essays in a lyrical prose.

Despite its "slight implication of literary nonsense" (D'Agata 2014, 7), the lyric essay has been described as a form that draws from two traditions:

> The lyric essay partakes of the poem in its density and shapeliness, its distillation of ideas and musicality of language. It partakes of the essay in its weight, in its overt desire to engage with fact, melding its allegiance to the actual with its passion for imaginative form. (D'Agata and Tall 1997, 7)

This definition places the accent on the use of a poetic language and of what could be termed formalism as features distinguishing the lyric essay from an "ordinary" one. In an article on the online blog as a form that revives the classic essay, Sven Birkerts (2006) refers with the term to essays that "do not necessarily march forward logically but present their elements associatively, sometimes without obvious connective tissue; or they combine their materials more in the manner of collage, juxtaposing several themes or kinds of narrative sequences. In some ways, they adopt the resources of poetry." The lack of connective tissue is suggestive of a looser, fragmentary structure. Ander Monson (2008), indeed, emphasizes both

attention to form and a poetic fragmentariness that can be described as a structure of gap:

> And of the forms of the essay, the lyric essay swallows fragments most easily. In order to accommodate gap, the essay must ape the poem—it must create an openness, an attention to beauty rather than meaning, at least on the micro-scale, it must jump through gaps and continue on, an elision of the white space on the page.

Although references to the lyrical component of essayistic cinema start as early as André Bazin's article on Marker's *Letter from Siberia*, which he describes as "an essay at once historical and political, written by a poet as well" (44), far less critical attention has been paid to the definition of the lyric essay film than to the literary one. This may be because of the oxymoronic edge of the term, on which I remarked above. Although acknowledging that the essay film's voiceover can include the lyrical mode, for instance, Corrigan (2011) describes the lyrical as being almost at odds with the essayistic:

> With a perplexing and enriching lack of formal rigor, essays and essay films do not usually offer the kinds of pleasure associated with traditional aesthetic forms like narrative or lyrical poetry; they instead lean toward intellectual reflections that often insist on more conceptual or pragmatic responses, well outside the borders of conventional pleasure principles. (5)

Conversely, in an article on Chris Marker's *The Last Bolshevik*, David Foster (2009) explores the concept of a lyrical essay cinema drawing on Gerhard Richter's definition of *Denkbild*, or "thought-image," as practiced by Walter Benjamin, Theodor Adorno, and Siegfried Kracauer, a method that "brings together the philosophical essay and the lyrical poem in a way that is both critically rigorous and personally engaged" (3). For Foster, "concerns of reflexivity, narrative and metaphor are central to an understanding of lyricism":

> The metaphoricity of poetic discourse replaces narrative organization with strategies of correlation and re-imagination. Thus, lyric film might be summed up as mode of discourse that deploys various permutations and negotiations of subjectivities, inflected by reflexive or transtextual gestures and organized by counter-narrative procedures and the metaphoric "seeing as" that proceeds along lines of correspondence and relation. (8)

In an article on what he terms "personal-screen cinema," in turn, Steven Wingate (2015) discusses the lyric essay film as a new form whose roots he traces in creative nonfiction, a field he associates with the metafiction

movement in literature (Donald Barthelme), the subjective or poetic documentary in film (D. A. Pennebaker), and the recent lyric essay as identified and described above. Wingate, who is particularly concerned with the contemporary short video essay as a form of personal audiovisual expression, also discusses its links with experimental film and video art. Among its features, he insists in particular on its fragmentariness, generic hybridism, and power to reaestheticize our lives.

Of the essay films discussed in this book, Sokurov's *Elegy of a Voyage*, des Pallières's *Drancy Avenir*, and Pasolini's *La rabbia* may be described as lyrical. Sokurov's film is built on metaphor, in particular the metaphor of liquidity, to convey a dual argument on the increasingly fluid nature of the image on the one hand and of the Self in the contemporary society on the other. The film, furthermore, adopts an elegiac approach through its dusky images and overall poignant tone. Also a poignant text, *Drancy Avenir* produces metaphoricity through its slowly moving images, suggestive of the passing of time and of lives and of the ineluctability of the demise; its visual strategy is coupled with an eloquent, elegant voiceover narration. Both films, then, are characterized by the formalism of a highly aestheticizing gaze and proceed in an allusive rather than rational way. The work of a poet, Pasolini's *La rabbia* is a highly fragmentary text that mobilizes the concept of poetic rage and includes a lyrical commentary making use of rhyme and refrain; the visual language was also described as poetic for its use of anaphora and of gestural, symbolic, and formal rhymes. Also, the film analyzed in the first part of this chapter, Nguyễn Trinh Thi's *Letters from Panduranga*, has poetic features, drawing as it does on metaphor (of duality), on rhythm and repetition of both words and images, and on circularity (the film ends with the same images with which it opens and with the lines "Perhaps I've been dreaming in a poem that is coming to its end").

In line with the aims of this study, in what follows I will focus my attention on lyricism as a function of the essay film's thinking—hence, on its capacity for thought. My hypothesis is that the lyrical in the essay film is not subordinate to logical thinking or separate from it, as an addendum; rather, it is argument and instrument of argumentation.

BETWEEN SKEPTICISM AND AFFECT: *THE IDEA OF NORTH* AND NONVERBAL LYRICISM

My case study of lyricism as counternarration, *The Idea of North* (1995) is a fourteen-minute short by the North American director Rebecca Baron titled after Glenn Gould's 1967 radio documentary of the same name, produced by the Canadian Broadcasting Corporation, in which five people

discuss their views of Northern Canada—a space that represents "the fulcrum of poetic loneliness and vast, empty places" (Neumann 2011, 37). The same poetic idea of North meets and clashes in Baron's film with the North seen as an extreme horizon of scientific discovery and technological mastery of space. *The Idea of North* sets off, as Baron's voiceover explains, from the narrator's encounter with a set of photographs that were taken in 1897 during a Swedish hydrogen-balloon expedition to the North Pole. Led by Salomon August Andrée, an engineer, physicist, and explorer, the expedition was ill-fated: the balloon crash-landed after three days of flight, and the three men of the crew died in the attempt to reach safety, after surviving some thirteen weeks on the ice. The photographs were eventually found in the camera, which had been buried for thirty-three years in the ice; they were first printed in 1930. The film is a partial, allusive reconstruction of the expedition and of the last days of the explorers based on the photographs, on excerpts from the men's diaries, and on contextual evidence found by the party that discovered the last campsite and uncovered the bodies.

Coming from an age of unfaltering faith in science, technology, and progress, the story told by the film is one in which the trust in man's knowledge and will merged with adventurism to ruinous effects. The fate of the three men is sealed from the start of the narrative, locked in the fixity of the photos that captured their last reflections and in the ice that froze their bodies and their technology. The narrator's impassionate voiceover starts in the first person, recounting her encounter with the first set of five photographs of the expedition printed in a book, and then moves on to a few further images she discovered later, some of which were enhanced to increase the focus, clean the marks left by time and the elements, and bring out the detail (Figure 6.5). The vicissitudes and outcomes of the expedition are described by the narrator in a radically lacunary way, stemming from the waning visible evidence and fragments of historical knowledge; we learn some of what happened to the men and hear that they continued to uphold their scientific commitment by collecting samples even under impossible conditions. The image track, meanwhile, supports what we are told; in the absence of sufficient original images, evidently reconstructed and allusively performed footage is introduced. We see, for instance, detail shots of hands carefully wrapping scientific specimens or breaking ice with a tool (Figure 6.6); a human figure slowly walking away from the lens on an icy surface; and hands trying to open the pages of an old frozen book. At one point, the narrator starts reading from one of the diaries that were found at the campsite, and so the narration suddenly switches to the first person plural, increasing our sense of proximity to the events and to the men. Our desire to get closer and comprehend, however, is at once titillated and frustrated. The narration is fragmentary and disjointed, just like

Figure 6.5: Original photograph of Salomon August Andrée's balloon expedition to the North Pole. *The Idea of North* (Rebecca Baron, 1995). Screenshot.

Figure 6.6: Reenactment: collecting scientific specimens. *The Idea of North* (Rebecca Baron, 1995). Screenshot.

the visible evidence is lacunary and waning. The film opens with a series of undistinguishable images and noises, giving the impression of somebody trying to tune into a transmission from a distant past. As they become clearer, images and sounds are nevertheless repeatedly disjointed by irrational cuts, black or white screens, and silence, suggesting the filmmaker's unwillingness to provide a comprehensive narration by filling the many, gaping holes of the story. At the end of the film, fragments of sentences from the diaries appear as captions on a black screen: the few words separated by the many elision dots visualize the acute lack of connective tissue of the story, the voids in a narrative that are too severe to be filled.

An argumentation thus develops from the interplay of images and sounds, which are radically different for quality and status (at the image-track level: still and moving images, original, enhanced, and reenacted images, black screens, scratched screens, superimposed captions; at the soundtrack level: music, noises, recorded voices, and the filmmaker's voiceover). These components incessantly come together to form constellations, lumps, layers of meaning—only to break apart again. The film explores at least two interconnected aspects of the theme of the gulf between man's trust in technology and its ultimate inadequacy. First, it foregrounds Andrée's misplaced faith in the balloon and in the expedition's scientific premises and technological tools, which from today's perspective look gravely inadequate, almost grotesque, in the face of the extremity of the conditions of flight over, and survival at, the North Pole. Second, the imperfect preservation of documentary traces through the written diaries and the photographic camera demonstrates the frailty of our technologies of record and memory, inviting by extension a reflection on film's limitations as a tool to preserve and mediate human experience.

Furthermore, an argument on narration as inference and speculation develops because of the deficiency of the elements of the story and of a narrative mode based on a radically fragmental approach. The faded photographs and diary words are incomplete, pale, almost illegible traces of an embalmed subjectivity and a distant human experience that remain largely unknowable; the film attempts not a full, perfected reconstruction, but mimics the allusive unfolding of an experiential engagement via performative elements that offer glimpses of knowledge and of empathetic understanding—while discouraging the illusion of full apprehension. By underscoring the "I," then, along with the film's personal motivation and origination (as the voiceover recites, "I begin in the middle; I begin with a set of five photographs printed in a book of Scandinavian photography"), the text openly embraces contingency, partiality, and incompleteness ("the middle"), while declaring its interest in an experiential relationship with the world. At the same time, the logical argument extends to a meditation

on questions of temporality, with the creation of a compelling, "paradoxical interplay of film time, historical time, real time and the fixed moment of the photograph" (Baron 1997).

In mixing extremely hybrid materials, *The Idea of North* experimentally shatters the distinction between fiction and documentary, record and argument, essay and art object. But there is yet another component that exceeds all this and must be accounted for. Although the narrative voiceover is not poetic, the film is undoubtedly lyrical: it has the brevity and compactness of a poem, as well as its profound linguistic (in the sense of film language) and epistemic allusiveness and affective poignancy. The lyricism may be said to be the result of a range of techniques, starting from the choice of format. Baron's use of 16mm is indeed significant because this is a film that produces an aesthetic and affective "surplus" that, I argue, runs contrary to its logical argument on the fallibility and obsolescence of technology. The 16mm recreates the "grain" of an outdated image, thus evoking through form that past which, the film argues, is impossible to resurrect; simultaneously, it excites visual pleasures linked both to a film aesthetics strongly associated with formal experimentalism and to that nostalgia for "imperfect," blemished past technologies that is typical of our flawless digital age (Haswell 2014). It is precisely this aesthetic/affective surplus, and its contribution to the film's thinking, that I wish to investigate here.

In addition to the aesthetic grain of the image, lyricism springs from other elements of the film, including the allusiveness of its reconstructions of imagined moments of the expedition, which, albeit not devoid of an ironic touch, foreground detail in an aestheticized and poignant manner; they support the spectator's momentary affective reconnection with states of loneliness, denial, hope, despair, pain, and death experienced by the three explorers. The complex layering of times in the film is also deeply allusive, at once affording the experience of transcendence of temporal limits and remarking on its illusionary and mediated nature. Whereas a loop from a Beethoven sonata at the beginning and end of the film alludes to a modernist, fragmentary approach, the main musical theme, from the poignant *Valse triste* by the Finnish composer Jean Sibelius, underscores the somberness of an elegiac meditation on human failure and demise and introduces lyrical elements of rhyme and repetition. A poetic idea of North as the ultimate limit of our imagination of the world, and of our experience of it, underlies the whole text.

Baron's film is sustained by a skeptical intellectual inquiry in the fallibility of our technologies of record and memory and the injudiciousness of our absolute faith in science and progress and in the dominion of man over nature. Yet, as the film's form gravitates toward formlessness (static noise, undistinguishable voices, scratches, black or white screens, indiscernible

images, gaps and voids, irrational cuts), critical thought in the film equally gravitates toward its crisis. *The Idea of North* at one level embraces and promotes skeptical thinking—its historicizing reading and denunciation of technology's fallibility produce a dispassionate sanctioning of the irremediable temporal, cultural, and geographical distance of the events and their ultimate unreadability and nonnarrability. Yet the film is not fully resolved by its intellectual stance. In its striving to understand and reproduce its object, *The Idea of North* raises the possibility of an affective spectatorial response based on the lyrical impression made by images and sounds that, despite their evident fabrication, for a few moments become capable of bearing the distant echo of a human experience.

The affective possibilities of nonverbal lyricism are a point of crisis in the film's skeptical thinking, but they are not separate from the argument, as an insignificant aesthetic surplus. To be an essay on the failures of the photographic image, the film must work against itself, put its own images into crisis, and deeply query their ability to be an effective record of human experience; at the same time, by radically disjointing its own conceptual limbs, the film allows glimpses of experiential empathy to form in the lyrical interstices between images and sounds, between temporal strata, and between source media—thus somewhat undermining its own skepticism. The unreadability of the past and impossibility of apprehending it through our technologies of memory, on the one hand, and the affective evocation of human experience through an aesthetic and lyrical use of just such technologies, on the other hand, short-circuit, interminably contradicting and reinforcing each other, resulting in a powerful essayistic reflection on the contradictory nature of mediated knowledge and of narration.

SUMMARY

Starting from the consideration that "discourses are a form of narration" (Farocki and Hüser 2004, 313), I proposed to consider narrative not as an addendum, a fictional layer superimposed on the documentary matter, seen as the real substance of the essay film and of its intellectual contribution, but as a fundamental component of the argumentation. As such, narration with all its components—including the adoption of specific narrative forms, plot structures, narrative functions, voiceover and captions, point of view, temporal organization and rhythm of the story, and music as narrative—participates in the same strategies of disjunction analyzed throughout the book.

The chapter then explored epistolarity and lyricism as examples of narration and counternarration, both seen as disjunctive strategies that may be

mobilized by the essay film to create a "form that thinks," to use Jean-Luc Godard's expression from *Histoire(s) du cinéma* (1997–1998); indeed, to create a form that, while thinking, questions and challenges its own thinking, thus gravitating toward a crisis of rationality.

In detail, epistolarity, frequently adopted by film essayists and by many authors and philosophers before them, was discussed as a narrative form marked not only by the intimacy of its address, but also by distance and gap. *Letters from Panduranga* by Nguyễn Trinh Thi was explored as an example of essay film that exploits such a gap to create a disjunctive form predicated on duality and schism—between past and present, myth and history, fiction and nonfiction, and positions from which to look and to frame (portrait or landscape, proximity or distance, participation or detachment). Another form with a long history of association to the essay, lyricism apparently contradicts both rational thought and narrative structuring, but was here explored as part of the essay's argumentation. The lyricism of my case study, Rebecca Baron's *The Idea of North*, is not linguistic: as Baron has commented, with *The Idea of North* she wanted to explore "what film could offer history in excess of language" (Baron and Sarbanes 2008, 121). Through aesthetic and poetic affectivity, *The Idea of North* strives to capture an echo of a lost, nonnarratable human experience. At the same time, lyricism in Baron's film participates in argumentation by counteracting the film's skeptical thinking. In this, lyricism is an undoing that is essential to the disjunctive textuality of the essay, one that can break off at any time, just like epistolarity offers the essay film a structure of gap that is a potential for disassemblage—and that at once facilitates the location of the right distance from the subject matter.

Framing

Looking for an Object, or The Essay Film as
Theoretical Practice

No "theory," no "practice," no "theoretical practice" can be effective here if it does not rest on the frame, the invisible limit of (between) the interiority of meaning (protected by the entire herme-neutic, semiotic, phenomenological, and formalist tradition) and (of) all the extrinsic empiricals which, blind and illiterate, dodge the question. (Derrida 1979, 24; emphasis in the original)

Photography thinks, which is to say that it relates to itself as the photo-being that it is. It is experi-enced and constructed as an illumination, a dividing up and sharing out of shadow, frame, grain, and depth of field, and in doing so it determines a knot of signification whose intimate entwining is played out in the grasping or gripping of hesitation. (Nancy 2005, 105)

LOOKING VISIBLY

Filmed on the Gaina and Apuseni mountains in Transylvania, Romania, Irina Botea's *Picturesque* (2012) opens with the pleasing, symmetric frontal shot of a semicircle of verdant trees, with a dead, fallen tree at their center. Immersed in natural sounds, the shot immediately follows a black screen displaying first a quote from "To Posterity" by Bertolt Brecht and then the film's title. Written around 1939, Brecht's verses—"When to speak of trees is almost a crime/For it is a kind of silence about injustice!"—frame the opening shot and the entire film from a political perspective and call into question the purpose, apparently governing Botea's film, of finding a "picturesque image." A male voice observes from the off-screen, "You need be a real wiz to understand what's going on in here. You should use sub-titles"—an affirmation that further relativizes the shot, problematizing the

capacity for transparency of a camera framing a portion of the world and emphasizing the ambiguity of the concept of the picturesque, while also attracting attention to the shot as shot. The following image confirms the same points: a static shot of a hill and an old house half-hidden in the trees against the backdrop of a sublime cloudy sky. An off-screen female voice (the director's) asks, "I do not really get this . . . Do you see it? Do you think the composition is beautiful?" The first half of the film alternates "postcard" landscapes and interior shots of dilapidated, abandoned buildings. The film consists in an exploration of the region of the Apuseni Mountains, which once formed part of the Austro-Hungarian Empire, an area whose complicated history was entangled with the fact that it held one of the most important and coveted gold reserves in Europe. The crew's guide, seventy-five-year-old Mr. Nelu (Ioan Parva), a native and a tourist writer for the magazine *The Picturesque Romania*, is first introduced against the backdrop of the mountainous landscape and a road sign for the village of Avram Iancu, which bears the name of the local hero of the Austrian Empire Revolutions of 1848–1849. Before Mr. Nelu is invited to talk about Avram Iancu himself, we hear in the off-screen the director ask the cameraman Toni Cartu for a close-up. The camera then visibly searches for the right angle, zooming closer to Mr. Nelu and moving sideways, better to frame him against the landscape. Other comparable moments in the film include a tentative close-up shot of Mr. Nelu taking a picture with his photo camera, in which the adjustments of the angle convey visible hesitation and are mirrored by Mr. Nelu's own act of framing through his lens (Figure 7.1). Visible framing also occurs internally, as in the fixed shot of the open door of a building

Figure 7.1: Mr. Nelu frames the landscape through his photo camera. *Picturesque* (Irina Botea, 2012). Irina Botea 2012. Screenshot.

where two children and a half-hidden adult stand, speaking to the camera; the deep darkness of the interior, exacerbated by the brightness of the summer day, emphasizes this entranceway as mise-en-abyme framing.

This visibility of the framing is reinforced throughout the film by off-screen exchanges among crewmembers on the "rightness" of the image, by Botea's discussions with Mr. Nelu about what he regards as picturesque, and by the directions given to the filmed subjects about how to position themselves and when to start moving or talking. A particularly emblematic sequence takes place at the former offices and workshops of the Ghelari Central Mine, where Mr. Nelu and the abandoned site's guardian have been instructed to walk in a circle with the camera following them via a continuous 360-degree panning shot. The attempts at accomplishing the difficult, self-reflexive (because visibly performative and unrealistic) shot are emphasized not only through a shooting mistake, which requires a second take, but also through the visible and audible screen directions imparted from the off-screen to the social actors, who at one point humorously duck to hide in the tall grass so that the camera can continue to pan, unencumbered by their presence. The slow, spiraling shot allows us to carefully observe the abandoned structures that, as Mr. Nelu explains, were built during the Austro-Hungarian Empire and are now overgrown with weeds and vegetation. Mr. Nelu's improvised, eloquent tourist-guide speech mixes architectural observations, historical facts, and explanations of how the mine once functioned, while subtly raising the question of the reasons of the desertion of the site, as when he comments that it seems iron is no longer needed today and then sarcastically adds, "In the same way, we don't need Apuseni's gold anymore, as we gave it away." The regret and nostalgia for the past liveliness and productivity of the area, based on work, industrial production, connections, and exchanges, also emerges elsewhere in Mr. Nelu's narration, alongside the feelings of patriotism that are often intrinsic to ideas of the picturesque as an affective landscape and that are further strengthened by the remarks about the local hero, Avram Iancu. References like these hint at broader issues that are otherwise missing from the surface of the tourist image: the lack of examination of the historical, economic, and political causes of the depopulation of the area, an absence that is apparently hidden by, and sublimated into, the idea of the picturesque—of a beautiful, charming, sublime, moving, touristic image. In truth, the meaning of the term "picturesque" is investigated precisely through the verbal and visual scrutiny of a collection of potentially sublime Romantic topoi, including cloudy skies, dilapidated dwellings, abandoned interiors, and hilltop cemeteries. Crucially, it is through framing that *Picturesque* conveys its essayistic argument. Through a strategy that raises questions regarding the tourist image and that is critically predicated on a dual recourse to the frame (intended

both as the literal operation of mise en cadre and as narrative, ideological, and cultural framing), the film reflects on "how tourism contributes to, and perpetuates, the perception of the world as an idyllic, extraordinary, safe, clean and uniform place [and as] a depoliticized zone, experienced at a safe distance and easily consumable; consequently removing uncertainty, chaos and conflict" (Botea 2013). At once, it reflects on how the sublime is a matter of framing: "the sublime is the majesty of nature seen from the inside, through a (real or imagined) window frame—it is the distance provided by the frame which makes the scene sublime" (Žižek 2011). Behind the image of rural charm confected by the camera angle, however, lurks the impression of depopulation, obsolescence, and void, which is the direct result of the film's search for an object to shoot and for an angle from which to shoot it. This visible search ultimately emphasizes a gap and a missing object. As the director has commented, "As a consequence of the camera's wandering eye, the film captures lush, desolate, austere landscapes that may perform less as bucolic pastures and more as the empty fields between utopias" (Botea 2013).

Picturesque has two endings, both of which contribute in decisive ways to the argument of the film. The first is shot from within an interior with large windows overlooking the mountaintops in the distance, topped by another sublime sky; the vista is framed between the rectangles of the windows and the "fringe" provided by a straw roof edging the top of the screen. Mr. Nelu's profile is silhouetted against the window, while a male voice from the off-screen (that of cameraman Nicu Ilfoveanu) reads from a compilation of Mr. Nelu's poems. The film ends on Mr. Nelu's spontaneous

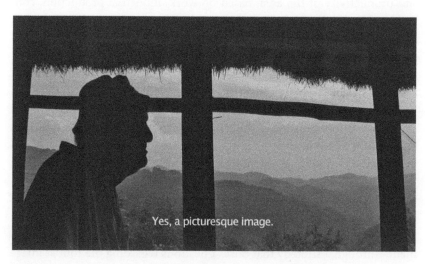

Figure 7.2: "Yes, a picturesque image." *Picturesque*. Irina Botea 2012. Screenshot.

reaction to some of his verses: "Yes, a picturesque image"—an exclamation that also comes across as an unknowing comment on the last shot of the film, which frames him against the dramatic sky and mountains (Figure 7.2). After the end titles, however, the film offers a coda, with Mr. Nelu, who, now sitting in the middle of a meadow, reads some pages he wrote about his experience on the shoot (Botea 2015). This coda retrospectively reframes the whole film, because Mr. Nelu's commentary reverses the point of view—which had firmly been on him for the duration of the film—and offers his perspective on the crewmembers and their motivations. If Brecht's opening quote initially frames the film by raising political and ideological questions, then, the coda is a Brechtian device that further breaks the illusion and subverts the potential transparency of the film, querying the partiality of its point of view and hinting at all that was left out of frame.

THINKING FRAMES

In writings on film, the frame is usually understood as an element at once of the image, of the apparatus of the cinema, and of film language that participates in, supports, and structures meaning-making in multiple ways, some of which have to do with spheres including technology, perception, psychology, aesthetics, narrative, ideology, and culture. The word "frame" itself is ambiguous and multilayered; Edward Branigan (2003) has identified and investigated no less than fifteen different, although related ways in which the term is used in discourses about film. These are the frame as the real edge of an image on screen; as an illusory border of the image projected by the spectator; as "the *gestalt form* of an image that makes it appear as a rectangular whole because of principles of good continuation and closure" (64); as the shape of objects as outlined inside an image; as the overall composition of an image—that is, the "disposition and balance of figures, forms, colors, lighting, angle, perspective, focus, movements, and subspaces" (65); as the totality of the two-dimensional area of an image plus the three-dimensional space it represents; as the materiality of the screen/auditorium that surrounds the image; as the rationale implicit in how and why an image is seen (for instance, in a view of a character from a window); as the view given on a fictive action from within the diegesis (a point-of-view shot, a dream sequence, etc.); as the narration or discourse that produces a story; as the psychological disposition underlying the spectator's emotions while watching a film; and as the subset of our knowledge of the world presupposed and activated by a story. While bearing in mind all of these semantic fields and meanings and although a thorough analysis of

both textual and contextual framings (Sommer 2006) could be almost endless, here I am particularly interested in the physical act of framing, either through a lens or through postproduction devices, and in its emblematic and critical dimensions; more specifically, in how the act of framing contributes to produce essayistic thinking in film. In particular, as in my discussion of *Picturesque*, I will focus on framing as it becomes "visible" and, in doing so, attracts attention to the frame of the image itself as well as to its object, thus marking a distance between the two.

In the first meaning identified by Branigan, that of the real edge of an image on screen, the frame is often an "invisible" element of the film experience. As Branigan has argued, the visibility of the frame has been conceptualized in contrasting ways by film theorists depending on their positioning vis-à-vis the question of realism:

> Jean Mitry argues that characters' movements, camera movements, and continual changes of shot tend to make the spectator "forget the 'frame.'" Mitry adds, "Thus if everything contrives to make us forget the frame as such, everything contrives at the same time to make us feel its effects." Mitry has it both ways, while Bazin would have us forget the frame in favor of a photographic and phenomenal "realism" (e.g., through continuous sweeping camera movements that create a "lateral depth of field") while Eisenstein, Arnheim, and Burch would have us remember the frame as an antidote to "realism." (67)

Having it both ways seems necessary in this case, because its visibility/invisibility is a constitutive feature of the frame, although, as Derrida (1979) has written of the frames of paintings in his discussion of the *parergon*, even when they are conspicuous they tend to disappear, albeit in ways that are themselves in need of hermeneutics:

> The parergonal frame is distinguished from two grounds, but in relation to each of these, it disappears into the other. In relation to the work, which may function as its ground, it disappears into the wall and then, by degrees, into the general context. In relation to the general context, it disappears into the work. Always a form on a ground, the parergon is nevertheless a form which has traditionally been determined not by distinguishing itself, but by disappearing, sinking in, obliterating itself, dissolving just as it expends its greatest energy. (24–6)

This is all the more true of the frame of the film, which, being an immaterial edge, expends much less energy than the frame of a painting. Essay films, however, do not conform to ideals of mimetic realism; they are performative texts that explicitly display the process of thinking and that engage reflexively with their object. Their self-reflexive stance, thus, implies that issues of textual and contextual framing are at the center of their critical practice.

My interest in framing here follows from the observation that to frame is, ultimately, to detach an object from its background and, thus, to create a gap between the object and the world. This process in a film is at once literal and metaphorical, practical and conceptual. The essay film seeks its object by "dividing up and sharing out" (Nancy 2005, 105)—and these are operations that pertain at once to the intellectual definition of the object and its visual production. It has often been remarked that the object of the literary essay is multiform and that anything can be its object. For Aldous Huxley (1960), for instance, "the essay is a literary device for saying almost everything about almost anything" (v). Theodor Adorno (1984) offers a more developed observation when he writes that "[t]he essay owes its freedom in its choice of objects, its sovereignty vis-à-vis all priorities of fact or theory to the circumstance that for it all objects are equally near the center" (167). Réda Bensmaïa (1987) has argued that the specificity of the essay must be sought not in its production of objects but in their arrangement, one that is based precisely on the marking of a gap:

> The "objects" used by the essayist are not drawn from a particular genre or domain: they can be taken from any semantic or cultural register: history, literature, painting, philosophy, sports, film, cooking—whatever you like. And, consequently, they are distinguished only by the way they are inserted into the essay's discourse. But, generally, they are constituted as specific objects by the gap they manifest in relation to a semantic or rhetorical norm. (18)

Ultimately, this gap is caused by the heretical stance of the essay, which resists compositional unity and classical rhetoric; as Bensmaïa has suggested, citing Michel Tort's reference to a "fundamental structure of gap," what the essay challenges is "the closure of the text as Totality and the mastery of meaning as Truth" (19). In relation to the essay film, then, I argue that the act of framing often becomes a visible search for an object, either in the living image of the world or within film or photo archives. This practice is both literal and conceptual, insofar as it is a filmic operation used to clarify that the essayistic object is not in evidence, is not natural, but must be looked for, circumscribed, and "cut out," and that this process is always a fabrication and the selection of a perspective. It is a process of framing the world from a particular viewpoint, but it is also the coming-into-being of the object of the essay, which does not preexist it—and, thus, the coming-into-being of the essay itself. As such, framing in the essay film often becomes the visible evidence of a process of thinking; it becomes performative, it performs the act of essayistic reflection, and in so doing it relativizes it. By isolating the object against its background and by wedging

a gap between them, framing contributes to undermine the totality of the text and its mastery of meaning as truth.

The object of the essay, then, is elusive, and the essay film often thematizes its elusiveness by foregrounding gaps. This is particularly evident in archival films, which many essays are. The missing images, the voids in the archive, come to represent the unavoidable incompleteness of knowledge, the holes in historical memory, the intangibility of truth, and the limitations of thought. In this, the essay film is a metahistorical form, which reflects on a historical object and, at the same time, on the constructedness of the processes that constitute it as such. The following case studies, through a discussion of which I will further conceptualize the function of framing as the coming-into-being of the essay and of its object, are indeed archival films, which draw from either still or moving images at the dual purpose of constructing a historical object and of deconstructing historical discourse.

REFRAMING: FILLING THE GAPS, MARKING THE VOID

As Michael Zryd (2003) has claimed in an article about archival film practices,

Found footage filmmaking is a metahistorical form commenting on the cultural discourses and narrative patterns behind history. Whether picking through the detritus of the mass mediascape or refinding (through image processing and optical printing) the new in the familiar, the found footage artist critically investigates the history behind the image, discursively embedded within its history of production, circulation, and consumption. (42)

This passage describes rather closely what Mohammadreza Farzad's *Gom o gour* (*Into Thin Air*, 2010), first screened at the 2011 Berlinale, aims to do. The film is an investigation of archival footage and photographs of the Iranian Revolution and, in particular, of the massacre of Tehran's Jaleh Square that took place on September 8, 1978, a crucial date known as "Black Friday." It focuses in particular on less than a minute of footage of the killing and wounding by the military of a never-clarified number of citizens who, seemingly unaware of the martial law and official curfew that had been declared the day before (but only publicly announced that morning), had gathered to protest against the Shah's rule. Although official sources acknowledged the death of two hundred people, thousands of bodies were brought to Behast Zahra cemetery the day after, and many others were never found by their relatives. The silent footage, produced by an anonymous source, became public only after the fall of the regime (February 11, 1979). As the first-person voiceover (read by Vahid Bagherzadeh) remarks at the start of

the film, Mohammadreza Farzad was born in the same month of 1978; this suggests an affective involvement in the historical events, which colors the investigation of the filmed evidence of the massacre and frames it instantly from within a first-person perspective, further conveyed by a sequence in which archival footage is directly projected over the bodies of the film-maker and his family. The author's sentiments find expression not only in the sense of mourning that infuses the entire piece and that is echoed by the pathos of the accompanying music, but also in the act of rewinding, slowing down, freezing, and replaying the surviving footage over and over again, a gesture that comes across almost as the compulsion to repeat a trauma. The repetition is at once the manifestation of the profound disbelief induced by the horrific nature of the event and of an urge to behold and ponder it. Although even repeated viewings cannot explain what remains incomprehensible in its obtuse and shocking violence, the scrutiny of the images is a form of homage to the victims, many of who have remained unnamed, and at once a way to grant them visibility and remembrance. *Into Thin Air* works, indeed, at various levels simultaneously, including those of the historical account and of metahistorical discourse. Its historical approach is, however, unorthodox, based as it is on mostly imaginary (although entirely plausible and emblematic) narratives.

Through a reframing activity, the essayist turned montagist isolates in the archival footage the shapes of some of the people desperately running away from the bullets—falling, dragging themselves, turning toward the military, exiting the frame—and then engages in a process of identification of the anonymous victims, searching for them in further documentary photographs and footage of the Iranian revolution. This search is at once impractical and fictional: the images are so grainy, scratched, and washed out that it is impossible to clearly see any of the faces and thus also to recognize them in other documents—as it is equally impossible to locate in the footage the known victims, such as Ali Reza, a fifteen-year-old boy who died in the carnage and to whom the film pays some attention. Nevertheless, by carefully analyzing the silhouettes and by linking them to the well-focused images of men and women in other photographs and footage, the film fulfills at least two purposes: it individualizes and humanizes the victims, thus bringing them closer to us, and it finds a way of constructing, starting from an extremely fragmentary and incomplete document, an iconographic narrative and representation of this emblematic event of the Iranian revolution. The voiceover narrator focuses on the events directly leading to Black Friday and on those of the day of the massacre, from the point of view of hypothetical participants. The account provides a type of microhistorical perspective that shapes the film's approach to historical discourse. As such, the film is a collage of instances not only of Black

Friday, and of prior protests leading to it, but also of moments of ordinary life (as in the scenes from a street market), of contemporary events (such as a football match between Iran and the USSR played two days before the massacre), and of aspects of the current sociocultural milieu (as conveyed, for instance, by a sequence of a film screened in Tehran the same month of the protests). Information of contextual or historical value is also conveyed by the narrator, who, for instance, mentions the law that banned public gatherings of more than two people or refers to the high temperature recorded at the time in the streets of Tehran. Eyewitness voices also are heard directly, as during a radio interview or in the footage of the trial deposition of Ali Reza's father. The recounting of the events of Black Friday, then, is accompanied by a montage of still documentary images, which provides a complementary perspective on the footage itself, filling some of its gaps. The montage of these images creates the impression of a dynamic narrative, which goes some way toward compensating for the incompleteness of the filmed documentation. The effect here is not unlike that produced by Chris Marker's sequences of still images in *La Jetée* (1962), in that the stillness of the photographs is compensated by the dynamism of the narration and of montage. *Into Thin Air*'s narrative strategy is always explicit; the voiceover commentary is speculative, suppositional, and interrogative. When we are presented with unaltered, uncommented, silent images, then, such as those of the death of Ali Reza, the force of their documentary impact is all the more affecting. Also incisive is the sequence in which the camera pauses on the real photos of the dead decorating their graves—those very faces that it had not been possible to spot in the footage and that now appear clearly before us, in their ineludible individuality and in the fixity of their destiny.

Precisely because it is fundamentally imaginary, unsystematic, and profoundly lacunary, *Into Thin Air*'s collaged construction is essayistic; it is a construction that rests on framing, this time intended as a postproduction practice. The film engages with two forms of optical reframing. One is based on graphics: each time the footage is rewound and scrutinized, a human shape is outlined through a circle traced around it, which follows it for the duration of the action, thus detaching it from the crowd and from the background (Figure 7.3). This practice brings the reframed figure into existence at once as historicized subject (rescuing it from its position as anonymous/ invisible member of a crowd) and as historical object (not a generic victim, but an object demanding historical inquiry). The second approach consists in reframing portions of the original image by moving closer to a part of the image itself and thus changing its focus, and so by "dividing up and sharing out" (Nancy 2005, 105)—as happens in the particular case of a photograph of the massacre taken from the perspective of the military: a pyramid

He falls down and is lost in the crowd. Who is he?

Figure 7.3: Optical reframing through graphics. *Into Thin Air* (*Gom o gour*, Mohammadreza Farzad, 2010). Mohammadreza Farzad 2010. Screenshot.

of bodies pathetically and futilely scrambling to seek escape from the line of fire (Figures 7.4 and 7.5). Reframing sections of the crowd here mobilizes the image, further increasing its pathos, while also emphasizing emblematic details that could otherwise go unnoticed, such as the buttocks of a man bending in the hope of finding shelter among the people surrounding him, as if he were digging in the pile of bodies. This reframed close-up stands out as an indictment of the barbaric assault on the disarmed civilians and of their dehumanization.

In an article on filmic reframings of archival photographs of the North American Civil War, Judith Lancioni (1996) has remarked that "reframing visually advances the argument that history is not a product, an absolute truth enshrined in libraries and archives, but rather an on-going critical encounter between the past and the present. That encounter, moreover, is not passive or accidental; it is rhetorical" (398). Reframing is for Lancioni a rhetorical strategy that attracts attention to the epistemology of seeing and thus also to the historicity of images:

> The effect of reframing is analogous to the operation of a very elemental perceptual gestalt, namely the figure/ground relationship. Figure and ground are relative, but

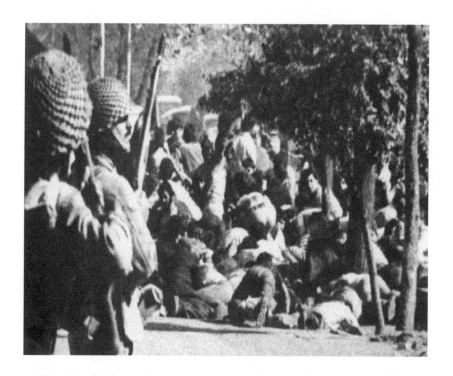

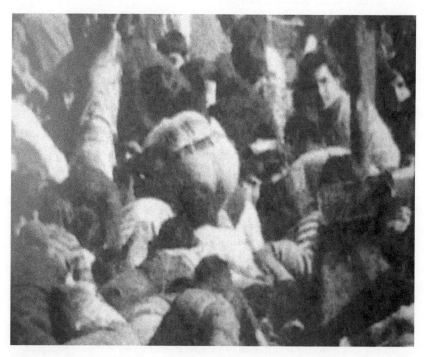

Figure 7.4 and 7.5: Reframing portions of the original image. *Into Thin Air*. Mohammadreza Farzad 2010. Screenshot.

exclusive, terms; in other words, what is conceived as background cannot be reconsti-
tuted as figure without a certain amount of conscious adjustment. When viewers see in
close-up (i.e., as figure) an individual whom they have just seen as part of a group shot
(i.e., as background), they must make perceptual readjustments that may make them
more conscious of the epistemology of seeing. (407)

The same observation is at the basis of Slavoj Žižek's (2011) critical method
of the "parallax view":

The common definition of parallax is: the apparent displacement of an object (the shift
of its position against a background), caused by a change in observational position that
provides a new line of sight. The philosophical twist to be added, of course, is that the
observed difference is not simply "subjective," due to the fact that the same object which
exists "out there" is seen from two different stations, or points of view. It is rather that, as
Hegel would have put it, subject and object are inherently "mediated," so that an "epis-
temological" shift in the subject's point of view always reflects an "ontological" shift in
the object itself.

By cutting figures out of their background and by reframing images, the
film invites us to reflect on practices of reading visual evidence (and, by
extension, auditory evidence, such as the recordings of a number of radio
announcers reporting on the events, often in a distorted and censored man-
ner). Indeed, as a metahistorical contribution, *Into Thin Air* is a reflection
on images as historical documents, on the object of history, and on his-
torical discourse—as well as specifically on the activity of reading history
through moving images.

The debate on what Hayden White (1988) has proposed to call histo-
rio*photy*, that is, "the representation of history and our thought about it
in visual images and filmic discourse" (1193), has often concentrated on
the aptitudes and limitations of narrative cinema and of traditional docu-
mentary film as mediums through which to represent history according to
criteria of accuracy and truthfulness, in comparison to and in contrast with
the competences of historio*graphy*. This debate is not entirely adapted
to the essay film form or to other types of experimental cinema, as also
noted by Bartosz Zając (2014) in his analysis of found footage material
as a source of historical knowledge in compilation films, and as already
implied in Robert Rosenstone's (1988) observation that, whereas "the big
Hollywood feature and the standard documentary are currently the most
common forms of history on film" (1181), other types of films—as exam-
ples of which Rosenstone brings two essays, Chris Marker's *Sans Soleil* and
Jill Godmilow's *Far from Poland* (1985)—"present the possibility of more
than one interpretation of the events; they render the world as multiple,

complex, and indeterminate, rather than a series of self-enclosed, neat, linear stories" (1182). Zając (2014) has moved beyond the classical illustrative function of visual documents in films that include archival images to examine more complex filmic narratives, which mobilize a polyphonic approach to historical discourse and employ strategies to undermine the authority of official narratives, dialectical tensions, and ambiguity. Farzad's *Into Thin Air* is a montaged essay film that engages precisely in these strategies; furthermore, it develops its own reflection on historiophoty not only by incorporating archival still and moving visual evidence of the events it investigates, but also by making reference to representational/narrative films as forms of writing history thought moving images. Some sequences of two films made after the end of the Revolution are embedded in *Into Thin Air*: Amir Ghavidel's *Khoon-baresh* (*Rain of Blood*, 1979) and Amir Naderi's *Jostoju* (*The Search*, 1980)—the former a fiction based on historical facts and the latter a documentary on the search for the missing. A narrative historical reconstruction, *Rain of Blood* notably casts two of the real protagonists of the Black Friday episode recounted by the film: the mutiny of three soldiers who refused to shoot the helpless crowd, one of whom lost his life as a consequence of his decision. *The Search*, in contrast, is a documentary inquiry, and the selected sequence includes interviews with eyewitnesses and people whose relatives went missing on Black Friday, never to be found again. The interviewees are often shot frontally and speak directly to the camera. Although they are examples of (historical) fiction and documentary cinema, respectively, both films are very far from Hollywood; the acting is stiff and the productions are all but well polished, raising questions on whether, to be accepted as accurate historiography, historiophoty is expected to display standardized, high production values. However we answer this question, the sequences from *Rain of Blood* and *The Search* present us with real protagonists, social actors who participate in either narrative or documentary representations that aim to offer faithful, authoritative, and complete historical reconstructions. This is most certainly not the case of *Into Thin Air*. Its narrator did not witness the events; his perspective is declaredly colored by an affective response; the objective is not perfected, complete, accurate historical reconstruction; the "characters" in the reconstructions are mainly fictionalized, and the film's position is declaredly based on unavoidable defeat before the gaps of the visual archive and of historical evidence. As the voiceover acknowledges at the end of the film, "It is not the first time I stare at these crippled and unfinished scenes and lose the faces before I have even found them." Its incompleteness, however, does not imply that the archive should not be investigated. *Into Thin Air* does not shun the elusiveness of evidence, the problems of narrative account, the limits of documentation, and the

uncertainties of speculation (while also clearly emphasizing them, starting from the film title itself, and its allusion to intangibility); indeed, it exploits all of these limitations to construct an argument founded precisely on gaps produced by framing and reframing—which here become a true theoretical and critical practice.

Into Thin Air constructs its object and comes into being as essay through reframing; Peter Thompson's *Universal Diptych* (1982) adopts a comparable strategy. The work is composed of *Universal Hotel* and *Universal Citizen*, both from the same year and both lasting twenty-eight minutes. The two films are, at first sight, distinct, almost unrelated—in truth, they are intimately, if unfathomably, connected, and as all diptychs, they develop a subtle intertextual dialogue. The first is an investigation into a series of horrifying hypothermia Nazi experiments carried out by Dr. Sigmund Rascher at Dachau concentration camp in 1942. The purpose of the sadistic experiments was, ostensibly, to identify the best method to rewarm German pilots who fell into the Arctic Sea. In particular, the film focuses on one inmate, a Polish prisoner of war, who was immersed a number of times in a pool of water at very low temperature and then revived in various ways, including by physical contact through another inmate, a former German prostitute. In the absence of detailed information and starting from eleven photographs and two drawings collected from archives in six different countries, the narrator reconstructs the mechanics of the experiment; the film ends with a dream of the Polish prisoner set in a "Universal Hotel" (while it started with the filmmaker shooting images from his window in a hotel of the same name in Siena, Italy). *Universal Citizen*, in contrast, is the highly subjective account of a trip of the narrator/filmmaker to Guatemala, where he also stays at a Universal Hotel; his activities and encounters mostly take place off-screen, including his dealings and conversations with a Libyan Jew, a former Dachau inmate who refuses to be photographed, but who eventually agrees to be filmed from a distance.

Declaredly prompted by personal interest sparked by the filmmaker's encounter with an image, as for *Into Thin Air* and the Black Friday footage, *Universal Hotel* shares more than one feature with Farzad's film. Both start from radically incomplete visual evidence of traumatic historical events and ask similar questions about the ethics, motivations, and results of archival practices. Both construct their object starting from a handful of images and create an essayistic historiophoty that is declaredly partial, evidently labored, and overtly fictional—but not false or void of historiographical value. Indeed, both create narratives that are plausible and, thus, deeply emblematic and, notably, both use reframing techniques as a theoretical and critical practice.

Framing is absolutely central to *Universal Hotel*. The film starts with a black screen, over which the narrator's voice immediately establishes a mise en cadre that is at once perceptual (a perspective framed by a window) and cognitive (a temporal and experiential farness): "I see everything from a distance, from my window in the Universal Hotel." After the film's title is displayed, a woman walks with uncertain step through a square (Siena's Piazza del Campo), away from the camera, till she exits the frame (Figure 7.6); simultaneously, we hear the director making phone calls in different languages about his search for documentary evidence of the Dachau experiments. The scene is twice repeated from the same angle, and it is then reframed from higher up, as if from a hotel window. These acts of framing and reframing attract our attention to the intentionality behind the choice of a perspective and to the problematics of selecting a point of view from which to look at reality—all the more so when this is past, lacunary, and beyond our experiential reach. We look through the window at a portion of the square; the voice on the soundtrack does not aid us to decipher what we see, but rather talks of other matters and other places. More images from a window follow; this time, it is the window of a train, hinting at a journey through Europe that touches key cities for the history of the Holocaust: Brussels, Paris, Baden-Baden, Dachau. We then reach on foot, in subjective shot, the Netherlands Institute for War Documentation,

Figure 7.6: Perceptual and cognitive mise en cadre. *Universal Hotel* (Peter Thompson, 1982). Chicago Media Works 2013. Screenshot.

whose door is defaced by a swastika. After a fade to black, the narrator describes his encounter with the photograph that first sparked his interest: "1980. I open a book and see this photograph." However, the image we are shown is reframed: no longer inserted in its publication context, it is surrounded by a large black frame. The voiceover narrator provides us with contextual information from the book: the names of the two doctors carrying out the experiment, in which a man, simply called Testperson, floats in icy cold water; the fact that several rewarming methods had already been tested and that the scientists were now testing "animal rewarming" by means of physical contact between Testpersons and former prostitutes. After another black screen, the narrator recounts a strange dream he had that same year, in which he saw a cathedral in flames from his window at the Universal Hotel, and then spoke to Testperson from behind a closed door. This dream, which returns later in the film, also has the function of a frame: after having been given the only factual elements of the story, grounded in archival research and in published sources, we are warned that the reconstruction of the events that the narrator will attempt should be framed from a subjective, imagined, affective perspective.

After the dream, three more images of the hypothermia experiments at Dachau, which the filmmaker traced in other books from various archives, are shown, again out of context and surrounded by black frames (Figure 7.7).

Figure 7.7: Testperson in an image of the hypothermia experiments at Dachau. *Universal Hotel.* Chicago Media Works 2013. Screenshot.

They spark a series of hypothetical reconstructions of the events, in which the four images (and then further photographs and drawings later located by the narrator) are organized and reorganized into meaningful sequences, adapted to tell the story of Testperson and of the rewarming experiment. As Gary Weissman (2013) has shown through a detailed textual analysis and on the basis of contextual research on the Dachau tests, these narrative reconstructions of the events are ultimately pure fabrication, because we have no means to know that all the photographs pertain the same experiment, what method of rewarming they are a record of, and even if the Testperson was the same in all pictures. Weissman also notes that, because in each new narrative iteration (there are seven in total) the narrator notices new details and corrects his previous misreadings, "viewers may not observe problematic aspects of his narrative that the filmmaker himself appears to overlook, sharing those presumptions that shape what is seen and not seen in the photographs" (38). This results in an affective involvement of the spectator in the narrative, which is, however, offset by the detached tone of the narrating voice and tempered by the oneiric framing of the film. I would argue that the complexity of the resulting, contrastive spectatorial experience, at once emotional and detached, horrified by the harrowing story and always aware of its (emblematic) fictionality, is a powerful, critical tool that inscribes a distinctive metahistorical discursiveness in the film.

The narratives that Thompson presents are based on reframing and are in themselves reframings; each new image he finds, each new detail he notices in an image, each interpretative error he acknowledges prompts a readjustment of perspective, a rearrangement of the sequence of photographs, and a rewriting of the story—and of history. The reframing is at once literal and metaphorical and is conveyed both through the voiceover, which interprets and reinterprets the photographs, attracting our attention to always new elements, and optically, by moving closer to the images so as to blow up certain details. Like in *Into Thin Air*, reframed narratives are thus created that are overtly fabricated yet plausible, answering an urge to fill the gaps of the archive, to join the dots of the visible evidence, to recount the ineffable, to give voice to the silent witnesses. This urge compels both Farzad and Thompson to compulsively interrogate the same archival images over and over again, entreating them to reveal their secret, to the point that narratives do stem from them. In one case in each film, these narratives near "a docudrama-like move toward cinematic reenactment" (Weissman 2013, 40)—although one tempered by self-reflexivity. In both films, then, a sequence of fixed images is mobilized through reframing so as to be experienced by the spectator almost as a moving sequence, à la *La Jetée*. I have already discussed the relevant sequence of *Into Thin Air*; the one in *Universal Hotel* consists in an iteration of the story that deploys fabricated

sound effects and voiceover narration, a strategy that ultimately emphasizes precisely all that is lacking in the archive, as argued by Weissman (2013):

> The addition of sound effects—howling wind, the splash of water, footsteps, dog barking, a whistle, and, most notably, the camera's shutter mechanism—creates an illusion of immediacy and presence. In its very effort to transcend the fixity of the still image and recreate the photographed event, this iteration calls the viewer's attention to how mute and inanimate are the photographs themselves. (39)

Thompson's attempts at revitalizing the archive are defeated, because the voids are so radical that they can only be filled by a leap of imagination. There is no visual evidence of the "animal rewarming" test that is at the core of the story, and thus the narrator, over dark images of black icy water, says what he imagines did happen. Images filmed in 1982 of the very site of the tests, then, of which only a concrete floor remains, reconfirm the hard reality of the loss of evidence, as well as our experiential distance from the events (Figure 7.8).

Similarly to Farzad's acknowledgment in *Into Thin Air* ("It is not the first time I stare at these crippled and unfinished scenes and lose the faces before I have even found them"), and with a strong reframing effect comparable to the famous speech at the end of Orson Welles's *F for Fake* (1973) ("For

Figure 7.8: Site of the Dachau experiments today. *Universal Hotel.* Chicago Media Works 2013. Screenshot.

the past seventeen minutes I've been lying my head off"), the narrator now admits,

> What I found in seven archives is one name, two drawings and eleven photographs. The name is the equivalent of a number, the two drawings could document the end of any test, and the eleven photographs emphasize a uniform: how it fastens and how it sags when wet. The making of uniforms was the duty of the Ministry of Textiles. The photographer made the photographs for their designers.
>
> I make statements about the photographs that cannot be proven.
>
> I speak with uncertainty.

Significantly, at this point the narrator returns to the dream he previously used to introduce the seven narratives and reports the dialogue he had with Testperson in it, in which he touches on the ethics of giving voice to silent witnesses, on intentionality, and on the elusiveness of history.

The recourse to dream is customary in Peter Thompson's documentary work, as he discussed in an interview with Jonathan Rosenbaum (2009, 42). In the same interview, Thompson compares his subjective nonfictional filmmaking practice to the construction of "heterocosmos," "different worlds" in which to experiment, which he understands in the light of framing:

> Renaissance writers sometimes leave a given world and generate an alternative one in which the claims of the world left behind are acknowledged or settled. That alternative world is both disjunctive and make-believe. Its separateness and limits are signaled by some original framing device showing it to be contrary to established fact. After being securely framed in that way, it then admits within its imaginary world factual elements in order for them to be amplified. (40)

The dream in *Universal Hotel* is a framing device (itself inside the framing device of the Universal Hotel and its windows and doors) that allows the mixing of factual reality and an enhanced psychological truth. But the film is further reframed via a second film, with which it forms a diptych. *Universal Citizen*, a travelogue recounting a trip of the filmmaker to Guatemala with his wife, Mary, is again accompanied by Thompson's somewhat detached voiceover. Again the narrator stays at a Universal Hotel, this time in Tayasal; what is more, we recognize that the cathedral on fire in the sequence of the dream in *Universal Hotel* is in fact a view from the narrator's hotel window in *Universal Citizen*. Did the dream take place in Guatemala? Is the eponymous "Universal Hotel" in Siena or in Tayasal or both? As the narrative unfolds, we begin to question all spatial and temporal coordinates, and the relationship between the two parts of the diptych becomes increasingly

unfathomable and tantalizing, as in a series of Chinese boxes; and so the second film generates a constant mental reframing of the first.

If the reframing activity in *Universal Hotel* was optical as well as narrative, in *Universal Citizen* it is a matter of narration. At the start of the film, the narrator recounts a story about Cortez and the Mayan Indians, which was told to him, as he claims, "by a man swinging in a Cuban hammock, smoking a Turkish cigar and playing Arabian music on his Japanese tape recorder. He is a Jew, born in Libya, and schooled in six countries"—that is to say, a cosmopolite, a universal citizen. The figure of the universal citizen, a Libyan Jew and a smuggler, is then further characterized by details that are reminiscent of Testperson: "He was an inmate at Dachau. It was freezing there. There he dreamed of hot baths and swore he would live in the tropics if he survived." However, the mythical Cortez framework within which he is first introduced places a question mark on the identification. The universal citizen, then, is elusive; he refuses to be filmed, except once, from a distance and while he swims (Figure 7.9). Later, the narrator expresses doubts on his Dachau stories, which, he says, "don't ring true." Equally, small details begin to appear not what they seemed: his Turkish cigars are after all Cuban, and his home does not belong to him, but to the town's mayor. Other details, however, can be observed and are true, like that he speaks six languages and

Figure 7.9: The universal citizen swimming. *Universal Citizen* (Peter Thompson, 1982). Chicago Media Works 2013. Screenshot.

that he likes water. These cognitive readjustments are similar to the process of reframing that was at the core of the series of narratives of *Universal Hotel*. The film's ending provides the final reframing, showing the same sequence set in the Siena square that mysteriously opened *Universal Hotel*. In this second version, the voiceover explains that the woman we saw was the filmmaker's wife, Mary, whom he had challenged to reach the fountain in the middle of the square with her eyes closed. The second sequence is, thus, a complete reframing of the first, which profoundly changes the meaning of what we had seen the first time—as the film *Universal Citizen* changes the meaning of *Universal Hotel*. Simultaneously, the sequence defines one of the main themes of the diptych, that of vision and of blindness, of advancing by trial and error.

The Chinese-box structure of *Universal Diptych* is somewhat reminiscent of that of D. M. Thomas's 1981 novel *The White Hotel*—which is also concerned with the Holocaust, with a hotel that burns down (as happens to the Tayasal hotel after the filmmaker's stay), and with a cosmopolitan character, a Jewish woman whose complex life story coincides, as Leslie Epstein (1981) wrote, with "the diagnosis of our epoch through the experience of an individual" (1). The same can be said of Thompson's film. Although *Universal Diptych*'s claims to historical truth are admittedly limited and frail, its symptomatic efficacy is extraordinary. As Steve Harp (1988) has written, "For Thompson, the tendency to render the individual anonymous, the inevitability of personal loss, and the delicate transitoriness of human relationships are the benchmarks of universal citizenship" (21). Conveyed through an anonymous individual who is impossible to identify, Thompson's universal citizenship is, however, also carefully situated and historically defined. As such, Testperson/universal citizen is an utterly emblematic figure, through whom the diagnosis of an epoch is performed.

Conclusion

Reframing

The last case study addressed in the book is a diptych. Peter Thompson's *Universal Hotel* and *Universal Citizen* are subtly and ineffably connected in ways that speak eloquently to the topic of this book as a whole—to the critical, self-reflexive, metahistorical interstitial practices that it has strived to describe. The diptych is an open text and itself an opening; a dual work, each part of which stands as an intimation of textual incompleteness. The second film in a diptych can be seen as an essay on the first and, at the same time, as an acknowledgment of its gaps and its lacks. Paradoxically, then, whereas the two texts together form a unity and complete each other, each also continues in its own time to refer to the other, making it eternally incomplete. The dialogue between the two takes place in an interstice, which is intertextual, and which generates a continuing series of readjustments.

This work of progressive readjustment is a reframing labor, a process of gradual rethinking of the world and, at the same time, the coming-into-being of an essayistic object. Diptychs like Thompson's *Universal Diptych*, or Cynthia Beatt's *Cycling the Frame* and *The Invisible Frame*, analyzed in Chapter 4—but also texts that use split screens, such as Nguyễn's *Letters from Panduranga*, discussed in Chapter 6—illuminate the core and the means of a critical practice that is central to what the essay film does. The essay film is performative inasmuch as it does not present its object as a stable given, as evidence of a truth, but as the search for an object, which is itself mutating, incomplete, and perpetually elusive and thus deeply uncertain and problematized. What characterizes the object of the essay is not its being unique to the form—the essay is, in fact, eminently free in its choice of objects

(Adorno 1984, 167)—but rather its "arrangement," which is determined by a structure of gap (Bensmaïa 1987, 17–18). The work of the essay is a "dividing up and sharing out," to borrow an expression of Jean-Luc Nancy (2005, 105). This is work that produces and highlights crevices—"between two actions, between affections, between perceptions, between two visual images, between two sound images, between the sound and the visual" (Deleuze 1989, 180), and indeed more, as we have seen in the course of the book: between media, between generic conventions, between temporal layers, between narration and discourse, between the film and its object.

"The closer one comes to an ending, the closer one moves to a rewriting that is a beginning," says Nicholas Ray in *Lightning over Water* (Nicholas Ray and Wim Wenders, 1980). This book has itself been the search for an object, the essay film, a form that at the onset of my study I described as future philosophy—and thus as inherently contrarian, not of its time, and incessantly transforming. The chapter coming at the end of the book is, accordingly, only a beginning and an opening; what it brings into focus is the centrality of framing as a critical and theoretical practice, one that is all but perfected, closed, and stable. Through their acts of visible looking, tentative reframings, and progressive readjustments, Irina Botea's *Picturesque*, Mohammadreza Farzad's *Into Thin Air*, and Peter Thompson's *Universal Diptych* give body to the laboring of the essay film as search of an object and thus of itself—as an open, performative, unfolding text wholly dependent on, indeed equivalent with, such a search. The essay invents its object (and itself) on each occasion; at the end of the search an object is found—and a film exists; were it not for this work, the object—the text—would cease to be open and would crystallize into a stable configuration. But stability is not of the essay, a form whose disjunctive ethos inscribes in the text the potentiality of a breaking down, a disassemblage.

The importance of the activity of reframing to the book as a whole thus becomes clear in retrospect, from Aleksandr Sokurov's reframing of paintings as argument on the mediatic fluidity characterizing the history of the image, to Harun Farocki's optical reframing and rereading of famous Holocaust images in *Respite*, to the ironic uncovering of the "ethnolandscape" as a framing device in films by Luis Buñuel, Werner Herzog, and Ben Rivers, to the reframing effects of sound in "musical" essays, to the ideological and material presence/absence of Berlin Wall in Cynthia Beatt's *The Invisible Frame* and *Cycling the Frame*, to Davide Ferrario's reframing of a Holocaust text by Primo Levi through the lens of post–Berlin Wall Europe, to the optical readjustments required by the split screens and framing practices in Nguyễn Trinh Thi's *Letters from Panduranga*, to the reframings, at once skeptical and lyrical, of faded photographs from the end of the 1800s in Rebecca Baron's *The Idea of North*.

The recurrence of themes of framing and reframing in the book mirrors their absolute centrality to the practice of the essay film as critique of ideology (Adorno 1984, 166). Although all modern filmic thought may be said, following Deleuze (1989), to be interstitial in nature, what is distinctive of the essay film is its stubborn labor of testing its perspective, its positioning, and its distance from the world; the visible result of this labor is that the essay film detaches objects from their background, thus introducing a gap of potentiality between object and world. This gap is its philosophy.

My study aimed to excavate the discursive structures of the essay film and to produce a closer understanding of how the essay film thinks; in the process of doing so, this work has also said something of what the essay film thinks about. From this end point, it is indeed possible to retrospectively reframe the book as a search not only for the essay film, but also for its discursive object. When one looks back at the shaping force of the interstice with respect to medium, montage, genre, temporality, sound, narration, and framing, one object powerfully emerges as the recurring preoccupation of the films with which I have engaged: history. Spanning eras, sites, and traumas as diverse as the Enlightenment, colonialism, the Second World War, the Holocaust, the atomic bomb, the Berlin Wall, the struggles for independence in Africa and South America, the Cold War, Cuba, Palestine and Israel, the civil rights movement, ethnic obliteration in Vietnam, the Iranian revolution, and yet more, all of the films discussed in this book are concerned with a historical object and at the same time with film's own relationship with historicity, the archive, individual and public memory, reality, temporality, visible evidence, and event. Although not every essay film may be said to debate a specific historical object, it seems to me that each essay film reflects on its relationship with its object as seen in time and history. The film essayist is always at once a critic and a metahistorian, whose engagement with an object is also a reflection on the gap—be it cognitive, temporal, cultural, or experiential—that distances him or her from that object and on how film may negotiate just such a gap. And because the essayist films in first person, whether singular or plural (Lebow 2012), her or his reflection on the historical object is also always necessarily political. To say "I" (or "we") implies taking personal responsibility for one's discourse. Accordingly, all the films in this book take a political stance vis-à-vis their object of inquiry. The political sentiments they express reverberate through the interstice. The cuts they carve between images, sounds, genres, narrative, and temporal layers are the incommensurable gaps within which specific political positions—which are in turn critical, ironic, satirical, radical, skeptical, Neutral, lyrical, or denunciatory—become manifest.

Although the chapters in this book engage with their case studies on their own merits, thus facilitating a concentrated focus on these films as

particular, emblematic examples and on their own primary historical and critical engagements, they also draw conclusions regarding the essay film in all of its impressive temporal, geographical, and formal breadth and, in particular, regarding its distinctive method of interstitial thinking. This method has here been shown to be remarkably consistent in both sound and silent film work produced from the early 1930s to the present day, drawing on archival images or original footage, made in diverse formats (from 16mm to 35mm film, from Betacam SP to digital video), in different parts of the world (from Europe to the United States, from Latin America to Asia), and for diverse outlets (from theatrical distribution to television, from the Internet to the art gallery). It is the "method of between" (Deleuze 1989, 180) that radically calls what we see and hear into question, repositioning us vis-à-vis an object, and opening the film to the new.

BIBLIOGRAPHY

Abu Hamdan, Lawrence. 2015a. "Lawrence Abu Hamdan: Biography." Accessed April 29, 2016. http://lawrenceabuhamdan.com/info/.

Abu Hamdan, Lawrence. 2015b. "Re: Language Gulf in the Shouting Valley." Personal email communication. 29 September.

Adorno, Theodor W. 1982. *Prisms*. Translated by Samuel and Shierry Weber. Cambridge, MA: MIT Press.

Adorno, Theodor W. 1984. "The Essay as Form (1958)." Translated by Bob Hullot-Kentor and Frederic Will. *New German Critique* 32 (Spring/Summer): 151–71.

Agel, Henri. 1971. *Esthétique du cinéma*. Paris: Presses Universitaires de France.

Alter, Nora M. 1996. "The Political Im/perceptible in the Essay Film: Farocki's *Images of the World and the Inscription of War*." *New German Critique* 68 (Spring/Summer): 165–92.

Ames, Eric. 2009. "Herzog, Landscape, and Documentary." *Cinema Journal* 48 (2): 49–69.

Arnaud, Diane. 2005. *Le cinéma de Sokourov: figures d'enfermement*. Paris: Editions L'Harmattan.

Arthur, Paul. 2003. "Essay Questions: From Alain Resnais to Michael Moore." *Film Comment* 39 (1): 58–63.

Astruc, Alexandre. 1948. "Naissance d'une nouvelle avant-garde: la caméra-stylo." *Ecran français* 144: 5.

Astruc, Alexandre. 1999. "The Birth of a New Avant-Garde: La Caméra-Stylo." In *Film and Literature: An Introduction and Reader*, edited by Timothy Corrigan, 158–62. Upper Saddle River, NJ: Prentice Hall.

Bakhtin, Mikhail M. 2002. "Forms of Time and the Chronotope in the Novel: Notes toward a Historical Poetics." Translated by Caryle Emerson and Michael Holquist. In *Narrative Dynamics: Essays on Time, Plot, Closure and Frames*, edited by Brian Richardson, 15–24. Columbus: Ohio State University.

Balázs, Béla. 2010. *Béla Balázs: Early Film Theory: Visible Man and the Spirit of Film*. Translated by Erica Carter. Oxford and New York: Berghahn Books.

Balsom, Erika. 2009. "A Cinema in the Gallery, a Cinema in Ruins." *Screen* 50 (4): 411–27.

Baron, Rebecca. 1997. "The Idea of North." In *Views from the Avant-Garde*, Program Notes of the New York Film Festival. Accessed November 23, 2015. http://www.rebeccabaron.com/.

Baron, Rebecca, and Janet Sarbanes. 2008. "The Idea of Still. Rebecca Baron interviewed by Janet Sarbanes." In *Still Moving: Between Cinema and Photography*, edited by Karen Beckman and Jean Ma, 119–33. Durham, NC, and London: Duke University Press.

Barthes, Roland. 1977. *Roland Barthes by Roland Barthes*. Translated by Richard Howard. New York: Hill and Wang.

Barthes, Roland. 1985. "Loving Schumann." *The Responsibility of Forms*, 293–8. New York: Hill and Wang.

Barthes, Roland. 2005. *The Neutral: Lecture Course at the Collège de France (1977–1978)*, translated by Rosalind E. Krauss and Denis Hollier. Text established, annotated, and

presented by Thomas Clerc under the direction of Eric Marty. New York: Columbia University Press.

Bauman, Zygmunt. 2000. *Liquid Modernity*. Cambridge, MA: Polity Press.

Bazin, André. 2003. "Bazin on Marker." Translated by David Kehr. *Film Comment* 39 (4): 44–5.

Beatt, Cynthia. 2009. "Interview with Cynthia Beatt." Interview by Katja Petrowskaja, October 29. Accessed April 27, 2015. http://www.invisible-frame.com/en/the-film/interview/.

Bellour, Raymond. 1987. "The Pensive Spectator: Disparate Processes Used in Viewing Cinema and Photography." *Wide Angle* 9 (1): 6–10.

Bellour, Raymond. 2011. "The Cinema and the Essay as a Way of Thinking." In *Der Essayfilm. Ästhetik und Aktualität*, edited by Sven Kramer and Thomas Tode, 45–58. Konstanz: UVK.

Belpoliti, Marco. 2010. "Cinque pezzi su Primo Levi." In *Da una tregua all'altra*, edited by Marco Belpoliti and Andrea Cortellessa, 27–76. Milan: Chiarelettere.

Belpoliti, Marco, and Andrea Cortellessa, eds. 2010. *Da una tregua all'altra*. Milan: Chiarelettere.

Benjamin, Walter. 1968. "Theses on the Philosophy of History." In *Illuminations: Essays and Reflections*, edited by Hannah Arendt, translated by Harry Zohn, 253–64. New York: Harcourt, Brace & World.

Benjamin, Walter. 1999. *The Arcades Project*. Translated by Howard Eiland and Kevin McLaughlin. Cambridge, MA: Harvard University Press.

Bense, Max. 2012. "From 'On the Essay and Its Prose.'" In *Essayists on the Essay: Montaigne to Our Time*, edited by Carl H. Klaus and Ned Stuckey-French, 71–74. Iowa City: University of Iowa Press.

Bensmaïa, Réda. 1987. *The Barthes Effect: The Essay as Reflective Text*. Minneapolis: University of Minnesota Press.

Bhabha, Homi K. 1994. *The Location of Culture*. London and New York: Routledge.

Biemann, Ursula. 2003. "The Video Essay in the Digital Age." In *Stuff It: The Video Essay in the Digital Age*, edited by Ursula Biemann, 8–11. Zurich: Voldemeer.

Birkerts, Sven. 2006. "For Cyberwriters, a Lyrical Link." *The Times Higher Educational Supplement*, October 20. Accessed 30 July, 2016. http://www.timeshighereducation.co.uk/story.asp?storyCode=206182§ioncode=26.

Bonitzer, Pascal. 1976. *Le Regard et la voix*. Paris: Union Générale d'Éditions.

Botea, Irina. 2013. *Picturesque*. Accessed February 20, 2015. http://www.irinabotea.com/pages/picturesque.html.

Botea, Irina. 2015. "Re: Picturesque." Personal email communication. 24 February.

Branigan, Edward. 2003. "How Frame Lines (and Film Theory) Figure." In *Film Style and Story: A Tribute to Torben Grodal*, edited by Lennard Højbjerg and Peter Schepelern, 59–86. Copenhagen: Museum Tusculanum Press, University of Copenhagen.

Brecht, Bertolt. 1947. "To Posterity" [An die Nachgeborenen]. In *Brecht: Selected Poems*, translated and with an introduction by H. R. Haus, 173, 177. New York: Grove Press.

Brenez, Nicole. 2012. "Light My Fire: *The Hour of the Furnaces*." *Sight & Sound* 22 (4). Accessed April 30, 2015. http://www.bfi.org.uk/news-opinion/sight-sound-magazine/features/greatest-films-all-time-essays/light-my-fire-hour-furnaces.

Bruzzi, Stella. 2006. *New Documentary*. 2nd ed. London: Routledge.

Burch, Noël. 1981. *Theory of Film Practice*. Translated by Helen R. Lane. Princeton, NJ: Princeton University Press.

Burke, Edmund. 1987. *A Philosophical Inquiry into the Origin of Our Ideas of the Sublime and Beautiful*. Oxford: Blackwell.

Caquard, Sébastien. 2009. "Foreshadowing Contemporary Digital Cartography: A Historical Review of Cinematic Maps in Films." *Cartographic Journal* 46 (1): 46–55.

Chiesi, Roberto. 2008. *La rabbia di Pasolini*. Edited by Roberto Chiesi, 6–17. Insert, *La Rabbia*. Directed by Pier Paolo Pasolini. Rome: RaroVideo. DVD.

Chion, Michel. 1999. *The Voice in Cinema*. Translated by Claudia Gorbman. New York: Columbia University Press.

Cleere, Elizabeth. 1980. "Three Films by Werner Herzog Seen in the Light of the Grotesque." *Wide Angle* 3 (4): 12–19.

Clifford, James. 1988. *The Predicament of Culture: Twentieth-Century Ethnography, Literature, and Art*. Cambridge, MA: Harvard University Press.

Colley, Ann C. 2010. *Victorians in the Mountains: Sinking the Sublime*. Farnham: Ashgate.

Condee, Nancy. 2011. "Endtsate and Allegory." In *The Cinema of Alexander Sokurov*, edited by Birgit Beumers and Nancy Condee, 188–99. London: IB Tauris.

Conley, Tom. 2000. "The Film Event: From Interval to Interstice." In *The Brain Is the Screen: Deleuze and the Philosophy of Cinema*, edited by Gregory Flaxman, 303–25. Minneapolis: University of Minnesota Press.

Cook, Simon. 2007. "'Our Eyes, Spinning Like Propellers': Wheel of Life, Curve of Velocities, and Dziga Vertov's 'Theory of the Interval.'" *October* 121: 79–91.

Corrigan, Timothy. 2011. *The Essay Film: From Montaigne, after Marker*. Oxford and New York: Oxford University Press.

Cortellessa, Andrea. 2010a. "Da *La tregua* a *La strada di Levi*." In *Da una tregua all'altra*, edited by Marco Belpoliti and Andrea Cortellessa, 171–91. Milan: Chiarelettere.

Cortellessa, Andrea. 2010b. "Presentazione." In *Da una tregua all'altra*, edited by Marco Belpoliti and Andrea Cortellessa, 3–9. Milan: Chiarelettere.

Cortellessa, Andrea, Marco Belpoliti, and Davide Ferrario. 2010. "*La strada di Levi*. Una conversazione con Marco Belpoliti e Davide Ferrario." In *Da una tregua all'altra*, edited by Marco Belpoliti and Andrea Cortellessa, 193–258. Milan: Chiarelettere.

Crawford, Peter Ian. 1992. "Film as Discourse: The Invention of Anthropological Realities." In *Film as Ethnography*, edited by Peter Ian Crawford and David Turton, 66–82. Manchester: Manchester University Press.

Cronin, Paul, ed. 2002. *Herzog on Herzog*. London: Faber & Faber.

D'Agata, John. 2014. "Introduction." In *We Might As Well Call It the Lyric Essay*, edited by John D'Agata, 5–10. New York: Hobart and William Smith Colleges Press.

D'Agata, John, and Deborah Tall. 1997. "New Terrain: The Lyric Essay." *Seneca Review* 27 (2): 7–8.

De Villiers, Nicholas. 2006. "A Great 'Pedagogy' of Nuance: Roland Barthes's *The Neutral*." *Theory & Event* 8 (4): 1–11.

Debaise, Didier. 2013. "A Philosophy of Interstices: Thinking Subjects and Societies from Whitehead's Philosophy." *Subjectivity* 6 (1): 101–11.

Debord, Guy. 2006. "Theory of Derive." In *Situationist International Anthology*, edited by Ken Knabb, 62–8. Berkeley: Bureau of Public Secrets.

Deleuze, Gilles. 1989. *Cinema 2: The Time-Image*. Translated by Hugh Tomlinson and Robert Galeta. Minneapolis: University of Minnesota Press.

Deleuze, Gilles. 1994. *Difference and Repetition*. Translated by Paul Patton. New York: Columbia University Press.

Deleuze, Gilles. 2003. *Francis Bacon: The Logic of Sensation*. Translated by Daniel W. Smith. Minneapolis: University of Minnesota Press.

Deleuze, Gilles. 2006. *Foucault*. Translated by Seán Hand. London: Continuum.

Derrida, Jacques. 1979. "The Parergon." Translated by Craig Owens. *October* 9 (Summer): 3–41.

Didi-Huberman, Georges. 2008. *Images in Spite of All: Four Photographs from Auschwitz*, translated by Shane B. Lillis. Chicago: University of Chicago Press.

Didi-Huberman, Georges. 2013a. "Image, poésie, politique, à partir de *La Rabbia* de Pier Paolo Pasolini." Presentation at the Centre de recherches sur les arts et le langage (CRAL), Paris, January 28. http://cral.ehess.fr/index.php?1404.

Didi-Huberman, Georges. 2013b. "Rabbia poetica. Nota su Pier Paolo Pasolini." *Carte Semiotiche. Rivista Internazionale di Semiotica e Teoria dell'Immagine*. Annali I: "Anacronie. La temporalita plurale delle immagini," edited by Angela Mengoni, 70–9. Lucca: La Casa Usher.

Doane, Mary Ann. 1980. "The Voice in the Cinema: The Articulation of Body and Space." *Yale French Studies* 60: 33–50.

Dubbini, Renzo. 1994. *Geografie dello sguardo: visione e paesaggio in età moderna*. Turin: Einaudi.

Duncan, James. 1993. "Sites of Representation." In *Place/Culture/Representation*, edited by James S. Duncan and David Ley, 39–56. New York: Routledge.

Eaglestone, Robert. 2010. "Reading *Heart of Darkness* after the Holocaust." In *After Representation? The Holocaust, Literature, and Culture*, edited by R. Clifton Spargo and Robert M. Ehrenreich, 190–219. New Brunswick, NJ: Rutgers University Press.

Elsaesser, Thomas. 2009. "Holocaust Memory and the Epistemology of Forgetting? Re-wind and Postponement in *Respite*." *Harun Farocki: Against What? Against Whom?*, edited by Antje Ehmann and Kodwo Eshun, 57–68. London: Koenig Books.

Emerson, Ralph Waldo. 1969. *The Journals and Miscellaneous Notebooks of Ralph Waldo Emerson, 1838–1842*. Vol. 7. Cambridge, MA: Harvard University Press.

Epstein, Leslie. 1981. "Novel of Neurosis and History: *The White Hotel* by D. M. Thomas." *The New York Times*, Sunday, March 15, 7, 1.

Farassino, Alberto. 2000. *Tutto il cinema di Luis Buñuel*. Milan: Baldini & Castoldi.

Farge, Arlette. 1989. *Le Goût de l'archive*. Paris: Seuil.

Farocki, Harun, and Rembert Hüser. 2004. "Nine Minutes in the Yard. A Conversation with Harun Farocki." In *Harun Farocki. Working on the Sightlines*, edited by Thomas Elsaesser, 279–314. Amsterdam: Amsterdam University Press.

Faulkner, William. 1951. *Requiem for a Nun*. New York: Random House.

Feinstein, Stephen. 2000. *Witness and Legacy: Contemporary Art about the Holocaust*. Minneapolis: Centre for Holocaust and Genocide Studies, University of Minnesota/ Lerner.

Fleming, David H. 2013. "The Method Meets Animation: On Performative Affect and Digital-bodies in Aronofsky's 'Performance Diptych.'" *International Journal of Performance Arts and Digital Media* 9 (2): 275–93.

Foster, David. 2009. "'Thought-Images' and Critical-Lyricisms: The Denkbild and Chris Marker's *Le Tombeau d'Alexandre*." *Image & Narrative* 10 (3): 3–14.

Foucault, Michel. 1986. "Of Other Spaces." Translated by Jay Miskowiec. *Diacritics* 16 (1): 22–7.

Frodon, Jean-Michel, ed. 2007. *Cinema and the Shoah: An Art Confronts the Tragedy of the Twentieth Century*. Translated by Anna Harrison and Tom Mes. New York: SUNY Press.

Fusco, Coco. 1994. "The Other History of Intercultural Performance." *TDR* 38 (1): 143–67.

Gaskell, Ivan. 2006. "Diptychs—What's the Point?" *The Journal of Aesthetics and Art Criticism* 64 (3): 325–32.

Genette, Gérard. 1997. *Palimpsests: Literature in the Second Degree*. Translated by Channa Newman and Claude Doubinsky. Lincoln: University of Nebraska Press.

Giori, Mauro. 2012. "Parlavo vivo a un popolo di morti: *Comizi d'amore*, cinema-verità e film a tesi." *Studi pasoliniani* 6 (6): 99–112.

Godard, Jean-Luc, and Youssef Ishaghpour. 2005. *Cinema: The Archeology of Film and the Memory of a Century*. Oxford and New York: Berg.

Good, Graham (1988). *The Observing Self: Rediscovering the Essay*. London: Routledge.

Gurkin Altman, Janet. 1982. *Epistolarity: Approaches to a Form*. Columbus: Ohio State University Press.

Haggith, Toby, and Joanna Newman. 2005. "Introduction." In *Holocaust and the Moving Image: Representations in Film and Television since 1933*, edited by Toby Haggith and Joanna Newman, 1–15. London: Wallflower Press.

Harp, Steve. 1988. "Passion of Remembrance." *Afterimage* 16 (1): 20–1.

Harte, Tim. 2005. "A Visit to the Museum: Aleksandr Sokurov's *Russian Ark* and the Framing of the Eternal." *Slavic Review* 64 (1): 43–58.

Harvey, David Oscar. 2012. "The Limits of Vococentrism: Chris Marker, Hans Richter and the Essay Film." *SubStance* 41 (2): 6–23.

Hassler, Donald M. 2012. "Letter." In *Encyclopedia of the Essay*, edited by Tracy Chevalier, 478–9. New York: Routledge.

Haswell, Helen. 2014. "To Infinity and Back Again: Hand-drawn Aesthetic and Affection for the Past in Pixar's Pioneering Animation." *Alphaville: Journal of Film and Screen Media* 8 (Winter). Accessed July 30, 2015. http://www.alphavillejournal.com/Issue8/HTML/ArticleHaswell.html.

Havard, Robert. 2001. *The Crucified Mind: Rafael Alberti and the Surrealist Ethos in Spain*. Rochester, NY: Boydell & Brewer.

Hesler, Jacob. 2009. "Playing with Death. The Aesthetic of Gleaning in Agnes Varda's *Les Glaneurs et la Glaneuse*." In *Telling Stories: Countering Narrative in Art, Theory, and Film*, edited by Jane Tormey and Gillean Whitely, 193–9. Newcastle upon Tyne: Cambridge Scholars.

Horace. 1989. *Epistles Book II and Ars Poetica*. Vol. 2. Edited by Niall Rudd. Cambridge, UK: Cambridge University Press.

Huxley, Aldous. 1960. *Collected Essays*. London: Harper & Brothers.

Huygens, Ils. 2007. "Deleuze and Cinema: Moving Images and Movements of Thought." *Image & Narrative: Online Magazine of the Visual Narrative* 18. Accessed June 12, 2015. http://www.imageandnarrative.be/inarchive/thinking_pictures/huygens.htm

Huyssen, Andreas. 2000. "After the War: Berlin as Palimpsest." *Harvard Design Magazine* 10 (Spring/Summer): 3–5. Accessed April 27, 2015. http://www.harvarddesignmagazine.org/issues/10/after-the-war.

Ibarz, Mercè. 2004. "A Serious Experiment: *Land without Bread*, 1933." In *Luis Buñuel: New Readings*, edited by Isabel Santaolalla and Peter William Evans, 27–42. London: British Film Institute.

"*The Invisible Frame/Cycling the Frame*." 2014. Berlin Art Film Festival. Accessed December 2, 2016. http://berlinartfilmfestival.de/2014/?projects=program-11.

Kearney, Richard. 2002. *On Stories*. London and New York: Routledge.

Lacan, Jacques. 1998. *The Seminar XI: The Four Fundamental Concepts of Psychoanalysis*, edited by Jacques-Alain Miller, translated by Alan Sheridan. New York: Norton.

Lancioni, Judith. 1996. "The Rhetoric of the Frame: Revisioning Archival Photographs in *The Civil War*." *Western Journal of Communication (includes Communication Reports)* 60 (4): 397–414.

Latsis, Dimitrios S. 2013. "Genealogy of the Image in *Histoire(s) du Cinéma*: Godard, Warburg and the Iconology of the Interstice." *Third Text* 27 (6): 774–85.

Lebow, Alisa. 2012. "Introduction." In *The Cinema of Me: The Self and Subjectivity in First Person Documentary*, edited by Alisa Lebow, 1–11. New York: Columbia University Press.

Léger, Marc James. 2013. "Pasolini's Contribution to *La Rabbia* as an Instance of Fantasmatic Realism." *Left Curve* 37: 56–68.

Liandrat-Guigues, Suzanne. 2004. "Un Art de l'équilibre." In *L'Essai et le cinema*, edited by Suzanne Liandrat-Guigues and Murielle Gagnebin, 7–12. Seyssel: Champ Vallon.

Liehm, Mira. 1984. *Passion and Defiance: Film in Italy from 1942 to the Present*. Berkley and Los Angeles: University of California Press.

Lindeperg, Sylvie. 2007. *Nuit et brouillard: Un film dans l'histoire*. Paris: Odile Jacob.

Lindeperg, Sylvie. 2009. "Suspended Lives, Revenant Images: On Harun Farocki's Film *Respite*." In *Harun Farocki: Against What? Against Whom?*, edited by Antje Ehmann and Kodwo Eshun. Translated by Benjamin Carter, 28–34. London: Koenig Books.

Lukács, György. 2010. "On the Nature and Form of the Essay: A Letter to Leo Popper." In *Soul & Form*, translated by John T. Sanders and Katie Terezakis, 16–34. New York: Columbia University Press.

Luisetti, Federico. 2011. *Una vita: Pensiero selvaggio e filosofia dell'intensità*. Milan: Mimesis.

Lupton, Catherine. 2006. *Chris Marker: Memories of the Future*, 2nd ed. London: Reaktion Books.

Lyotard, Jean-François. 1988. *The Differend: Phrases in Dispute*, translated by Georges Van Den Abbeele. Minneapolis: University of Minnesota Press.

Lyotard, Jean-François. 1995. "Discussions, or Phrasing 'After Auschwitz.'" In *Auschwitz and After: Race, Culture, and the "Jewish Question" in France*, edited by Lawrence D. Kritzman, translated by Georges Van Den Abbeele, 149–79. New York: Routledge.

Magaletta, Giuseppe. 2010. *Pier Paolo Pasolini: le opere, la musica, la cultura*. Vol. 2. Foggia: Diana Galiani.

Mandelbaum, Jacques. 2007. "Recovery." In *Cinema and the Shoah: An Art Confronts the Tragedy of the Twentieth Century*, edited by Jean-Michel Frodon, translated by Anna Harrison and Tom Mes, 25–42. New York: SUNY Press.

Marchessault, Janine, and Susan Lord. 2008. "Introduction." In *Fluid Screens, Expanded Cinema*, edited by Janine Marchessault and Susan Lord, 3–28. Toronto: University of Toronto Press.

Marcus, George E. 1995. "The Modernist Sensibility in Recent Ethnographic Writing and the Cinematic Metaphor of Montage." In *Fields of Vision: Essays in Film Studies, Visual Anthropology, and Photography*, edited by Leslie Devereaux and Roger Hillman. Berkeley: University of California Press.

Mason, Henry L. 1984. "Testing Human Bonds within Nations: Jews in the Occupied Netherlands." *Political Science Quarterly* 99: 315–43.

Melnick, Daniel C. 1994. *Fullness of Dissonance: Modern Fiction and the Aesthetics of Music*. Cranbury, NJ: Associated University Presses.

Monson, Ander. 2008. "Essay as Hack." Accessed July 30, 2015. http://otherelectricities.com/swarm/essayashack.html

Montaigne, Michele de. 1700. *The Essays of Montaigne*. Translated by Charles Cotton, 3rd ed. London: Printed for M. Gillyflower et al.

Montero, David. 2012. *Thinking Images: The Essay Film as a Dialogic Form in European Cinema*. Oxford: Peter Lang.

Morgan, Frances. 2015. "Sound On Film: Listening to Ben Rivers' *Slow Action*." *Sound and Music*. Accessed September 15, 2015. http://www.soundandmusic.org/features/sound-film/listening-ben-rivers-slow-action.

Mulvey, Laura. 2006. *Death 24x a Second: Stillness and the Moving Image*. London: Reaktion Books.

Murray, Timothy. 2000. "Wounds of Repetition in the Age of the Digital: Chris Marker's Cinematic Ghosts." *Cultural Critique* 46 (Autumn): 102–23.

Nancy, Jean-Luc. 2005. *The Ground of the Image*. New York: Fordham University Press.

Naficy, Hamid. 2001. *An Accented Cinema: Exilic and Diasporic Filmmaking*. Princeton, NJ: Princeton University Press.

Nardelli, Matilde. 2010. "Some Reflections on Antonioni, Sound and the Silence of *La notte*." *The Soundtrack* 3 (1): 11–23.

Neumann, Anyssa. 2011. "Ideas of North: Glenn Gould and the Aesthetic of the Sublime." *voic-eXchange* 5 (1): 35–46.

Nguyễn, Trinh Thi. 2016. "Re: Letters from Panduranga." Personal email communication. 11 May.

Nichols, Bill. 1994. *Blurred Boundaries: Questions of Meaning in Contemporary Culture*. Bloomington: Indiana University Press.

Nichols, Bill. 2010. *Introduction to Documentary*, 2nd ed. Bloomington: Indiana University Press.

Nicolson, Marjorie Hope. 1997. *Mountain Gloom and Mountain Glory: Development of the Aesthetics of the Infinite.* Washington: University of Washington Press.

Nora, Pierre, ed. 2001–2010. *Realms of Memory: Rethinking the French Past,* edited by Lawrence D. Kritzman. Translated by Arthur Goldhammer. 3 vols. Chicago: University of Chicago Press.

Panse, Silke. 2006. "The Film-maker as *Rückenfigur*: Documentary as Painting in Alexandr Sokurov's *Elegy of a Voyage.*" *Third Text* 20 (1): 9–25.

Pasolini, Pier Paolo. 2011. "*La rabbia* (1962–1963)." *Per il cinema,* Vol. 2, edited by Walter Siti and Franco Zabagli, 3066–72. Milan: Mondadori.

Pethő, Ágnes. 2011. *Cinema and Intermediality: The Passion for the In-between.* Cambridge, UK: Cambridge Scholars.

Poznanski, Renée. 2001. *Jews in France during World War II.* Translated by Nathan Bracher. Hanover, NH: University Press of New England.

Pratt, Mary Louise. 2007. *Imperial Eyes: Travel Writing and Transculturation.* New York: Routledge.

Quilty, Jim. 2014. "Art Nesting in Archives and Activism." *The Daily Star* (Lebanon), April 16. Accessed April 29, 2015. http://www.dailystar.com.lb/Culture/Art/2014/Apr-16/253427-art-nesting-in-archives-and-activism.ashx#ixzz30Ls7v0J5

Raffestin, Claude. 2001. "From Text to Image." In *From Geopolitics to Global Politics: A French Connection,* edited by Jacques Lévy, 7–34. London: Frank Cass.

Rancière, Jacques. 1997. "La Constance de l'art: A propos de *Drancy Avenir.*" *Trafic* 21: 40–3.

Rascaroli, Laura. 2002. "The Space of a Return: A Topographic Study of Alain Resnais's *Providence.*" *Studies in French Cinema* 2: 50–8.

Rascaroli, Laura. 2006. "*L'Année dernière à Marienbad/Last Year in Marienbad.*" In *The Cinema of France,* edited by Phil Powrie, 101–10. London: Wallflower Press.

Rascaroli, Laura. 2009. *The Personal Camera: Subjective Cinema and the Essay Film.* London: Wallflower/Columbia University Press.

Ravetto-Biagioli, Kriss. 2012. "Theory by Other Means: Pasolini's Cinema of the Unthought." *International Social Science Journal* 63 (207/208): 93–112.

Raymond, André. 1994. "Islamic City, Arab City: Orientalist Myths and Recent Views." *British Journal of Middle Eastern Studies* 21 (1): 3–18.

Renov, Michael. 1989. "History and/as Autobiography: The Essayistic in Film and Video." *Frame/work: A Journal of Images and Culture* 2 (3): 6–15.

Renov, Michael. 2004. *The Subject of the Documentary.* Minneapolis and London: Minnesota University Press.

Richter, Hans. 1992. "Der Filmessay. Eine neue Form des Dokumentarfilms." In *Schreiben Bilder Sprechen: Texte zum essayistischen Film,* edited by Christa Blümlinger and Constantin Wulff, 195–8. Wien: Sonderzahl.

Rist, Peter. 2007. "Agit-prop Cuban Style: Master Montagist Santiago Álvarez." *OffScreen* 11 (3). Accessed April 29, 2015. http://offscreen.com/view/agit_prop_cuban_style.

Rivette, Jacques. 1977. "Letter on Rossellini." In *Rivette: Texts and Interviews,* edited by Johnathan Rosenbaum, translated by Amy Gateff and Tom Milne, 54–64. London: British Film Institute.

Rizzarelli, Maria. 2011. "Un blob su commissione: *La rabbia* di Pier Paolo Pasolini." In *Autori, lettori e mercato nella modernità letteraria,* edited by Alberto Zava, Ilaria Crotti, Enza Del Tedesco, and Ricciarda Ricorda, 267–76. Pisa: ETS.

Rodowick, David Norman. 1997. *Gilles Deleuze's Time Machine.* Durham, NC: Duke University Press.

Rodowick, David Norman. 1999. "The Memory of Resistance," in *A Deleuzian Century?,* edited by Ian Buchanan, 37–58. Durham, NC: Duke University Press.

Rony, Fatimah Tobing. 1996. *The Third Eye: Race, Cinema, and Ethnographic Spectacle.* Durham, NC: Duke University Press.

Rose, Sven-Erik. 2008. "Auschwitz as Hermeneutic Rupture, Differend, and Image." In *Visualizing the Holocaust: Documents, Aesthetic, Memory,* edited by David Bathrick, Brad Prager, and Michael D. Richardson, 114–37. Rochester, NY: Camden House.

Rosenbaum, Jonathan. 2009. "A Handful of World: The Films of Peter Thompson—An Introduction and Interview." *Film Quarterly* 63 (1): 36–43.

Rosenstone, Robert A. 1988. "History in Images/History in Words: Reflections on the Possibility of Really Putting History onto Film." *The American Historical Review* 93 (5): 1173–85.

Rossetto, Tania. 2012. "Embodying the map: Tourism practices in Berlin." *Tourist Studies* 12 (1): 1–24.

Russell, Catherine. 1999. *Experimental Ethnography: The Work of Film in the Age of Video.* Durham, NC: Duke University Press.

Sachs, Ruth Hanna. 2009. *Leaflets of Our Resistance.* Vol. 1. Camarillo, CA: Exclamation!.

Sánchez, Carlos Vara. 2014. "Bill Viola's *Nantes Triptych*: Unearthing the Sources of its Condensed Temporality." *Aniki: Revista Portuguesa da Imagem em Movimento* 2 (1): 35–48.

Sartarelli, Stephen. 2014. "Notes." In *The Selected Poetry of Pier Paolo Pasolini: A Bilingual Edition,* edited and translated by Stephen Sartarelli, 449–82. Chicago: University of Chicago Press.

Sayad, Cecilia. 2013. *Performing Authorship: Self-inscription and Corporeality in the Cinema.* London: IB Tauris.

Sekula, Allan. 2003. *Titanic's Wake.* Cherbourg-Octeville: Le Point du Jour.

Sgueglia, Lucia. "A est di cosa? Per una geografia della *Tregua*." In *Da una tregua all'altra,* edited by Marco Belpoliti and Andrea Cortellessa, 77–94. Milan: Chiarelettere.

Shohat, Ella, and Robert Stam. 2013. *Unthinking Eurocentrism: Multiculturalism and the Media.* New York: Routledge.

Sicinski, Michael. 2010. "Listen to Britain: On the Outskirts with Ben Rivers." *Cinema Scope* 43 (Summer): 22.

Silverman, Kaja. 2002. "The Dream of the Nineteenth Century." *Camera Obscura* 17: 1–29.

Smith, Jonathan. 2013. "The Lie That Blinds: Destabilizing the Text of Landscape." In *Place/Culture/Representation,* edited by James S. Duncan and David Ley, 78–92. New York: Routledge.

Snyder, John. 1991. *Prospects of Power: Tragedy, Satire, the Essay, and the Theory of Genre.* Lexington, Ken.: University Press of Kentucky.

Solanas, Fernando, and Octavio Getino. 1976. "Towards a Third Cinema," in *Movies and Methods,* edited by Bill Nichols, vol. 1, 44–64. Berkeley: University of California Press.

Sommer, Roy. 2006. "Initial Framings in Film." In *Framing Borders in Literature and Other Media,* edited by Werner Wolf and Walter Bernhart, 383–406. Amsterdam and New York: Rodopi.

Suárez, Juan Antonio. 2013. "Three Regimes of Noise in 1960s and 1970s Experimental Film: Jack Smith, Terry Fox, Hélio Oiticica." In *Homenaje: Francisco Gutiérrez Díez,* edited by Rafael Monroy, 297–311. Murcia: Editum.

"Surplus: Terrorized into Being Consumers." 2015. *DocumentaryStorm.* Accessed April 29, 2015. http://documentarystorm.com/surplus/.

Taylor, Nora A. 2015. "The Imaginary Geography of Champa." In *Lettres de Panduranga by Nguyen Trinh Thi,* pp. 55–60. Dijon: Les presses du réel.

Tode, Thomas. 1997–1998. "Démontage du regard définitif." Translated by Catherine Charrière. *Images documentaires* 29/30 (Special issue on Johnas van der Keuken): 37–50.

Truffaut, François. 1957. "Vous êtes tous témoins dans ce procès. Le cinéma français crève sous les fausses légendes." *Arts* 15 May: 3–4.

Turim, Maureen. 1999. "Artisanal Prefigurations of the Digital: Animating Realities, Collage Effects, and Theories of Image Manipulation." *Wide Angle* 21 (1): 48–62.

Turner, Victor Witter. 1967. *The Forest of Symbols: Aspects of Ndembu Ritual.* Ithaca, NY: Cornell University Press.

Van Gennep, Arnold. 2011. *The Rites of Passage.* Chicago: University of Chicago Press,.

Vertov, Dziga. 1984. *Kino-eye: The Writings of Dziga Vertov.* Edited and with an introduction by Annette Michelson. Translated by Kevin O'Brien. Berkeley and Los Angeles: University of California Press.

Viano, Maurizio. 1993. *A Certain Realism: Making Use of Pasolini's Film Theory and Practice.* Berkley and Los Angeles: University of California Press.

Vogel, Amos. 2013. "On Seeing a Mirage." In *The Films of Werner Herzog: Between Mirage and History,* edited by Timothy Corrigan, 44–49. Oxon: Routledge.

Wagstaff, Emma. 2006. *Provisionality and the Poem: Transition in the Work of du Bouchet, Jaccottet and Noël.* Amsterdam and New York: Rodopi.

Walker, Michelle Boulous. 2011. "Becoming Slow: Philosophy, Reading and the Essay." In *The Antipodean Philosopher,* edited by Graham Robert Oppy and Nick N. Trakakis. Vol. 1, 268–78. Plymouth, UK: Lexington Books.

Weissman, Gary. 2013. "A Filmmaker in the Holocaust Archives: Photography and Narrative in Peter Thompson's *Universal Hotel.*" *Post Script: Essays in Film and the Humanities* 32 (2): 34–52.

White, Hayden. 1988. "Historiography and Historio*photy.*" *The American Historical Review* 93 (5): 1193–9.

Wilson, Eric Dean. 2014. "Regarding Diptychs." *The American Reader* 30 (September). Accessed April 27, 2015. http://theamericanreader.com/regarding-diptychs/.

Wilson, Kristi M. 2013. "Ecce Homo Novus: Snapshots, the 'New Man,' and Iconic Montage in the Work of Santiago Álvarez." *Social Identities* 19 (3/4): 410–422.

Wingate, Steven. 2015. "The Lost Origins of Personal-Screen Cinema." In *Small Cinemas in Global Markets: Genres, Identities, Narratives,* edited by David Desser, Janina Falkowska, and Lenuta Giukin, 231–246. London: Lexington.

Wittgenstein, Ludwig. 1969. *On Certainty.* Edited by G. E. M. Anscombe and George Henrik von Wright. New York: Harper & Row.

Zając, Bartosz. 2014. "Obrazy (w) historii: film kompilacyjny i francusko-niemieckie kroniki filmowe w latach 1940–1944." *Sztuka i Dokumentacja* 10: 91–104.

Zavattini, Cesare. 1979. "I sogni migliori." In *Neorealismo ecc,* edited by Mino Argentieri, 37–40. Milan: Bompiani.

Žižek, Slavoj. 2011. "Architectural Parallax, Spandrels and Other Phenomena of Class Struggle." Lacan.com. Accessed June 12, 2015. http://www.lacan.com/essays/?page_id=218.

Zryd, Michael. 2003. "Found Footage Film as Discursive Metahistory: Craig Baldwin's *Tribulation 99.*" *The Moving Image* 3 (2): 40–61.

INDEX

Đà Nẵng (Vietnam), 147
Dachau (extermination camp), 51,
 179–83, 185
Dada, 118
Dadi, Iftikhar, 27
Daleká cesta. See Long Journey, The
De Gaulle, Charles, 128
Debord, Guy, 1, 101
Décimas de la Revolución, 132
Delbo, Charlotte, 60
Deleuze, Gilles, 9–15, 18, 23, 24, 26, 37, 39,
 47, 48, 52, 65, 97, 114, 118, 123, 138,
 144, 188–90. See also image;
 in-betweenness; interstice; unthought
Der Ursprung der Nacht (Amazonas-Kosmos).
 See Origin of the Night: Cosmos of the
 Amazon, The
Deren, Maya, 72
dérive, 101. See also Debord, Guy;
 Situationism
Derrida, Jacques, 74, 165, 170
des Pallières, Arnaud, 18, 49, 51, 52, 60–63,
 65, 67, 157
dialectics, 7, 8, 13, 14, 48, 53, 59, 70, 96,
 97, 139; Hegelian, 13
dialogism. See dialogue
dialogue in the essay film, 8, 15, 16, 35,
 58, 59, 97; epistolary, 149, 150, 154;
 intertextual, 179, 187; Platonic, 97;
 with the Self, 146; Socratic, 8; tactile,
 112. See also dialectics
Diary for Timothy, A, 3
Diary of a Pregnant Woman, 1
Didi-Huberman, Georges, 18, 52, 53, 131.
 See also image
Dimanche à Pekin, 1
diptych. See essay film
Diptych: Dialectic, 96
Do lok tin si. See Fallen Angels
Domínguez, Reutilio, 132
Don Camillo, 126
Dono, Heri, 27n1
Drancy, 50, 51, 61, 62. See also La Cité de
 la Muette
Drancy Avenir, 18, 49–50, 52, 60–67, 157
Dreyer, Carl Theodor, 90n1
Drowned and the Saved, The. See sommersi e
 i salvati, I
Druze, 120–22, 124
Duras, Marguerite, 60
Düsseldorf, 88

Dyptyk filmowy Daniela Szczechury. See Film
 Diptych by Daniel Szczechura
Dziga Vertov Group, 9, 15

Eastwood, Clint, 95
Ecran français, L' (periodical), 3
Edward II, 101
Egoyan, Atom, 146
Egypt, 128, 132
Eisenhower, Dwight D., 128
Eisenstein, Sergei, 2, 111, 170
Eisner, Lotte, 82, 87n8
Elegiya dorogi. See Elegy of a Voyage
Elegy of a Voyage, 17, 26–28, 30–37, 39–47,
 114, 157
Elizabeth II, 128
Emerson, Ralph Waldo, 69
Empty Centre, The, 101n3
Engels, Friedrich, 119
England, 87
Enlightenment, 5, 16, 17, 26, 29, 33, 189
Epistles, 155
essay film, forms of: diptych, 17, 19, 95–98,
 101, 104, 106, 112, 114, 126, 129, 184,
 186, 187; and disjunction, 7–12, 17,
 19, 20, 23, 24, 26, 35, 37, 39, 44–46,
 48, 114,
 118–20, 122, 124, 127, 134, 138,
 144–46, 151, 154, 162, 163,
 184, 188; epistolary, 17, 20, 144–54;
 ethnographic, 17, 71–92; hypertextual,
 107–14; and logocentrism, 8, 19, 20,
 118–20, 124, 135, 136, 138,
 140, 143; lyric, 17, 20, 154–63; and
 multivoicedness, 124, 129, 139;
 musical, 17, 20, 124–41, 188;
 travelogue, 17, 26, 84, 107, 145,
 146–48; and vococentrism, 20,
 115–17, 119, 140
Essay on Criticism, 155
Essay on Man, 155
Europe, 17, 19, 26–29, 32–34, 39, 40, 44,
 63, 72, 73, 75, 77–79, 81, 84, 87, 102,
 108, 109, 112, 113, 127n6, 166, 180,
 188, 190
Eustache, Jean, 11

F for Fake, 183
Fallen Angels, 95
Falls, The, 87
Far From Poland, 177

Lightning Source UK Ltd.
Milton Keynes UK
UKHW010318040921
389827UK00012B/383